NORTHERN RENAISSANCE ART

1400-1600

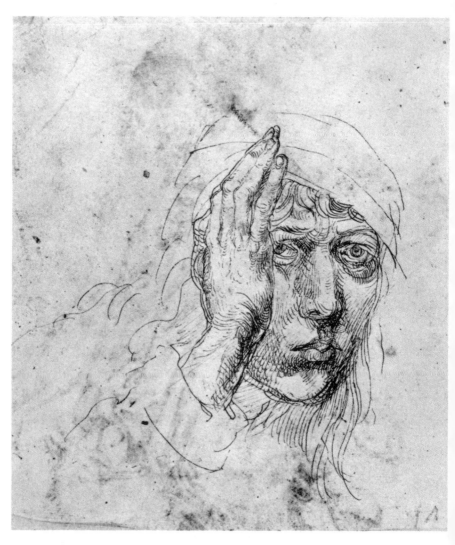

Albrecht Dürer, Self-portrait. Probably 1491. Pen and ink, 204 x 208 mm. Erlangen, University Library. Courtesy: Handschriftenabteilung, Universitätsbibliothek Erlangen.

Northern Renaissance Art

1400 – 1600

SOURCES and DOCUMENTS

Wolfgang Stechow

NORTHWESTERN UNIVERSITY PRESS

Evanston, Illinois

Northwestern University Press
Evanston, Illinois 60208-4210

Printed in the United States of America

ISBN 0-8101-0849-6

Library of Congress Cataloging-in-Publication Data

Northern Reniassance art, 1400–1600 : sources and documents / Wolfgang
 Stechow.—Northwestern University Press pbk. ed.
 p. cm.
 Reprint. Originally published: Englewood Cliffs, N.J. : Prentice-
Hall, 1966. (Sources and documents in the history of art series)
 ISBN 0-8101-0849-6
 1. Art, Renaissance—Europe, Northern—Sources. 2. Art—Europe,
Northern—Sources. I. Stechow, Wolfgang, 1896–1974.
N6370.N67 1989
709'.02'4—dc20 89-25542
 CIP

The paper used in this publication meets the minimum requirements of the
American National Standard for Information Sciences—Permanence of Paper
for Printed Library Materials, ANSI Z39.48-1984.

Preface

Although the compiler of this volume has not had to face the same overwhelming *embarras de richesse* as his colleagues in the field of Italian art, his task has nonetheless been of the kind that may have forced him to omit or abbreviate everyone's favorite document. There exist no fully objective guide lines to what is more or less important in, say, 15th-century contracts, Dürer's Netherlandish diary, or van Mander's *Painter's Treatise,* even though there may be some criteria of what is most or least important. On this matter, as well as on the selection of a large number of more isolated documents and sources, the compiler had to follow his own subjective choice—and he can only hope that this choice has been on the whole a reasonable one.

Attempts at exact chronological arrangement seemed to lead to uncertainties and confusion—as did attempts at strict distinction between documents, properly speaking, and sources, in the sense of early writing about more or less contemporary works of art. Eventually—and not without qualms—an arrangement according to countries (Netherlands, Germany, France, England) was adopted, with a roughly chronological order within each section according to artists, but without regard to the date of the sources (some of which are rather late for the simple reason that we have nothing earlier and more important on an artist of the highest distinction, such as, for example, Grünewald). The remarks connecting the documents and sources with each other have been kept as brief as possible.

Few existing translations into English have been used in this volume, except for Dürer, where the combination of Conway and Panofsky was clearly unbeatable. A large number of the documents and sources which follow have not been published in English before; some others existed only in translations which were unusable (van Mander). Several outstanding editions and translations into other languages, particularly German, such as Sanders' of Ofhuys's report on Hugo van der Goes, and Floerke's and Hoecker's of van Mander (*Lives* and *Foundation of the Painter's Art,* respectively), were gratefully consulted, together with their commentaries, and were only occasionally found to be in need of correction in a renewed study of the original.

The new translations were intended to be more accurate than elegant, and have not disturbed some long sentences and conventional tautologies of the original. With few and obvious exceptions, proper

names were left intact at the cost of a few more footnotes because the original spellings may prove to be helpful in other contexts. Original English texts are given in modernized spelling.

In the notes, the anticipated needs of the reader have been heeded rather than any strict system. Data and dates on artists of the first rank were omitted or kept to a minimum. Attempts were made, with regard to minor artists, to condense and bring up to date the information provided by Thieme-Becker and by former editors of the respective documents. Matters of interpretation and translation are briefly discussed in debatable cases. Some helpful recent literature has been cited.

Extensive architectural sources do not appear in this book because they are to be included in separate volumes on architecture.

For valuable help in clarifying difficult single problems of translation and identification, my sincere thanks go to: Mr. Richard D. Buck, Director of the Intermuseum Laboratory at Oberlin, Ohio; Mr. W. Thomas Chase of the Conservation Center, Institute of Fine Arts, New York; Dr. Jan Emmens, Kunsthistorisch Instituut der Rijksuniversiteit, Utrecht; Dr. F. G. Grossmann, City Art Galleries, Manchester; Drs. H. Miedema, Amsterdam; and Professor Sanford Shepard of Oberlin College. I am also grateful for the advice liberally offered me by the editor of this series, Professor H. W. Janson, and Messrs. James M. Guiher and William R. Grose of Prentice-Hall, Inc.

For permission to use existing translations or editions I wish to thank: The Warburg Institute of the University of London; the Walpole Society, London; Fortress Press, Philadelphia; Yale University Press; Princeton University Press; Doubleday & Company, Inc.; and Phaidon Press, Ltd., London.

The Universitätsbibliothek, Erlangen, kindly gave the permission to use Albrecht Dürer's early self-portrait as frontispiece.

<div align="right">WOLFGANG STECHOW</div>

ABBREVIATIONS OF FREQUENTLY CITED LITERATURE

B.: Adam Bartsch, *Le peintre graveur.* Vienna, 1803-1821.

Conway: (Sir) William Martin Conway, *The Literary Remains of Albrecht Dürer.* Cambridge, 1889. New edition with the title, *The Writings of Albrecht Dürer,* with an introduction by Alfred Werner (New York: Philosophical Library, 1958).

Hoecker: R. Hoecker, *Das Lehrgedicht des Karel van Mander* in *Quellenstudien zur holländischen Kunstgeschichte*, VIII. The Hague: Martinus Nijhoff, 1916.

Holt: Elizabeth Gilmore Holt, *A Documentary History of Art*. Garden City, New York: Doubleday Anchor Books, 1957. This is an expanded edition of *The Literary Sources of Art History* (Princeton: Princeton University Press, 1947).

Van Mander-Floerke: *Das Leben der niederländischen und deutschen Maler des Carel van Mander*. Reprint of the Netherlandish edition of 1617 and German translation by Hanns Floerke (Munich and Leipzig: Georg Müller, 1906).

Rupprich: Hans Rupprich, ed., *Albrecht Dürer, Schriftlicher Nachlass*, I. Berlin: Deutscher Verein für Kunstwissenschaft, 1956.

Vasari-Milanesi: Giorgio Vasari, *Le vite de' più eccellenti pittori, scultori ed architetti*, ed. Gaetano Milanesi. Florence: Sansoni, 1878-1885.

Winkler: Friedrich Winkler, *Die Zeichnungen Albrecht Dürers*, 4 vols. Berlin: Deutscher Verein für Kunstwissenschaft, 1936-1939.

Wurzbach: Alfred von Wurzbach, *Niederländisches Künstler-Lexikon*. Vienna and Leipzig: Halm and Goldmann, 1906-1911.

Contents

I

The
Netherlands

THE FIFTEENTH CENTURY

The documentation of Netherlandish art during the first of its most glorious epochs, the 15th century, is extremely scarce when compared with that of Italian art of the same time. Much of this contrast can be readily understood as resulting from the discrepancy between the two countries with regard to typical Renaissance interests: primarily, the concern for the theory and the history of art. The north, however, seems to have been less in arrears with regard to the interest in the artistic personality on the part of both the artist himself and his public. After all, we have more signed paintings by Jan van Eyck than by any Italian painter of the same decade; we can also be reasonably sure that his contemporary reputation as an artist, rather than as a mere craftsman, was very high; and the same is true of Roger van der Weyden and Hugo van der Goes. But we must wait until 1562 before finding a northern literary panegyric on Jan van Eyck—more than a hundred years after the first eulogy bestowed on him by an Italian writer. Without Jan van Eyck's signed works we should be almost completely in the dark about him, and everybody knows the documentary disaster that has befallen the works of that giant among his contemporaries, the "Master of Flémalle." No wonder then that, with the exception of the letters written on behalf of Jan van Eyck by his duke and of a few verses by Mark van Vaernewyck, the following excerpts on the great founder of Netherlandish painting should all be of Italian origin. Testimony on the other masters is widely scattered, and in many cases there is an almost complete void until the late 16th century when Carel van Mander picked up the pieces of evidence still available at that time. It is also significant that one of the finest literary treatments ever accorded Hieronymus Bosch should be due to a Spaniard of the late 16th century. Little documentation exists on 15th century Netherlandish art other than painting.

Jan van Eyck

In an appointment dated May 19, 1425, Jan van Eyck's foremost patron, Duke Philip the Good of Burgundy (1396-1467), had ordered all authorities concerned to respect and continue the "honors, rights, prerogatives, profits, and emoluments" granted his "painter and equerry" under his former lord, Duke John of Bavaria, and his receiver general was to pay him the sum of one hundred Parisian pounds annually.[1] It is safe to say that no painter in the north had ever before occupied a com-

[1] The accountant's statement based on this letter of May 19, 1425, is reprinted by W. H. J. Weale, *Hubert and Jan van Eyck* (London 1908), pp. xxx f., and translated in Holt, pp. 303 f.

parable rank. Apparently a complaint resulted in the following letter addressed by the Duke to his accountants in Lille on March 12, 1435: [2]

To Our Beloved and Faithful Keepers of
Our Accounts at Lille

Very dear and beloved, we have heard that you do not readily verify certain of our letters granting life pension to our well beloved equerry and painter, Jan van Eyck, whereby he cannot be paid said pension; and for this reason, he will find it necessary to leave our service, which would cause us great displeasure, for we would retain him for certain great works with which we intend henceforth to occupy him and we would not find his like more to our taste, one so excellent in his art and science. Therefore, we desire and expressly order that, according to these wishes, you do verify and ratify our said letters of pension and have this pension paid to the said Jan van Eyck, all according to the content of our said letters with no further talk or argument from you nor any omission, change, variation, or difficulty, as much as you would not anger and disobey [us].

For once and for all do so much so that we have no further need to write. This we would only do with great displeasure.

Very dear and well beloved, may the Holy Spirit have you in his Holy care. Written in our city of Dijon, the XII day of March, 1435.

Italian literary interest in the achievements of northern artists started with Ghiberti's eulogy of the enigmatic sculptor Gusmin. It soon turned to the Netherlandish painters, some of whose vastly admired works in a revolutionary technique had begun to trickle into Italy. After Cyriacus of Ancona (p. 8), Bartolommeo Fazio (Facius) occupies a key place in this group. A humanist of rank, with a knowledge of Greek, he was employed and honored at the court of Alfonso V of Aragon at Naples. His "De Viris Illustribus," written in 1456, grants artists a remarkably important position among other professions; and two of the four painters he considers in detail are Netherlanders (Jan van Eyck and Roger van der Weyden). Living in Naples, he was among the first Italians to see and admire works by Jan van Eyck. [3]

Jan of Gaul has been judged the leading painter of our time. He was not unlettered, particularly in geometry [4] and such arts as contribute to the enrichment of painting, and he is thought for this reason

[2] Weale, *op. cit.*, pp. xlii f.; here given in the translation by Holt, pp. 304 f., where the date erroneously is given as 1433 instead of 1435 (1434 old style).

[3] The following passage is given in the translation by Michael Baxandall which is based on a 15th–century manuscript (Vat. lat. 13650): "Bartholomaeus Facius on Painting," *Journal of the Warburg and Courtauld Institutes,* XXVII (1964), 90 ff. (102 ff.).

[4] Perspective. This must be understood in a strictly empirical sense.

to have discovered many things about the properties of colors recorded by the ancients and learned by him from reading Pliny and other authors. His is a remarkable picture in the private apartments of King Alfonso,[5] in which there is a Virgin Mary notable for its grace and modesty, with an Angel Gabriel, of exceptional beauty and with hair surpassing reality, announcing that the Son of God will be born of her; and a John the Baptist that declares the wonderful sanctity and austerity of his life, and Jerome like a living being in a library done with rare art: for if you move away from it a little it seems that it recedes inward and that it has complete books laid open in it, while if you go near it is evident that there is only a summary [6] of these. On the outer side of the same picture is painted Battista Lomellini,[7] whose property it was—you would judge he lacked only a voice—and the woman whom he loved, of outstanding beauty; and she too is portrayed exactly as she was. Between them, as if through a chink in the wall, falls a ray of sun that you would take to be real sunlight. His is a circular representation of the world, which he painted for Philip, Prince of the Belgians, and it is thought that no work has been done more perfectly in our time; you may distinguish in it not only places and the lie of continents, but also, by measurement, the distances between places. There are also fine paintings of his in the possession of that distinguished man, Ottaviano della Carda: [8] women of uncommon beauty emerging from the bath, the more intimate parts of the body being with excellent modesty veiled in fine linen, and of one of them he has shown only the face and breast but has then represented the hind parts of her body in a mirror painted on the wall opposite, so that you may see her back as well as her breast. In the same picture, there is a lantern in the bath chamber, just like one lit, and an old woman seemingly sweating, a puppy lapping up water, and also horses, minute figures of men, mountains, groves, hamlets, and castles carried out with such skill you would believe one was fifty miles distant from another. But almost nothing is more wonderful in this work than the mirror painted in the picture, in which you see whatever is represented as in a real mirror. He is said to have done many other works, but of these I have been able to obtain no complete knowledge.

[5] Alfonso V of Aragon, King of Naples. This triptych has not survived. The St. Jerome is probably reflected in a painting by Colantonio (formerly in San Lorenzo in Naples, now in the Capodimonte Museum), datable ca. 1445. See also pp. 7 and 30.

[6] "Capita"; see Baxandall, *op. cit.*, p. 103, note 25.

[7] Member of a Genoese family with business connections in Bruges, friend of Facius; see R. Weiss, "Jan van Eyck and the Italians," *Italian Studies*, XI (1956), 2 ff.

[8] Formerly misread as "Cardinal Ottaviano"; Ottaviano della Carda was a nephew and adviser of Federigo da Montefeltre (Baxandall). The picture is lost; on comparable motifs see W. H. J. Weale and M. W. Brockwell, *The Van Eycks and Their Art* (London 1912), pp. 197 f.

Nothing of very great importance was written in Italy on northern painters until Giorgio Vasari, almost one hundred years after Fazio, penned the celebrated passage on the "invention" of oil painting by Jan van Eyck for his fundamental work of the historiography of art, the Lives of the most Excellent Painters, Sculptors, and Architects, *first published in 1550, with a second edition in 1568. Vasari (1511–1574), an architect and painter of considerable importance, a native of Arezzo but a Florentine by choice and conviction, a friend of Michelangelo, and an indefatigable collector of drawings by the old masters and of facts about their lives and art, towers above all predecessors as an imaginative historian and as a brilliant writer. The size of our debt to him, certainly overrated before the 19th century but often underestimated later, is now being universally recognized as still of vast proportions. In the following excerpt, he is much less interested in individual works by the northern master than Fazio had been. His narrative is dominated by technical concerns and their dramatic impact on painting in general; with this in mind he did not hesitate to make the circumstances of van Eyck's "discovery of oil painting" look more dramatic than they could possibly have been, even if it had been an invention in the proper sense of the word. But even here a large amount of truth shines through the embroidery. The passage is part of the introduction to Vasari's* Life *of Antonello da Messina, the Italian painter who owed more than any other to the technical accomplishments of Jan van Eyck, and the chapter opens with a statement concerning the drawbacks and limitations of the tempera technique and the futile attempts made by earlier artists to overcome them. He then continues:* [9]

When things were at this impasse it happened that a painter working in Flanders by the name of Giovanni of Bruges, much esteemed in those parts for the fine craftsmanship he had acquired in his profession, set out to try several kinds of pigments and, since he was fond of alchemy, to use many types of oil for making varnishes and other things, as would come to the mind of highly imaginative people such as he himself was. Thus, when on a certain occasion he had spent the greatest effort on painting a panel, and after he had completed it with much diligence, he covered it with varnish and left it to dry in the sun as was his custom. But because either the heat was extreme or perhaps the wood poorly joined or poorly seasoned, that panel cracked open along the joins in a bad fashion. Wherefore Giovanni, seeing the damage that the heat of the sun had caused, resolved to find something that would prevent the sun from ever doing such great harm to his works again. Thus, since he was no less displeased with the varnish than with working in tempera, he set his mind to work on the invention of a kind of varnish which would

[9] Translated from Vasari-Milanesi II, 565 ff. The passage occurs as early as the first edition of 1550.

dry in the shade, without his having to expose his works to the sun. After having experimented with many materials, both pure and mixed, he finally found out that linseed oil and oil from nuts, among the many he had tried out, were apt to dry faster than all others. Thus these, boiled with other mixtures of his, yielded to him the varnish which he, and indeed all painters in the world, had so long desired. After experimenting with many other things, he saw that mixing the pigments with these kinds of oil gave them a very strong consistency which, after drying, not only suffered no ill effect from water but also intensified the colors so strongly that it gave them lustre by themselves without varnish; and what seemed to him to be most amazing was the fact that it produced an infinitely better effect of blending than did tempera. Greatly pleased by such invention, Giovanni quite understandably went to work on many pictures and filled the entire country with them, to the amazement and delight of the people and to very great profit for himself. Spurred on by experience from day to day, he went on to paint ever greater and better things.

Not long after, the fame of Giovanni's invention spread not only throughout Flanders but also through Italy and many other parts of the world, and aroused in the artists the greatest desire to know how he imparted such great perfection to his works. But because these artists only saw these works and did not know the means he employed in making them, they were reduced to extolling him and to heaping eternal praise on him while at the same time quite justifiably envying him; the more so as, for a while, he did not wish to be seen working by anyone nor to teach his secret to anybody. But in his advanced years he finally divulged it to his pupil, Ruggieri of Bruges,[10] and Ruggieri in turn to his disciple, Ausse,[11] and to others whom I mentioned when dealing with oil pigments in the chapter on painting.[12] Yet with all this, and in spite of the fact that the merchants procured some of the paintings and sent them all over the world to princes and persons of high rank to their great profit, the secret itself did not spread beyond Flanders. And although such pictures carried that sharp odor which resulted from the pigments and oils mixed together, particularly when they were fresh, so that it seemed that it should have been possible to recognize them, the matter nonetheless was not found out for many years. But after some Florentines who had business in Flanders and Naples had sent to King Alfonso I of Naples [13] a panel with many figures, done in oil by Jan, which, because of the beauty of its figures and the novel handling of the colors, became

[10] Roger van der Weyden; Vasari's "from Bruges" has given rise to much speculation but is certainly erroneous.

[11] Generally considered a misprint for "Ansse" (Hans Memling).

[12] In "Della Pittura," chapter VII (Vasari-Milanesi I, 184 ff.).

[13] Alfonso V of Aragon, called Alfonso I as King of Naples. The painting referred to is, perhaps, the triptych mentioned above, note 5.

a great favorite of that king, all the painters in that kingdom rushed to see it, and it was highly praised by all.

Mark van Vaernewyck (1518–1569), a Flemish historian writing in Ghent, was the first Netherlandish author to mention Jan van Eyck by name. The Ghent Altarpiece, still left anonymous in van Vaernewyck's "Vlaemsche Audvremdigheyt" (Flemish Chronicle) of 1560, received the following (originally rhymed) tribute in the second edition of that book, published at Ghent in 1562: [14]

In the Church of St. John one can see an altarpiece, of such brilliant conception and so ably executed that, to tell the truth, one could hardly find its equal in all of Europe. The name of its master was Jan van Eyck, and he hailed from Maeseyck, a little town in the rude district of Kempen, whence, in a rude epoch, God sent us this great artist. [15]

Roger van der Weyden

The first important report on the greatest of Jan van Eyck's successors is again the work of an Italian humanist. Writing in 1449, Cyriacus of Ancona (Cyriacus Pizzicolli, 1391–1457) singled out for comment one painting by Roger with which he had become intimately acquainted— unfortunately one which has not survived. It must have enjoyed particular fame in Italy for it was likewise praised, and somewhat more fully described, by Bartolommeo Fazio in his less fascinating account of Roger van der Weyden.[1] *Cyriacus of Ancona was perhaps the most widely traveled of all Italian humanists and had served as cicerone to Roman antiquities for the Emperor Sigismund as early as 1433. In contrast to Jan van Eyck, Roger had visited Italy and had established important contacts with the court of the Este in Ferrara and with the Medici in Florence.*[2]

After that famous man from Bruges, Johannes the glory of painting, Roger in Brussels is considered the outstanding painter of our time. By the hand of this most excellent painter is a magnificently wrought picture which the illustrious prince Lionello of Este showed me in Ferrara on July 8, 1449.[3] In it one sees our first progenitors, and in a most pious image the ordeal of the Deposition of the God-Incarnate, with a large

[14] Under the title: "Nieu tractaet ende curte beschryvinghe van dat edel graefscap van Vlaenderen" (New Treatise and Brief Description of the Noble County of Flanders).

[15] Obviously a free version of Vasari's words in his introduction to the Life of Giotto; Vasari-Milanesi I, 369 ("nato fra artefici inetti, per dono di Dio . . . età e grossa ed inetta . . .").

[1] Reprinted in E. Panofsky, *Early Netherlandish Painting* (Cambridge 1953), p. 362.

[2] The following passage is translated from the Latin text (Codex Trevisanus, Bibl. Capitol. 221) as given by E. Panofsky, *op. cit.*, p. 361. The first sentence is taken from Wurzbach II, p. 875; the translation of the last sentence from Panofsky, p. 2.

[3] On a possible reflection of this lost work see *ibid.*, p. 465, note 266,3.

crowd of men and women standing about in deep mourning. All this is admirably depicted with what I would call divine rather than human art. There you could see those faces come alive and breathe which he wanted to show as living, and likewise the deceased as dead, and in particular, many garments, multi-colored soldiers' cloaks, clothes prodigiously enhanced by purple and gold, blooming meadows, flowers, trees, leafy and shady hills, as well as ornate porticoes and halls, gold really resembling gold, pearls, precious stones, and everything else you would think to have been produced not by the artifice of human hands but by all-bearing nature itself.

The reputation and history of Roger's greatest and most influential work, the "Escorial Altarpiece," [4] *is sharply illuminated by a recently discovered passage, contained in the travel report of Vincente Alvarez, a Spanish official who accompanied Prince Philip of Spain (later King Philip II) on a journey to the Netherlands in 1548.* [5] *Among the works of art he admired in the chapel of Mary of Hungary's castle at Binche, Hainaut, was*

. . . a painting representing the *Descent from the Cross;* this was the best picture in the entire castle and even, I believe, in the whole world, for in these parts I have seen many good paintings but none that equaled this in naturalness and devotion. All who have seen it are of the same opinion. I have been told that this picture is more than one hundred and fifty years old. It seems that it used to be in Louvain and that Queen Mary had it brought from there and replaced it with a copy [6] which is almost but not quite as fine as the original.

Roger's almost equally celebrated "Justice Panels," painted for the court room in the town hall of Brussels between 1439 and the mid-fifties, were destroyed by fire in 1695 and are known to us only through tapestries woven after them about 1460–1470 and now in the Historical Museum in Berne. They were seen and commented upon by Dürer on August 27, 1520 (see below, p. 100). The following careful and valuable description is included in a manuscript entitled "Itinerarium Belgicum," written by one Dubuisson-Aubenay, [7] *who visited Belgium repeatedly between 1623 and 1627.*

The first panel contains in its first section Trajan on horseback

[4] Now in the Prado, Madrid, no. 2825. Painted before 1433.

[5] Translated from the French version given by S. Sulzberger, "La descente de croix de Rogier van der Weyden," *Oud Holland,* LXXVIII (1963), 150, where publication of a new edition of the whole report by Mme. M. Th. Dovillée in Antwerp is announced.

[6] According to van Mander the copy was executed by Michiel Coxcie. Its identification with the copy now in the Escorial (Prado no. 1893; acquired by Philip I in 1569) is not uncontested.

[7] Translated from the Latin text as reprinted by J. Maquet-Tombu in *Phoebus,* II (1949), 181, with corrections suggested by E. Panofsky, "Facies illa Rogeri maximi pictoris," *Late Classical and Medieval Studies in Honor of Albert Mathias Friend* (Princeton 1955), pp. 392 ff. On questions of subject and style see E. Panofsky, *Early Netherlandish Painting,* pp. 264 f.

departing against the Dacians with his army as the poor woman stops his horse by the reins and demands justice. In the second section the soldier who had killed the son of the woman is beheaded. The emperor is present with his nobles and councillors, among whom stands out the figure of a friar—according to appearance and to what I have been told, a Franciscan, which is an anachronism . . .

The first section of the second panel represents the Roman pontiff Gregory meditating and praying before the Column of Trajan; the second section, the pontiff inspecting with his cardinals and clergy the skull of Trajan in which a surgeon demonstrates the intact, healthy red tongue with a probe or spatula . . .

The first section of the third panel represents Herkinbald, Duke of Brabant, lying naked and sick in bed; he rises violently and cuts the throat of a young man, whom he had summoned before him. In the second section, this deed is deplored by a servant and witnessed by a woman, while the painter himself, beardless, attends . . .

The first section of the fourth and last panel shows Herkinbald lying in bed; the second, a bishop with a ministrant assisting him, and a large crowd . . .

Dieric Bouts

The contract of 1464 for Dieric Bouts' Holy Sacrament Altarpiece in St. Peter's Church at Louvain (Leuven) [1] *is the first document that has come down to us for a still extant work of great importance within the realm of Early Netherlandish Painting. With regard to its strict stipulations on subject matter, effort, priority over other work, time limits, and price, it corresponds closely to agreements concluded between artists and church authorities in contemporary Germany and Italy. In this respect it is a thoroughly medieval document, lacking the minor elements of greater freedom for the artist that even some slightly earlier ones contain (see below, pp. 142 ff.). The altarpiece was completed in 1467. After many vicissitudes, all parts, with the exception of the lost outer wings, have been reunited at their original site.*

All who will see the present document or will hear it read are hereby informed and notified that on the fifteenth of March 1464 (after the reckoning of the venerable court of Liége) a firm agreement and contract was set up and concluded between the four administrators of the Brotherhood of the Holy Sacrament at the Church of St. Peter in Louvain, who act on and in behalf of said Brotherhood—that is, Rase van Baussele as principal, Laureys van Winghe, Reyner Stoop, and Staas Roelofs Beckere [2] as the first party, and the painter, Master Dieric Bouts,

[1] Translated from the Netherlandish text as reprinted by Wolfgang Schöne, *Dieric Bouts und seine Schule* (Berlin 1938), p. 240.

[2] It is more probable that "Beckere" is part of the name than that it indicates the profession of baker (as interpreted by Schöne).

as the second party, that he should make for them a precious altarpiece with scenes pertaining to the Holy Sacrament. In this altarpiece there shall be presented on the center panel the Supper of our Beloved Lord with his Twelve Apostles, and on each of the inner wings two representations from the Old Testament: 1) the Heavenly Bread, 2) Melchizedek, 3) Elijah, 4) the Eating of the Paschal Lamb as described in the Old Covenant. Item, on each of the outer wings there shall be one picture: on one, the scene with the Twelve Loaves which only the priests were allowed to eat,[3] and on the other, . . . [lacuna].[4]

And the aforementioned Master Dieric has contracted to make this altarpiece to the best of his ability, to spare neither labor nor time, but to do his utmost to demonstrate in it the art which God has bestowed on him, in such order and truth as the Reverend Masters Jan Vaernacker and Gillis Bailluwel, Professors of Theology, shall prescribe to him with regard to the aforementioned subjects. And it is understood that said Master Dieric, after having begun work on this altarpiece, shall not contract any other work of this kind until this one has been completed. For his work said Master Dieric shall be paid and receive the sum of two hundred Rhenish guilders of twenty stivers each: to wit, twenty-five Rhenish guilders as soon as he has begun to paint this altarpiece, and further, twenty-five Rhenish guilders during the next half year, fifty Rhenish guilders after completing the work, and the remaining one hundred Rhenish guilders during the following year, not reckoning the first three months of the one after that. But if, by the grace of God, the good people should so amply demonstrate their charity and liberality toward said work that the abovenamed sum can be paid in full to said Master Dieric for his completed work, and if that sum of money would otherwise lie unused in awaiting the aforementioned time limit, it has been contracted that said Master Dieric shall be paid in full as soon as he has fulfilled his obligation. This has been witnessed (in addition to the Reverend Professors mentioned before) by Claes van Sinte Goericx, Knight, Master Laureys van Maeldote, Priest, and Master Gheert Fabri, Schoolmaster.

The last documented work by Dieric Bouts, left unfinished at the time of his death in 1475, was commissioned by the city fathers of Louvain. The two documents which follow do not speak a very clear language with regard to the ensemble planned for a room in the Louvain town hall, and the demise of the artist may have caused considerable alterations in the original intentions as well. The "small" altarpiece of the Last Judgment—*small in comparison with the Justice panels—was probably executed first; the central part is known only through a copy but the wings with* Hell *and* Paradise *have survived in the Louvre and in the*

[3] The "show breads," Leviticus 24, 5-9.
[4] The outer wings are lost—if they were ever done.

Lille Museum, respectively.[5] *The two large Justice panels, one completed by Bouts,*[6] *the other left unfinished by him and completed somewhat later by a much weaker hand,*[7] *depict a rare case of the kind of judicial "exemplum" which Roger van der Weyden had painted for the Brussels counterpart of Bouts' Louvain commission*[8] *and which remained so popular with Netherlandish authorities and painters of later generations.*

The first document[9] *has not survived in its original form and must be read in the light of our knowledge as gained from the second, and from a few minor ones. It has come down to us in a 17th century report clearly based on sources prior to 1489 but apparently interpolated with the aid of later documents.*

In the year 1468 [10] two paintings were made by Master Dierick Stuerbout [11] which are placed in the council room. In one, the emperor has judgment passed on a count, a member of the court, because the empress had accused him of having made attempts upon her honor; in the other, the emperor sentences his empress to be burnt, after the aforementioned accusation has been proved false.[12] This was estimated at 230 crowns of 72 placques each.[13]

In the same year, on May 20th, the city of Louvain made a contract with the aforementioned Master Dierick Stuerbout for a certain painting on wood, 26 feet wide and 12 feet high,[14] together with another panel with *Our Lord's Judgment,* 6 feet high and 4 feet wide, for the

5 But see A. Châtelet in *Nederlands Kunsthistorisch Jahrbuch* 1965.

6 The documents do not specify this but common consensus has identified it with the *Ordeal by Fire.*

7 *The Execution of the Innocent Count;* see note 6. The extent of Dieric Bouts' participation in this panel has been judged variously; see Schöne, p. 109, and A. and P. Philippot, "La Justice d'Othon de Thierry Bouts: Examen stylistique et technique," *Bulletin de l'Institut Royal du Patrimoine Artistique,* I (1958), 31 ff.

8 See above, p. 9.

9 Translated from the Netherlandish text as reprinted by Schöne, p. 242, and (with slight changes) by Frans van Molle, "La Justice d'Othon de Thierry Bouts: Sources d'Archives," *Bulletin de l'Institut* . . . (see note 7), p. 7, note 2.

10 The date 1468 must refer to the commission, not to the execution of the panels.

11 This name rests on a confusion between Bouts and the painter Hubrecht Stuerbout which became frequent even during Bouts' lifetime.

12 The story is related in the *Golden Legend* by Jacobus de Voragine and elsewhere, and was prescribed to Bouts by a learned theologian, Jan van Haeght; see Schöne, p. 111, and Nicole Verhaegen, "La Justice d'Othon de Thierry Bouts: Iconographie," *Bulletin de l'Institut* . . . (see note 7), 22 ff.

13 As mentioned here, the crown consisted of 72 "plekken," while the guilder was worth only 54 of them.

14 This must have *included* the Justice panels, as Schöne, p. 100, has shown.

price of 500 crowns; [15] this *Judgment* panel hangs in the councilmen's room of the town hall at Louvain.

The second document,[16] *datable between May 1st and July 31st, 1480, is preserved in the original and offers us the precious glimpse of a great master being called upon to estimate the value of a work by an illustrious predecessor.*

Item, Master Dierick Boudts, the painter, had made a contract with the city to paint four parts of a large work which were intended to be placed in a hall or room, with portraits and [other] paintings, and another small panel with its wings showing the Judgment, and the Judgment [also] on the inside, hanging in the council room. For these, the aforementioned Master Dierick was to receive from the city, after completion, the sum of 500 crowns, but this did not come to pass because he died in the meantime so that he was unable to finish them in his time. Of the large panels one was entirely, and the second, almost completed; the small panel with the *Judgment,* which hangs in the council room, is finished. For this the city has defrayed and paid to him and to his children the sum of 306 guilders and 36 placques [17] on the basis of an estimate and valuation from one of the most eminent painters that could be found around these parts, a man born in the city of Ghent and now residing in the Red Cloister in the district of Soignes.[18]

Aelbert Ouwater

For our knowledge of the life and work of Aelbert Ouwater we have to depend almost exclusively on the authority of Carel van Mander, whose "Lives of the Excellent Netherlandish and German Painters," first published at Haarlem in 1604 as part of his comprehensive Schilder-Boeck (Painters' Book), are the only northern equivalent of Vasari's southern accomplishment in this period. Van Mander (1548-1606), a Flemish-born painter and draughtsman of considerable rank [1] *who found a haven of refuge in Haarlem (1583) after an Italian journey (1573-1577) and brief periods of activity in Vienna, Courtrai, and Bruges, became primarily a writer toward the end of his career. In contrast to Vasari he also played a decisive role as the first Netherlandish theoretician of art (see below, pp. 57 ff.). His observations on contemporary Italian artists*

[15] See on this the following document.

[16] Translated from the Netherlandish text as reprinted by Schöne, p. 244, and (with slight changes) by F. van Molle (see note 9), p. 11 (reproduction of the original document; the transcription on p. 10, note 3, leaves out the passage on Bouts' death by mistake).

[17] See note 13.

[18] Hugo van der Goes; on his residence in the "Roode Klooster" near Brussels see below, p. 15.

[1] On this aspect, see E. Valentiner, *Karel van Mander als Maler (Zur Kunstgeschichte des Auslandes,* CXXXII [Strassburg 1930]).

have only recently been accorded due attention.[2] *The following Vita*[3] *is characteristic of his finest efforts at accuracy in procuring data on an old master already well-nigh forgotten in his time—efforts which are directly related to the indispensability of his labor for the modern art historian, for they alone have made the identification of Ouwater's only known work possible.*

While I was busy finding out what could be learned about the greatest representatives of our art and how they could be arranged in order of time, trying carefully to present the oldest first on my stage, an authentic source suddenly and to my amazement informed me that this Albert van Ouwater from Haarlem was an excellent painter in oils at such a very early period. For I have concluded, on the basis of some verified circumstances and some estimates, that he reaches back in time as far as Jan van Eyck. An honest old man, the painter Albert Simonsz at Haarlem, testifies and bears witness that in this our year 1604 it has been sixty years since he, Albert, was a pupil of the Haarlemer Jan Mostart, who was then about seventy years old, so that something like 130 years must have passed between the birth of the aforenamed Mostart and the present day. But now, Albert Simonsz, who has a good memory, maintains that Mostart said he never knew this Albert van Ouwater nor, for that matter, Geertgen van Sint Jans. Albert van Ouwater must have been older than the famous painter Geertgen tot Sint Jans who was a pupil of Ouwater. Thus I leave it to the reader to figure out and form a judgment as to how early the art of painting in oils was in use at Haarlem. From the hand of Ouwater was an altarpiece in the Groote Kerk in Haarlem, on the south side of the main altar;[4] this was called the Roman Altar as it was commissioned by the travelers and pilgrims to Rome. The central panel showed two standing figures in life size, St. Peter and St. Paul. On the predella of the altar was a lovely landscape in which one saw several travelers or pilgrims, some on their way, others resting, eating and drinking. He was outstanding in painting faces, hands, feet, draperies, and also in landscape. One can also hear it said and asserted by the testimony of the oldest painters that it was Haarlem where the best and earliest manner of landscape painting originated at a remote period. Ouwater also painted a moderately large, upright panel of which I have seen a copy in grisaille, representing a Raising of Lazarus.[5] After the siege and

2 See Helen Noë, *Carel van Mander en Italië* (The Hague 1954).

3 Translated from the Netherlandish text of the edition of 1617 (*Het Leven der Doorluchtighe Nederlandtsche en Hooghduytsche Schilders*), published as part of the 1618 edition of the *Schilder-Boeck*, also accessible in the reprint by Hanns Floerke, with German translation (Munich-Leipzig 1906), I, 64 ff.

4 Unidentified.

5 The original is now in the Berlin Museum and can indeed be traced back to Spain (via Genoa). It is the only universally accepted work by Ouwater.

surrender of Haarlem, the Spaniards, fraudulently and without paying, removed the original, together with other beautiful works of art, to Spain. The Lazarus in this picture was—considering the period—a very fine nude, unusually neat and effective. The architecture, a temple, was beautiful although the columns and other parts were a bit small; on one side were apostles, on the other Jews. Also present were some pretty women, and in the background some people who looked on through the small pillars of the choir [gate]. This superb work was often carefully inspected by Heemskerck, who could not look at it long enough; and he would say to its owner, who was his pupil: "What do you think, my boy, these people ate?"; by which he meant to say that they must have spent a gruesome amount of time and effort on such things. This is all about this old master that time and age have allowed to survive and to defy oblivion.

Hugo van der Goes

The report which Gaspar Ofhuys (ca. 1456–1523) wrote ca. 1509–1513 on the illness and last year of one of the greatest painters of his time, Hugo van der Goes,[1] has been called "a masterpiece of clinical accuracy and sanctimonious malice."[2] It has perhaps even greater significance for the history of medicine and psychology than for the history of art, but it affords a glimpse almost without parallel before the turn of the century and beyond at an artistic personality. In 1475, Ofhuys entered the "Roode Clooster," a monastery near Brussels, affiliated with the Windesheim Congregation, as a novice, together with the painter who at about the age of 50 made a sudden and as yet unexplained decision to withdraw from the world of guild rules and competition. They were both "fratres conversi," basically full religious members but with predominantly practical duties in house and field, their number restricted to eight in an over-all group of no more than twenty-five. The privileges accorded Hugo van der Goes by the abbot were obviously conspicuous (and too much for Ofhuys to appreciate). Soon after Hugo's death in 1482 Ofhuys became infirmarius of the monastery. The passage omitted before the last sentence deals briefly with the moral of the two alternative explanations, given before, of Hugo's disease: its "natural" origin would point to our obligation to combat and eradicate useless fantasies and worries, while its origin in God's will would point to the necessity of a special effort

[1] Translated from the Latin text of "Originale Cenobii Rubeevallis in Zonia prope Bruxellam in Brabancia" (Brussels, Bibl. Roy. Msc. II, 48.017) as transcribed, translated into German, and provided with a valuable commentary by Hjalmar G. Sander, "Beiträge zur Biographie Hugos van der Goes und zur Chronologie seiner Werke," *Repertorium für Kunstwissenschaft*, XXXV (1912), 519 ff. (534–538).

[2] E. Panofsky, *Early Netherlandish Painting*, p. 331.

on the part of the gifted to be humble in order to avoid worse punishment in hell.

In the year of our Lord 1482, death took converse brother [3] Hugo, who had made profession here. As a painter he enjoyed so great a reputation that people used to say he had no peer this side of the Alps. We were novices at the same time, he and I who am writing this down. Immediately upon Hugo's investiture and generally during his novitiate, the prior, Father Thomas, gave him permission to seek solace and entertainment of all kinds after the fashion of the people of the world, out of regard to the fact that Hugo had been an esteemed person among them. But this had the effect that he was made more familiar with worldly pomp than with the ways of penance and humility. This did not fail to cause strong objections: novices, some people would say, ought to be taught not exaltation but humility. But since he was a great expert in the art of painting he often received visitors of high rank, including the most illustrious Archduke Maximilian; all of them had a great desire to inspect his pictures. Thus whenever such guests came to see him, the prior Father Thomas, out of respect for them, permitted him to enter the guest room and to partake in festivities held there.

Now it happened that about five or six years after he had taken the vows it fell to our brother to make a journey which—if I remember right —took him to Cologne. He was accompanied by his half-brother Nicolaes, who had also taken his vows here as a *donatus,*[4] as well as by Brother Petrus from the Monastery of Marienthron, who was then staying in the monastery of Jericho in Brussels, and several other people. As his brother Nicolaes told me at the time, our brother Hugo, during one night of his journey home, was seized by a strange illness of his mind; he uttered unceasing laments about being doomed and sentenced to eternal damnation. He even wanted to lay murderous hands on himself and had to be prevented by force from doing so. Because of this strange illness that journey came to an extremely sad end. However, thanks to efficient help, Brussels was safely reached, and prior Thomas was immediately summoned. When he saw and heard all that had happened he suspected that Hugo was vexed by the same illness which had befallen King Saul; and remembering that Saul was relieved when David played the harp he at once permitted [5] plenty of music to be made in the presence of Hugo and also other soothing performances to be arranged in order to chase away those fantasies. But with all this, Hugo's health did not improve; he continued to rave and to pronounce himself a child of perdition. In this sad state he came home to the monastery.

[3] See the introductory remarks.

[4] *Donati* were not full members (they did not take the three vows) but people who secured a life-long sustenance in the monastery by donating all their possessions; their services were similar to those of the *conversi.*

[5] No instruments were normally allowed in Windesheim monasteries.

The care and succor which our brethren extended to him with charity and compassion day and night, will be remembered by our Lord in all eternity and beyond, even though at that time many people, including some magnates, talked otherwise.

There are many different opinions about the nature of the illness that had befallen this converse brother. Some said it was a special kind of "frenesis magna," others asserted that he was possessed by a demon. Apparently some symptoms of both of these calamities were present; but I have invariably heard that at no time during his illness did he ever threaten anybody except, over and again, himself. And since this is not reported either of phrenetics or of the possessed, I think God alone knows what disease this was.

Thus we can speak of two possible assumptions concerning the illness of our painter-brother converse. The first is that it was a natural one, a kind of frenzy. There exist various natural species of this disease: sometimes it is caused by "melancholy" victuals,[6] sometimes by imbibing strong wine; then again by passions of the soul such as anxiety, sadness, overwork, or fear. Sometimes such illness stems from the malignity of corrupt humors that predominate in the human body. As regards those passions of the soul, I know for certain that this converse brother was much afflicted by them. For he was deeply troubled by the thought of how he could ever finish the works of art he wanted to paint, and it was said at that time that nine years would hardly suffice for it. Again and again, he was steeped in reading a Flemish book. I also fear that his illness was aggravated by the drinking of wine—though this was undoubtedly done for the sake of his guests. It is therefore possible that in this way, in the course of time, the basis was laid for his grave illness.

The second possibility of explaining this disease is that it was sent by Divine Providence which, as it is written in the second Epistle of St. Peter, ch. 3, "is long-suffering to us-ward, not willing that any should perish, but that all should come to repentance." For this converse brother was highly praised in our order because of his special artistic achievements—in fact, he thus became more famous than he would have been outside our walls; and since he was only human—as are all of us—the various honors, visits, and accolades that came to him made him feel very important. Thus, since God did not want him to perish, He in His compassion sent him this humiliating disease which indeed made him very contrite. This our brother understood very well, and as soon as he had recovered he became most humble; on his own free will he refused to eat in our refectory and took his lowly meals with the lay brothers. I decided to speak of this in detail because I feel that God allowed all this to happen not only for the sake of punishing the sinner

[6] I.e., those causing an excess of black gall (meat, lentils, etc.).

or forcing him to mend his ways but also in order to instruct all of us. . . . He lies buried in our cloister, under the open sky.

Geertgen van Haarlem

Although the work of Geertgen van Haarlem has not been quite so relentlessly decimated by the vicissitudes of time, willful destruction, and neglect as that of Aelbert Ouwater, our knowledge concerning his life is almost as scanty, and would be nearly non-existent but for van Mander's efforts.[1]

Even as in the vicinity of the soaring and wild summits of the Alps or other high mountains one sees the water, coming from various places in small brooks, uniting farther down in ever wider river beds and canals, and finally hastening toward the limitless sea: so our art has taken its first beginning at scattered places and only gradually achieved greater perfection through the efforts of noble and wise minds. It has not been to the disadvantage of the noble art of painting that, among others, it attracted to itself Geerrit van Haerlem, called "te S. Jans"; for by placing before men's eyes at such an early period the beauty and charm of painting he greatly increased and fully manifested its honor and dignity. In his early days Geertgen was a pupil of the aforesaid Ouwater whom in some respects he equaled and even surpassed, particularly in cleverness, composition, excellence of figures, expression, and imagination; on the other hand I do not think he was his match with regard to purity and neatness or exactness of his work. Geertgen resided with the knights of St. John at Haerlem, from which fact he derived his name; but he did not become a member of the order. Here he painted the main altarpiece, a large and beautiful work representing the Crucifix in the center. The wings were likewise large and painted on both sides. One of the wings and the central part were destroyed during the iconoclastic troubles or the siege of the town; the one that has survived has been sawed apart, and the two fine pieces are now with the commander, in the main hall of the new building.[2] The one that was on the outside represents some miracle or uncommon story;[3] but the other one is a Lamentation or Deposition from the Cross in which Christ lies prostrate in a very natural depiction of death, and with him, some disciples and apostles in deep grief; particularly, the Marys exhibit such sorrowful countenances that it seems impossible to depict greater affliction. Mary, sitting there absorbed in deep grief, expresses the sorrow of her heart with profound feeling; so much so that most artists of our time stand amazed before it

[1] Van Mander-Floerke I, 68 ff.
[2] Now in the Vienna Museum.
[3] The Burning of the Bones of St. John by Julian the Apostate and the rescue of one of them by the Knights of St. John. In the background is the burial of the body and head of St. John.

and praise it highly. More of his work was to be seen outside of Haerlem at the place of the Regulars but it was destroyed through war or iconoclasm. Also by him is the picture of the Great Church in Haerlem which still hangs on the south side of that church, painted very vigorously and beautifully.[4] He was so great a master that the excellent Albert Dürer, visiting at Haerlem [5] and looking at his works in great amazement, said of him: Truly, he was "ein Maler im Mutterleibe." By which he meant to say that he was predestined by Nature or chosen before birth to be a painter. He died young, approximately twenty-eight years old.

Hieronymus Bosch

Carel van Mander's report on the life and work of the enigmatic master from Bois-le-Duc ('s Hertogenbosch, hence his name) is bracketed, chronologically speaking, by those of two Spanish writers, Felipe de Guevara and José de Sigüenza. Both of these are of extraordinary interest, but for entirely different reasons. Guevara, writing "Commentarios de la Pintura" [1] about 1560 as a connoisseur and critic, offers an amazingly precocious example of "disattribution" so popular with 19th and 20th century art historians; in fact, he was so anxious to prevent the oeuvre of his hero being encumbered with wrong attributions that he may have gone too far—as has happened frequently to modern emulators of his method. Only a portion of his account of the work of Bosch is reprinted here.

That which Hieronymus Bosch did with wisdom and decorum others did, and still do, without any discretion and good judgment; for having seen in Flanders how well received was this kind of painting by Hieronymus Bosch, they decided to imitate it and painted monsters and various imaginary subjects, thus giving to understand that in this alone consisted the imitation of Bosch.

In this way came into being countless numbers of paintings of this kind which are signed with the name of Hieronymus Bosch but are in fact fraudulently inscribed: pictures to which he would never have thought of putting his hand but which are in reality the work of smoke and the short-sighted fools who smoked them in fireplaces in order to lend them credibility and an aged look.

I dare to maintain that Bosch never in his life painted anything unnatural, except in terms of Hell or Purgatory as I have mentioned

[4] Still there.

[5] Dürer did not visit Haarlem during his journey to the Netherlands in 1520-1521, but may have been there on his "bachelor's journey," ca. 1490/91.

[1] Ed. Antonio Pons, Madrid 1788, here translated from the Spanish text published by F. J. Sanchez-Cantón, *Fuentes literarias para la historia del arte español*, I (Madrid 1923), pp. 159 f.

before. Granted, he endeavored to find for his fantastic pictures the rarest objects, but they were always true to nature; thus one can consider it a safe rule that any painting (even though provided with his signature) which contains a monstrosity or something else that goes beyond the confines of naturalness, is a forgery or imitation, unless—as I said before—the picture represents Hell or a part of it.

It is certain—and anyone who has carefully looked at Bosch's works must realize this—that he paid much attention to propriety and always most assiduously stayed within the limits of naturalness, as much and even more so than any fellow artist. However, it is only fair to report that among those imitators of Hieronymus Bosch there is one who was his pupil and who, either out of reverence for his master or in order to increase the value of his own works, signed them with the name of Bosch rather than his own. In spite of this fact his paintings are very praiseworthy, and whoever owns them ought to esteem them highly; for in his allegorical and moralizing subjects he followed the spirit of his master, and in their execution he was even more meticulous and patient than Bosch and did not deviate from the lively and fresh qualities and the coloring of his teacher. An example of this kind of painting [2] is a table in the possession of Your Majesty, on which are painted in a circle the Seven Capital Sins in figures and examples; [3] and while this is admirable in its entirety, it is especially the allegory of Envy which in my opinion is so excellent and ingenious and its meaning so well expressed that it can vie with the works of Aristides, the inventor of such paintings which the Greeks called *Ethike* [4]—meaning in our tongue as much as pictures which have as their subject the habits and passions of the soul of man.

Carel van Mander's report on Bosch [5] needs no further introduction.

Manifold and [often] strange are the inclinations, artistic habits, and works of the painters; and each became the better master in the field to which Nature drew and guided his desire. Who can relate all the

[2] It has been maintained that "this" refers back to the discussion of genuine works by Bosch (F. Schmidt Degener in *Gazette des Beaux-Arts*, 1906, I, 150, note 4, followed by Ch. de Tolnay, *Hieronymus Bosch* [Bâle 1937], p. 75). However the context, as well as the lack of a new paragraph before this sentence, makes it quite inevitable to relate it to the work of the highly praised pupil mentioned immediately before. (See H. Dollmayr in *Jahrbuch der Kunstsammlungen des allerhöchsten Kaiserhauses*, XIX [1898], 296, with an attempt to eliminate the Seven Capital Sins on stylistic grounds as well; see also M. J. Friedländer, *Altniederländische Malerei* V [1927], 82, Sanchez-Cantón, *loc. cit.*, note 3, and the Prado Catalogue.)

[3] Prado no. 2822. Signed: Hieronimus [sic] Bosch. Accepted as by Bosch but incorrectly described by Sigüenza (see note 14), p. 637.

[4] Or *Ethe*, the painting of character, according to Pliny, Nat. Hist. XXXV, 98, first practiced by Aristides (II) of Thebes at the time of Alexander the Great. See J. J. Pollitt, *The Art of Greece, 1400–31 B.C.: Sources and Documents*, p. 174.

[5] Van Mander-Floerke I, 140 ff.

wondrous and strange fantasies which Jeronimus Bos conceived in his mind and expressed with his brush, of spooks and monsters of Hell, often less pleasant than gruesome to look at? He was born at 's Hertogenbosch, but I have not been able to establish the dates of his life and death, except that it must have been at a very early period. Nonetheless, in his draperies and fabrics his manner differed greatly from the old-fashioned one with its manifold creases and folds. His manner of painting was firm, very skillful, and handsome; his works were often done in one process [6] yet remain in beautiful condition without alterations. Also, like many other old masters, he had the habit of drawing his design upon the white ground of the panel and covering it with a transparent, flesh-colored priming, often allowing the ground to remain effective.[7] One finds some of his works in Amsterdam. Somewhere I saw his *Flight into Egypt* in which Joseph, in the foreground, asks a peasant the way and Mary rides a donkey; in the distance is a strange rock in an odd setting; it is fashioned into an inn which is visited by some strange figures who have a big bear dance for money, and everything is wondrous and droll to look at.[8] Also by him, [in a house] near De Waal,[9] is a representation of how the patriarchs are redeemed from Hell and how Judas, who thinks he can escape with the others, is pulled up by a rope and hanged. It is amazing how much absurd deviltry can here be seen; also how cleverly and naturally he rendered flames, conflagrations, smoke, and fumes.[10] Also in Amsterdam is his *Carrying of the Cross*, which showed more solemnity than was his custom.[11] At Haarlem, in the house of the art-loving Joan Dietringh, I saw several of his pictures; among these were altar wings with several saints, including one with a holy monk who had a disputation with several heretics. He had all their books, together with his own, put in a fire; he whose book did not burn should be in the right, and one can see the saint's book flying out of the fire. In this picture, the fiery flames as well as the smoking pieces of wood, burnt and covered with ashes, were painted very cleverly. The saint and his companion looked very solemn, and the others had funny and strange faces.[12] Elsewhere one can see a miracle story in which a king and other people who have fallen to the ground look greatly frightened; the faces, hair, and beards are rendered very effectively though with little effort.[13] In the church at 's Hertogenbosch and elsewhere are still some of his works; also in Spain, in the Escorial, where they are highly esteemed . . .

[6] Cf. van Mander in the *Foundation of the Painter's Art,* below, p. 66.
[7] See below, p. 66.
[8] Unidentified.
[9] A harbor-like course of water in Amsterdam, near the Montelbaens Tower.
[10] Unidentified.
[11] Perhaps the painting now in the Vienna Museum.
[12] Unidentified.
[13] Pieter Bruegel's *Triumph of Death* in Madrid?

Fra José de Sigüenza's vast History of the Order of St. Jerome [14] *is rarely read, and his praises as an art critic are unsung. Yet what this historian had to say in 1605 about one of the greatest northern painters of the early 16th century towers over much that has been said about Hieronymus Bosch in recent times. It is as though, in the midst of his exacting work, the author had taken time out to look long at the paintings brought together at the Escorial by the insatiable Philip II, and to look at them with the conviction of a confirmed moralist, the mind of a real historian, and the eyes of a loving admirer, all collaborating to perfection.*

Among these German and Flemish pictures, which as I said are numerous, there are distributed throughout the house [15] many by a certain Geronimo Bosco. Of him I want to speak at somewhat greater length for various reasons: first, because his great inventiveness merits it; second, because they are commonly called the absurdities of Geronimo Bosque by people who observe little in what they look at; and third, because I think that these people consider them without reason as being tainted by heresy.

I have too high an opinion—to take up the last point first—of the devotion and religious zeal of the King, our Founder, to believe that if he had known that this was so he would have tolerated these pictures in his house, his cloister, his apartment, the chapter house, and the sacristy; for all these places are adorned with them. Besides this reason, which seems weighty to me, there is another which one can deduce from his pictures: one can see represented in them almost all of the Sacraments and estates and ranks of the Church, from the Pope down to the most humble—two points over which all heretics stumble—and he painted them with great earnestness and respect, which as a heretic he would certainly not have done; and he did the same with the Mysteries of the Redemption. I want to show presently that his pictures are by no means absurdities but rather, as it were, books of great wisdom and artistic value. If there are any absurdities here, they are ours, not his; and to say it at once, they are a painted satire on the sins and ravings of man. One could choose as an argument of many of his pictures the verses of that great censor of the vices of the Romans, whose song begins with these words: [16] "Quidquid agunt homines, votum, timor, ira, voluptas: / Gaudia, discursus nostri est farrago libelli. / Et quando uberior viciorum copia" etc., which, translated into our tongue, could be put this way by Bosch:

[14] Fr. José de Sigüenza, *Historia de la Orden de San Jeronimo*, published in 1605 ("privilegio" dated 1603), Part III, Book IV, Chapter XVII, here translated from the new edition in *Nueva Biblioteca de Autores Españoles*, XII (Madrid 1909), pp. 635 ff. The passage on Bosch is reprinted in full by F. J. Sanchez-Cantón, *op. cit.*, I (1923), pp. 425 ff.

[15] The Escorial.

[16] Juvenal, Satires I, 85 ff.

"All of man's desires, dreads, rages, vain appetites, pleasures, satisfaction, discourses I have made the subject of my painted work. But when there was such an abundance of vices," etc.[17]

The difference which, to my mind, exists between the pictures of this man and those of all others is that the others try to paint man as he appears on the outside, while he alone had the audacity to paint him as he is on the inside . . .

I am convinced that it is with [the poet Merlino Cocajo] that Geronimo Bosco [would have] wanted to compare himself; not because he knew him—for I believe the painter did grotesque scenes earlier than the author [18]—but because he was inspired by the very same thoughts and motives. He knew that he had a great talent for painting and that in many subjects he did he had already been overtaken by Albrecht Dürer, Michelangelo, [Raphael of] Urbino, and others. Thus he embarked upon a new road, on which he would leave the others behind while he was not behind anyone else, and on which he would turn the eyes of all toward himself: a kind of painting, comical and macaronic (on the outside) yet mixing with such jests many things that are beautiful and extraordinary with regard to imagination as well as execution in painting, now and then revealing how skillful he was in that art—just as Cocajo did when he spoke seriously. The panels and other pictures we have here may be divided into three different categories. The first comprises devotional subjects such as the events from the Life of Christ and His Passion, the Adoration of the Kings and the Carrying of the Cross; in the first of them he expresses the pious and sincere attitudes of the wise and virtuous, and here one sees no monstrosities or absurdities; in the second he shows the envy and rage of the false doctrine which does not desist until it has taken away the Life and Innocence, which is Christ, and here one does see the Pharisees and Scribes with their furious, cruel, and snarling faces, who in their habits and actions convey the fury of these passions. Several times he painted the Temptation of St. Anthony (and this is the second category of his paintings) as a subject with which he could reveal singular meanings. In one place one observes this Saint, the prince of the Hermits, with his serene, devout, contemplative face, his soul calm and full of peace; elsewhere, the endless fantasies and monsters which the arch-fiend creates in order to confuse, worry, and disturb that pious soul and steadfast love; for this purpose he conjures up animals, wild chimeras, monsters, conflagrations, images of death, screams,

[17] This last fragment of a sentence, clearly the translation of Juvenal's last incomplete line, was mistakenly shifted to the beginning of the next paragraph in the printed editions, where it makes no sense.

[18] Coc(c)ajo (pseudonym for Teofilo Folengo) was the Italian founder of "macaronic" writing (1491–1544); his "Liber Macaronices" (1517) appeared one year after Bosch's death. The present passage is preceded by an extended comparison between Bosch and Cocajo.

threats, vipers, lions, dragons, and horrible birds—of so many kinds that one must admire him for his ability to give shape to so many ideas. And all this he did in order to prove that a soul which is supported by the grace of God and elevated by His hand to a like way of life, cannot at all be dislodged or diverted from its goal even though, in the imagination and to the outer and inner eye, the devil depicts that which can excite laughter or vain delight, or anger and other inordinate passions . . .

Besides these pictures there are others, very ingenious and no less profitable, although they seem to be more "macaronic," and these constitute the third category of his work. The concept and artistic execution of these are founded on the words of Isaiah, when upon the command of the Lord he cried with a loud voice: "All flesh is grass, and all the goodliness thereof as the flower of the field" . . .

One could wish that the whole world were as full of imitations of this picture [19] as it is of the reality and actuality from which Geronimo Bosque drew his "absurdities"; for leaving aside the great beauty, the inventiveness, the admirable and well-considered treatment which shows in every part (it is amazing that a single head can imagine so many things), one can reap great profit by observing himself thus portrayed [20] true to life from the inside, unless one does not realize what is inside him and has become so blind that he is not aware of the passions and vices which keep him transformed into a beast, or rather so many beasts . . .

I shall say no more about the "absurdities" of Geronimo Bosque except to report that into almost all of his paintings, that is, into those which contain this fantastic element (we have seen that others are simple and saintly), he always puts a fire and an owl. By the former he gives us to understand that we must always keep in mind the Eternal Fire, and that in this way all toil is rendered easy, as one can see in all those panels with Saint Anthony. And by the latter he wants to say that his pictures were done with great attention and care, and that with care they should be viewed. The owl is a nocturnal bird, consecrated to Athena and to study, a symbol of the Athenians, among whom so flourished Philosophy, which one pursues in the quiet and silence of the night, using up more oil than wine.

Rules of the Guild of Tournai, 1480

Valuable information of a kind entirely different from that supplied by the work of the literati *and the contractual agreements is sometimes provided by rules and regulations issued by the authorities of guilds of painters and other artisans. These documents are apt to concentrate on*

[19] The "Garden of Lust" in the Prado, an exact description of which precedes this sentence.

[20] "Retirado" must be a misprint for "retratado."

defining permissible tools and materials in a consistent effort to eliminate shoddy and fraudulent work by unscrupulous or incompetent members. They are also likely to pose grave and sometimes unsolvable problems to the interpreter and translator, for in spite of great progress made in recent decades in the identification of medieval and later materials (particularly pigments) we are still far from being well informed about them, mainly as the result of inconsistencies in the nomenclature used by so many different workshops and in so many different languages. For this reason, the translation of the following document, an excerpt from the rules of the painters' guild at Tournai (Doornik), issued to the members on November 27, 1480,[1] can be only very approximate and tentative, and is accompanied by the original French word in the case of each debatable item.

Item, that from now on no person shall be allowed to paint, in any manner present or future, other than with the colors, utensils, and materials belonging to said painters and hereafter specified, to wit, with regard to utensils: brushes small and large (pinchiaux, brousses), fine canvas and coarse (trinques, revelz, grateuses) and all other utensils appertaining to that trade; also materials such as pure gold leaf, half (powdered?) gold (or partit), tinsel gold (or clinquant), silver leaf (argent foellé de bateur), dyeing clothlets (piau de tainte)[2] of all colors, all other materials used at present in this trade, as well as such pigments as lead white, ceruse, common white and black, Liége blue, vermilion, minium, rose, sinoper, lac, grain, madder (florée de warance), brazil, blue (azur), blue ashes[3] (chendre d'azur), woad (florée), indigo, litmus (lecquemous), folium (foel), verdigris, malachite (vert de montaigne), sap green (vert de vésie), terre verte (vert de glay), massicot (machuot), orpiment (or prennient), ochre, Austrian brown, common red, Armenian bole (bolarmenicq), and all other colors which are tempered with oils, or glue (vernis à colle), or gum, or similar things[4] . . .

[1] Translated from the French text as given by A. Pinchart, "Rapport sur les mémoires de concours concernant la profession de peintre," *Bulletin de l'académie royale des sciences, des lettres et des beaux-arts*, third series, II (Brussels 1881), 335 ff. (p. 341, note 2). The French text was reprinted in Hans Huth, *Künstler und Werkstatt der Spätgotik* (Augsburg 1923), p. 97, note 109; in this indispensable book one also finds (p. 98, note 116) a quote from a Munich guild rule of 1461 which says: "Item, everyone shall present and indicate orpiment, half gold or mosaic gold . . . as what it actually is, and shall not advise, use, or pass off half gold for pure gold, nor azurite for ultramarine, nor blue bice ("mensch") for azurite, nor rose ("rösel") or Paris red (madder?) for lac . . ." See Daniel V. Thompson, Jr., "Trial Index to Some Unpublished Sources for the History of Medieval Craftsmanship," *Speculum*, X (1935), 410 ff., and the literature there cited.

[2] On these see particularly Daniel V. Thompson, Jr., *The Materials of Medieval Painting* (New Haven 1936), pp. 143 ff.

[3] Blue bice according to Thompson, *ibid.*, p. 152.

[4] A very similar list is given in Jean Lemaire de Belges' *Couronne Margaritique* (on which see below, p. 27); reprinted in D. Yabsley, *La Plainte du Désiré* (Paris 1932), p. 40.

Jean Lemaire de Belges

Jean Lemaire de Belges (1473–ca. 1515)[1] *was one of the most ver-
satile writers of the early humanistic era in the north. Leading the
unstable life of a courtier, harassed by an ill fate which, with distressing
rapidity, deprived him of his protectors through death or other adverse
circumstances, dead himself at the age of little more than forty, he
nonetheless managed to leave behind a literary oeuvre of distinction
which is of uncommon interest to the art historian because of his intense
preoccupation with the visual arts and his close collaboration with artists
in at least one outstanding though abortive monumental enterprise—
the tombs of Duke Philibert of Savoy and Margaret of Austria at Brou
(see below, p. 146). On the last day of the year 1503, death took Louis of
Luxembourg, Count of Ligny, a few days after Lemaire had entered
his services; in his memory he wrote* La Plainte du Désiré *(1503/4, first
published in 1509), in which Painting, among others, mourns the death
of the Duke as an irreplaceable loss to herself. It is in this section of the
poem that Lemaire has "Paincture" cite the famous roster of what he
considered some of the outstanding Flemish, French, and Italian painters
of the past and present—valuable for the historian because of its com-
bination of names of lasting greatness and either proven or probable
mediocrity. (Lemaire's section on music is of equally great importance
for the historian of that art.)*

> And though I lack Parrhasius and Apelles,
> Whose fame resoundeth still from olden time,
> Some new and modern talents here I boast,
> More highly thought of for their splendid works
> Than Marmion was, lately of Valenciennes,[2]
> Or Fouquet [3] who was once so greatly praised,
> Nor Poyer,[4] Roger,[5] also Hugh van Ghent,[6]
> Or else Johannes,[7] who was so refined.
> Get busy then, my modern votaries,
> My handsome children, nursèd at my breast,
> Thou, Leonardo, full of grace supreme,

[1] His *Oeuvres* were edited by J. Stecher (Louvain 1891–1892); see also
Ph. Aug. Becker, *Jean Lemaire, der erste humanistische Dichter Frankreichs*
(Strassburg 1893), and P. Spaak, *Jean Lemaire de Belges* (Paris 1926). *La Plainte
du Désiré* was published with a valuable introduction by D. Yabsley (Paris
1932).

[2] Simon Marmion.

[3] Jean Fouquet.

[4] Jean Poyet, book illuminator in Tours, active 1483–1497.

[5] Roger van der Weyden.

[6] Hugo van der Goes.

[7] Jan van Eyck.

Gentle Bellini [8] of eternal fame,
And Perugino, blending hues so well:
And thou, Jean Hay,[9] idleth thy noble hand?
Come, visit Nature, thou and Jean of Paris [10]
So as to make her jealous and alert.

Shortly after the death of the Count of Ligny, Lemaire entered the services of Margaret of Austria (1480–1530), the daughter of Maximilian I and Mary, heiress of Burgundy; and a few months later her second husband, Duke Philibert of Savoy, died. Lemaire's second "plainte" within one year, the Couronne Margaritique, *was left incomplete and unpublished until 1549. It contains an even more elaborate lists of famous painters than the* Plainte du Désiré, *enriched by the names of many goldsmiths to whom Master "Mérite" showed the allegorical "couronne margaritique," planned by "Vertu" with the help of a council of great philosophers and orators, and designed by Varro's daughter, Martia. This time, the predominance of Netherlandish artists is overwhelming.*

And when the goldsmith to his workshop came
Some friends entreated him with eager words—
They whose renown transcended Spain and Austria—
Mérite ought not to withhold from them
The reason why his spirits were so high.
And thus Mérite at their mercy was;
Unable to withdraw he told them all,
For one of them our Master Rogier was,
The other Fouquet, favorite of all,
Hugo van Ghent, whose brush-strokes are so fine,
Attended there, as Dirck of Louvain [11] did,
Together with that painters' king, Johann,[12]
Whose works, so perfect and so gently wrought,
Shall never be uncared for or forgot;
Nor, if I were a writer worth his trade,
Should those of Marmion, the very prince
Of book illuminators—he whose fame
Like paste in ferment grows through noble art.

[8] "Gentil Bellin," certainly "Gentle (Giovanni) Bellini," not Gentile Bellini.

[9] E. Panofsky, "Jean Hey's 'Ecce Homo,'" *Bulletin des Musées Royaux des Beaux-Arts,* V (Brussels 1956), 94 ff. The present translation of the last eight lines is taken from this article.

[10] Jean Perréal, a close friend of Lemaire (see below, p. 147). On his authentic work—finally identified after many false starts—see Ch. Sterling, "Une peinture certaine de Perréal enfin retrouvée," *L'Oeil,* nos. 103–104 (1963), 2 ff.

[11] Dieric Bouts.

[12] Jan van Eyck.

The group was joined by Master Hans from Bruges,[13]
By Master Martin Hugh from Frankfort,[14] too;
Both men are workers well renowned.
Some other children of Pictura came:
Nicole of Amiens,[15] whose fame resounds;
And then from Tournai, full of gifts divine,
Came Master Loys [16] of th' unfailing eye,
And he who day and night works on designs
For tapestries, Baudouyn de Bailleul.[17]
There also was Jacques Lombard of Mons; [18]
From Antwerp came the excellent Liévin.[19]
O let us grant these masters the respect
Which once the ancients with great eloquence
Paid to Parrhasius, and others, too.

All masters are enthusiastic over the design of the Crown. When the question arises as to who should be entrusted with the execution, Gillis Steclin of Valenciennes [20] steps forward; he is favored with the proviso:

But it is meet, to make the work more pure,
To ask thy father that he join us here:
All know the hand, so skillful and so sure
Of Hans Steclin, that great son of Cologne.

When the precious materials are spread out before the masters, Mérite addresses them as follows:

What thinkest thou, André Mangot of Tours,[21]
And thou, Christoph Jeremia of Rome: [22]

[13] Hans Memling.

[14] "Hugues Martin"; Hugues usually means Hugh but in this case the more probable identification is with "Hübsch Martin" = Martin Schongauer although he was not from Frankfurt.

[15] Colin d'Amiens, designer of the tomb of Louis XI at Cléry-sur-Loire (1482).

[16] Probably Loys Leduc, master at Tournai in 1453.

[17] Baudouin of Bailleul designed the History of Gideon tapestries for Philip the Good in 1448.

[18] Mentioned in Tournai, 1471; worked for Charles the Bold.

[19] Probably not Liévin van Lathem but the Lieven of Antwerp who supposedly contributed to the Breviari Grimani (see below, p. 30).

[20] The hypothesis that this name stands for Guillaume Regnault, Hans Steclin's for Michel Colombe, etc. (J. B. Lemoisne, "Autour du tombeau de Philibert le Beau à Brou," *Revue belge d'archéologie et d'histoire de l'art,* XI [1941], 35 ff.) has been thoroughly refuted by Ghislaine de Boom (*ibid.,* pp. 219 ff.) and by J. Duverger and E. Dhanens (*ibid.,* XII [1942], 97 ff.).

[21] Active in Tours, 1463–1480.

[22] Cristoforo di Geremia, active in Rome, Florence, Mantua, 1456–1476.

What king wore such a treasure at a joust
In his arena? I can think of none.
What sayeth Donatello of Florence,
What thinketh petit Anton of Bordeaux,[23]
Jan van Nijmegen,[24] artist of renown?
Regard with care transparency and sheen
Of those ten pieces, luminous and clear!
And thou, prince of the goldsmiths of our time,
Robert Le Noble, son of Burgundy,[25]
Join us in judging that which would not hurt
The fame of Margeric of Avignon.[26]
Draw hither, goldsmith of the great Duke Charles,
Thou gentle, skillful man from Ghent, Corneille,[27]
And thou speak up, I pray, Jean de Rouen: [28]
Thy fame has spread from Paris down to Arles
In casting, sculpture, and the weaver's craft;
The art of chasing also is thy pride,
In architecture and in painting, too,
Thou art entrusted with as many tasks
As thy high noble spirit dares to meet.

Marcantonio Michiel

The extraordinary importance of the Venetian patrician, Marcantonio Michiel, for the historiography of Italian art does not concern us here; but the fine connoisseurship of the "Anonimo Morelliano" (as he was called before his identification), whose "Notizie del disegno" ranged over the whole of the Venetian and Lombard territory between 1521 and 1543 but were never completed or published during his lifetime, also extended to the many Netherlandish works eagerly collected in that area.[1]

In the house of Antonio Pasqualino at Venice in 1529 he saw:
The small picture with St. Jerome in Cardinal's habit, reading in

[23] Mentioned in 1506 as goldsmith in Bordeaux.

[24] Jan van Vlierden, active in Antwerp and Malines, 1483–1520.

[25] Bronze caster in Paris; he executed the design by Colin d'Amiens mentioned in note 15 above.

[26] Unknown?

[27] Cornelis de Bont, active in Ghent 1470–ca. 1510.

[28] If this refers to the architect and sculptor of that name who worked in Rouen between 1511 and 1521 and later in Portugal, it would be a remarkably early eulogy on him.

[1] The following excerpts are translated from the Italian text published by Theodor Frimmel, *Der Anomino Morelliano (Quellenschriften für Kunstgeschichte und Kunsttechnik des Mittelalters und der Neuzeit*, ed. Albert Ilg, n. s. I [Vienna, 1888]), pp. 98 ff.

his study,[2] is considered by some to be from the hand of Antonello da Messina. Others believe that the figure was overpainted by Jacometto Venitiano.[3] But the majority attribute it, as is most probable, to Gianes [4] or Memelin,[5] an old painter of the Netherlandish [6] Schools. And this is borne out by its style, although the face has been completed in the Italian manner so that it seems to be by Jacometto's hand. The buildings are in the Netherlandish [6] style, the little landscape is naturalistic and painstakingly executed, and one has a view through a window and through the door of the study. A peacock, a partridge, and a shaving basin are carefully portrayed. Seemingly fastened to the stool there is painted deceptively a small open letter which would seem to contain the name of the master. Nonetheless, if one looks carefully from near by, it does not contain a single letter, but it is all an illusion. There is also a good effect of perspective, and the entire picture excels in subtlety, color, design, strength, and modeling.

In the house of Carinal Grimano, in 1521 Michiel saw:

The portrait of Madonna Isabella of Aragon, wife of Duke Philip of Burgundy,[7] painted in oil, half figure and less than life size. It is from the hand of Zuan Memelin [i.e., Hans Memling] and was done in 1450. The self-portrait of said Zuan Memellino [i.e., Memling] painted in oil from a mirror; one gathers from it that he was about sixty-five years old, rather stout than otherwise, and ruddy [8] . . . The famous prayer book which Messer Antonio Siciliano [9] sold to the Cardinal for 500 ducats was illuminated by many masters during many years.[10] It contains miniatures from the hand of Zuan Memelin, of Girardo da Guant [11] and Livieno of Antwerp.[12] Among them, particular praise is given to the

2 London, National Gallery, no. 1418. This is now universally given to Antonello but may indeed be a free version of a Netherlandish work, Jan van Eyck's St. Jerome—a painting once in the possession of Alfonso of Aragon in Naples and mentioned by Bartolommeo Fazio (see above, p. 5).

3 Painter and illuminator, closely related to Antonello da Messina.

4 Jan van Eyck.

5 Hans Memling.

6 Literally: Western (Ponentina).

7 If this refers to Philip's third wife (1429), Isabella of *Portugal* (as was first written in the manuscript!), the question arises whether the entry may not apply to Roger van der Weyden's portrait of this sitter in the Rockefeller Collection in New York, which was indeed done ca. 1450, and was later—presumably in the 16th century—transformed into a "Persica Sibylla."

8 Not identified.

9 Unknown (not Antonello da Messina who died in 1479).

10 Most miniatures of the Grimani Breviary (ca. 1500–1520), now in the St. Mark's Library in Venice, are today attributed to Simon Bening and his workshop. Michiel was not well acquainted with the Breviary.

11 Probably Gerard Horenbout.

12 See the reference to him by Jean Lemaire (above, p. 28). Possibly a mistake for "Jennin" of Antwerp (Jan Gossaert, who signed one miniature of the Breviary).

Twelve Months, and most especially to February,[13] where one sees a boy who, urinating on the snow, makes it look yellow; the landscape is full of snow and ice.

In the house of M. Zuan Ram, near S. Stefano, 1530 or 1531:

The portrait of Rugerio de Burselles,[14] famous old painter, on a small panel, in oil, bust, was painted from a mirror in 1462 by this Rugerio's own hand.[15]

In the street of San Francesco in the house of the philosopher Leonico Thomeo:

. . . A small picture on canvas, one foot in size, in which is shown a landscape with some fishermen who have caught an otter, with two small standing figures of onlookers, was from the hand of Gianes da Brugia.[16]

THE SIXTEENTH CENTURY

As we proceed from the 15th to the 16th century in the Netherlands our reliance on Carel van Mander becomes at once more marked and more confident. There are still very few strictly contemporary documents available, and there exists no parallel to Dürer among the Netherlanders in the capacity of either an artist or a writer on art; Quentin Massys, who was more closely connected with the humanists of his time than was any other Netherlandish artist, has not left us a line. It is well known that even in the 17th century we shall not find any strong tendency in Flanders and Holland toward writing on art—particularly in the field of the theory of art. The writing of Gerard de Lairesse coincides with an un-mistakable decline of artistic productivity—at least as measured by the incredibly high standards of 17th-century painting in the Netherlands— and even the modestly gifted and illuminating writing of Joachim von Sandrart from Nuremberg was not matched in the Netherlands them-selves. With regard to the 16th century, one might say that Carel van Mander's position in Netherlandish historiography of art corresponds to that of Dürer, Vasari, Borghini, and Lomazzo rolled into one.

Lucas van Leyden

The extent of our debt to van Mander can be well gauged from a perusal of his Life of Lucas van Leyden, *the more so as it can be com-*

[13] Corrected from "January."

[14] Roger van der Weyden.

[15] Unidentified.

[16] A lost work by Jan van Eyck. Weale-Brockwell, p. 201, refer to a tapestry with this subject.

pared with what Vasari, a great admirer of the Netherlandish engraver and painter, has to say about him. It is one of van Mander's most extensive efforts in the field of biography, and we have to restrict ourselves to excerpts [1] *which illustrate the combination of carefully marshaled facts, enthusiastic appreciation, and lively narrative which again characterizes his approach.*

. . . Among many able and noble talents in our art of painting who from the very springtime of their lives have achieved excellence, and of whom we have spoken elsewhere, I know none who could be compared with this our Lucas van Leyden, so favored by Nature, who seems to have been born with brush and burin in hand, and as a master painter and draughtsman. It is amazing beyond belief to be told by those who nonetheless know it for certain that at the age of nine he published copper engravings after his own design which are executed with great skill and refinement, as one can still gather from several of them that are not dated. And from those that bear a date one can easily figure out at what age he engraved them, for he was born in Leyden in the year 1494,[2] around the last of May or early in June. His father, called Huygh Jacobsz, was likewise an outstanding painter in his time. Lucas, a master by nature, was a pupil of his father and later of Cornelis Engelbrechtsz; [3] and since in addition to nature's gifts he felt the urge of artistic ambition, he used his time well in constant application and tied or attached many a night to the preceding day by means of the light of a candle. His blocks and toys were all sorts of art utensils such as charcoal, chalk, pen, brush, and burin; and his mates were those of the same bent: young painters, stained glass workers, and goldsmiths. His mother tried often to prevent his drawing at night, not so much because of the cost of light but out of fear that with such constant waking and strenuous thought he might harm or hamper his young, tender body and mind. He never ceased to copy everything from life: faces, hands, feet, houses, landscapes, and all sorts of drapery in which he took special pleasure.

He was all-encompassing and universal; that is, he was capable and skillful in everything that pertains to the art of painting; he painted, in oil and in water color, historical subjects, portraits, landscapes, and figures, and practiced stained glass painting and engraving from his earliest days. When he was a child of twelve he painted with water color on canvas the legend of St. Hubertus,[4] an amazing achievement which brought him great renown. This was made for the Heer van Lockhorst, who gave him for it as many gold florins as he counted years. When he was fourteen years old, as one can see from the date 1508,[5] he engraved

1 Van Mander-Floerke I, 106 ff.
2 He was perhaps born earlier, in 1489 (Pelink, *Oud Holland* 1949, 196).
3 Leyden, 1468–1533. No works by Huygh Jacobsz are known.
4 Not identified.
5 B. 126, dated 1508.

the story of Mahomet who in his drunkenness had murdered a monk.
One year later, that is in 1509 when he was fifteen years old, he engraved
several pieces; among others, nine round scenes from the Passion (as
though done for the use of stained glass makers), to wit, Christ on the
Mount of Olives, the Capture of Christ, Christ before Annas, the Mock-
ing, Flagellation, Crowning with Thorns, Ecce Homo, Bearing of the
Cross, and Crucifixion.[6] These are very fine pieces and of excellent com-
position. Also a Temptation of St. Anthony [7] in which a beautiful, clothed
woman appears to him; this is extremely fine in the treatment of figures,
planes, and background, and as meticulously engraved as can be imagined.
In the same year he engraved that amazing, well composed Conversion
of Paul, where the blind saint is led to Damascus; [8] and this blindness,
as well as the entire scene, is well rendered. In this, as in all of his prints,
one observes a great diversity of faces and of garments of the Old Testa-
ment type: hats, caps, and hoods, almost all of them different; and this
is one reason why great masters of our time in Italy have made ample
use of his prints, copying or adapting them in their works, sometimes
with but few alterations.[9] This Conversion of Paul is also mentioned by
Vasari,[10] who praises Lucas in several respects even more than he does
the great Albert Dürer . . . It is true that said Vasari opines at one point
that Lucas was not so great a draughtsman as Albert; nonetheless he,
according to Vasari, was in many respects Dürer's equal with the burin.[11]
One can also observe in Lucas' prints a very different and beautiful kind
of widespread and clearly defined planes in his landscapes, and also a
softer and more even handling of the burin—with which his blowing
and flowing draperies are rendered as convincingly as ingeniously—than
can be seen in other work of his time, and I believe that connoisseurs
will agree with me on this. In the following year 1510, when he was
sixteen, he engraved the marvelous and rare Ecce Homo.[12] It is greatly
to be wondered at that a youth of such tender age should have displayed
such an abundant talent and wisdom, both in composition, diversity of
figures, and imagination with regard to costumes of various peoples,
and in those splendid and handsome modern buildings which are done
so well in terms of perspective and proportions . . .

But it would be impossible for me to enumerate all he has painted,
engraved, and done on stained glass; I do know that he was industrious
and meticulous in applying his colors cleanly and neatly, and that he,
though doing engraved work continuously, always practiced the art of

[6] B. 57-65, dated 1509.
[7] B. 117, dated 1509.
[8] B. 107, dated 1509.
[9] This is particularly true of Marcantonio Raimondi.
[10] Vasari-Milanesi V, 410.
[11] Vasari-Milanesi V, 407.
[12] B. 71, dated 1510.

painting; also, that he treated his prints with such neatness and precision that he never let an impression go out from his workshop that showed the slightest flaw or little spot. Also, his prints were valued very highly in his own time; thus his best pieces, the large sheets such as the most excellent Magdalene, the Crucifix, the Ecce Homo, the Three Magi,[13] etc., were paid a gold florin or twenty-eight stivers apiece. I have also heard it said that his daughter testified to his having burnt large quantities of prints which were faulty. He never traveled abroad in order to learn his art, although Vasari writes differently [14] and believes that all famous Netherlanders had to get their art from Italy and to learn it from Italians; but in this he errs, just as he is ill informed about a number of other things. Lucas was a married man; he wed a titled girl of the van Boshuysen family and thus to his regret lost much time with banquets and high living as is the custom with those in wealth and of noble descent. Some think that Albert Dürer and he tried to compete with each other or to outdo each other, that Lucas sometimes immediately represented the same stories or other subjects in print that Albert had done, and that they saw each other's works with great admiration; so that finally, when Albert Dürer had arrived in the Netherlands and visited Lucas at Leyden,[15] he made a portrait of Lucas,[16] and Lucas of him, on a little panel from life, [17] and they enjoyed each other's company in great friendliness. Lucas was somewhat small and delicate of stature. There is a portrait print of him, a little more than half figure, done by himself, where he appears young without a beard, wearing a large feather cap, and holding a death's-head against his chest in his garment.[18] Few paintings by his hand can be seen or found today, but they are most remarkable and they please on account of a special kind of —how do I say it?—lovely and ingratiating charm. But the finest and most beautiful of them all is a small altar with two wings which is now owned by that great collector and artist, Goltzius at Haarlem, who acquired it at Leyden in the year 1602 for a large sum; he takes great pleasure in it, being a man who because of his fine connoisseurship has a great appreciation and love for Lucas' works. It represents the story of the Blind Man of Jericho,[19] Bartimaeus the son of Timaeus, who is given sight as described by the Evangelist St. Mark in the tenth, and by St. Luke in the eighteenth chapter . . . In the Town Hall at Leyden is another beautiful and excellent painting which is there preserved, and honored through

13 B. 122 (1519), 74 (1517), 71 (1510), and 37 (1513).

14 Vasari-Milanesi VII, 589.

15 A mistake; the two met in Antwerp in June, 1521.

16 The silverpoint drawing in Lille, Winkler 816.

17 Not identified.

18 The print, illustrated in van Mander-Floerke I, 105, is by Lucas van Leyden (B. 174) but is not a portrait.

19 Now in Leningrad, Hermitage, Cat. 1958, no. 407.

public exhibition, by the magistrate; this represents the Last Judgment and is considered a particularly fine work.[20] It shows a great diversity of male and female nudes, and one can see that he worked with careful observation from life, especially in the female nudes which he painted with a lovely flesh tone, although—as was done frequently by the painters of that time—these nudes look a little too sharp or chiseled in the lighted parts. On the outer wings there are two large sitting figures representing Peter and Paul, one on each wing, painted very well and much more beautiful than the inside; for everything is finer in colors and painted more fluently—faces and other uncovered parts as well as draperies and also planes and background. In sum, the work is of such importance that great foreign potentates have made inquiries about purchasing it, but this has been politely refused by the noble magistrate because out of respect for their famous citizen they do not want to be without it, however large amounts of money they are offered for it: indeed a great lustre lent to the noble art of painting, producing on her a clear and shining reflexion.

* * *

I reported elsewhere how imaginative an artist Lucas was; this shows well in a print in which King Saul, obviously out of his mind and actually looking mad, means to pierce David, who plays for him, with his javelin.[21] The same or similar things one can observe in many of his other works, including a tiny little print, praised by Vasari in his writings, in which one sees a peasant who seems to suffer so much from a tooth being pulled by a quack that he does not notice or feel that in the meantime a woman picks his pocket.[22] In a similarly small print one finds a well observed and beautiful representation of an old man and woman who in a convincing manner accord or tune their musical instruments together; [23] this subject he seems to have taken from the philosopher Plutarch, where he writes about the matrimonial laws to the effect that in that state [of matrimony] the man's word must prevail in the house, even as the strongest chords of the largest instrument usually produce the fuller tone—for in this print he put the larger instrument into the man's hand. His most excellent engraving is the portrait of the Emperor Maximilian,[24] which he did when that emperor came to Leyden to receive homage; [25] it is the largest and most beautiful portrait head he ever did in print, executed with admirable strength and elegance.

He was an extraordinary man, and I do not know in which field he

[20] Now in the Museum Lakenhal, Leyden, no. 244.
[21] B. 27, an early work (ca. 1508).
[22] B. 157, dated 1523. Vasari-Milanesi V, 411.
[23] B. 155, dated 1524.
[24] B. 172, dated 1520.
[25] A mistake; Maximilian was in Leyden in 1508 and died in 1519. Lucas van Leyden relied on Dürer's woodcut portrait of the emperor.

deserves greatest praise: in painting, engraving, or stained glass making. It is said that he learned the art of engraving from somebody who etched armor with acid, with some additional instruction from a goldsmith. He also etched some fine pieces and carved several woodcuts which are excellently done.[26] Here and there one also finds stained glass work of his which is worthy of being preserved. One of these is owned by Goltzius, who esteems his works highly—a small piece on glass representing the dance of the women who go out to meet David; it is marvelously well done and has been excellently engraved by Jan Saenredam.[27]

<p style="text-align:center">* * *</p>

When finally his strength and health failed him more and more, when no more medicine was of any help and he felt his last hour approaching, he—two days before his death—was desirous to enjoy once more the fresh air and to see the sky, the work of the Lord; therefore his servant maid took him outdoors for a last time, and two days later he expired, in the year 1533, at the age of only thirty-nine. He was still living on the day which is well remembered by old people, namely that of the "Hot Procession of Leyden"; for on that day of procession many people were stricken by the heat and died. The last he engraved was a small piece with Pallas,[28] and it is said that this, just finished, was lying before him on his bed, as if to say or to prove that he loved and practiced his fine and noble art up to the last moment. He had only one daughter [29] who nine days before her father's demise gave birth to a son. When they returned with the child from baptism he inquired about the name of his young grandchild; and when he was told that there would still be a Lucas van Leyden after him he took it amiss as if this meant that they wished him away. This son of his daughter, named Lucas Damessen,[30] died at Utrecht in the year 1604 at the age of 71; he was also a rather good painter, as is his brother, Joan de Hooy, painter to the King of France.[31]

Pieter Bruegel

For our knowledge of the life of this greatest among the Nether-landish painters of the 16th century we must again rely primarily on

[26] See on these Hollstein X, 196 ff., and M. J. Friedländer, *Lucas van Leyden* (Berlin 1963), pp. 79 ff.

[27] B. 109. A stained glass with this composition is in the Ambrosiana, Milan; see G. J. Hoogewerff, *De Noord-Nederlandsche Schilderkunst,* III (The Hague 1939), p. 314. A painting of this subject by Lucas van Leyden, possibly the model for the stained glass, was in Rubens' estate, wrongly identified by F. Wolter with a poor copy in reverse, *Oud Holland,* XLIII (1926), 228 ff.

[28] B. 139, not signed.

[29] Marijtgen Lucasdr., married to the painter Dammes Claesz de Hoey.

[30] Lucas Dammesz de Hoey; no works known.

[31] Jean de Hoey, ca. 1545–1615, court painter to Henri IV by 1592.

Carel van Mander, who conceived of Bruegel basically as a peasant painter among peasants. More recent research, however, has brought to light and into prominence the fact, almost unsuspected at a time when the image of the "droll" Bruegel was unchallenged, that the master was intimately connected with a group of outstanding intellectuals of his time—that he was a city dweller deeply conscious of burning theological and humanistic problems of his time. His friendship with the great geographer Abraham Ortelius (1527–1598) has resulted in one of the finest interpretations of a great artist's stature that have come down to us from the 16th century—an "epitaph" written after the friend's premature death in 1569 and today preserved in Pembroke College, Cambridge.[1]

SACRED TO THE DIVINE MANES

That Pieter Bruegel was the most perfect painter of his century no one, except a man who is envious, jealous, or ignorant of that art, will ever deny. He was snatched away from us in the flower of his age. Whether I should attribute this to Death who may have thought him older than he was on account of his supreme skill in art, or rather to Nature who feared that his genius for dexterous imitation would bring her into contempt, I cannot easily say.

Abraham Ortelius dedicated [these lines] in grief to the memory of his friend.

The painter Eupompus,[2] it is reported, when asked which of his predecessors he followed, pointed to a crowd of people and said it was Nature herself, not an artist, whom one ought to imitate. This applies also to our friend Bruegel, of whose works I used to speak as hardly of works of art, but as of works of Nature. Nor should I call him the best of painters but rather the very nature [and substance] of painters. He is thus worthy, I claim, of being imitated by all of them.

Bruegel depicted many things that cannot be depicted, as Pliny says [likewise] of Apelles.[3] In all his works more is always implied than is depicted. This was also said [by Pliny] of Timanthes.[4] Eunapius in the *Life of Iamblichus:*[5] Painters who are painting handsome youths in

[1] I am greatly indebted to Dr. Fritz Grossmann for the following translation, based on a thorough study of the document, which Dr. Grossmann has not yet published. (See his *Bruegel, The Paintings* [London, n.d.], p. 24, note.)

[2] Greek painter, ca. 400 B.C.; this quotation in Pliny, Nat. Hist. XXXIV, 61 (J. J. Pollitt, *The Art of Greece* in the Sources and Documents Series [1965], p. 144).

[3] This dictum of Pliny's was applied to Dürer by Erasmus (see below, p. 123) and also quoted by van Mander in his *Foundation of the Painter's Art,* VIII, 12 (see below, p. 64).

[4] Greek painter, ca. 400 B.C.; for this reference see Pliny, Nat. Hist. XXXV, 74 (Pollitt, *op. cit.,* p. 162).

[5] Eunapius' *Lives of the Sophists* had just been published in Antwerp by Hadrianus Junius (1568).

their bloom and wish to add to the painting some ornament and charm of their own thereby destroy the whole character of the likeness, so that they fail to achieve the resemblance at which they aim, as well as true beauty. Of such a blemish our friend Bruegel was perfectly free.

Van Mander's Life of Pieter Bruegel [6] *needs no further introduction.*

In a wonderful manner Nature found and seized the man who in his turn was destined to seize her magnificently, when in an obscure village in Brabant she chose from among the peasants, as the delineator of peasants, the witty and gifted Pieter Breughel,[7] and made of him a painter to the lasting glory of our Netherlands. He was born not far from Breda in a village named Breughel,[8] a name he took for himself and handed on to his descendants. He learnt his craft from Pieter Koeck van Aelst,[9] whose daughter he later married. When he lived with Koeck she was a little girl whom he often carried about in his arms. On leaving Koeck he went to work with Jeroon Kock,[10] and then he traveled to France and thence to Italy. He did much work in the manner of Jeroon van den Bosch and produced many spookish scenes and drolleries, and for this reason many called him Pieter the Droll. There are few works by his hand which the observer can contemplate solemnly and with a straight face. However stiff, morose, or surly he may be, he cannot help chuckling or at any rate smiling. On his journeys Breughel did many views from nature so that it was said of him, when he traveled through the Alps, that he had swallowed all the mountains and rocks and spat them out again, after his return, on to his canvases and panels, so closely was he able to follow nature here and in her other works. He settled down in Antwerp and there entered the painters' guild in the year of our Lord 1551. He did a great deal of work for a merchant, Hans Franckert, a noble and upright man, who found pleasure in Breughel's company and met him every day. With this Franckert, Breughel often went out into the country to see the peasants at their fairs and weddings. Disguised as peasants they brought gifts like the other guests, claiming relationship or kinship with the bride or groom. Here Breughel delighted in observing the droll behavior of the peasants, how they ate, drank, danced, capered, or made love, all of which he was well able to reproduce cleverly and pleasantly in water colors or oils, being equally skilled in both processes.[11] He

[6] Here reprinted in F. Grossmann's translation (*Bruegel, The Paintings,* [London, Phaidon Press, n.d.], pp. 7 ff.).

[7] The artist himself spelled his name "Bruegel."

[8] The place has not been identified beyond doubt.

[9] Little connection with the style of this master can be detected in Bruegel's works.

[10] Hieronymus Cock, etcher and publisher in Antwerp. Bruegel himself did only one etching of his own; most of his designs were engraved in Cock's workshop. Bruegel was in Rome in 1553; he returned to the Netherlands in 1554 or 1555.

[11] Our knowledge of Bruegel as a water color painter is very scanty.

represented the peasants—men and women of the Campine [12] and else-
where—naturally, as they really were, betraying their boorishness in the
way they walked, danced, stood still, or moved. He was amazingly skill-
ful in his compositions and drew neatly and beautifully with the pen,
producing many small views after nature. As long as he lived in Antwerp
he kept house with a servant girl. He would have married her but for
the fact that, having a marked distaste for the truth, she was in the habit
of lying, a thing he greatly disliked. He made an agreement or contract
with her to the effect that he would procure a stick and cut a notch in it
for every lie she told, for which purpose he deliberately chose a fairly
long one. Should the stick become covered with notches in the course
of time, the marriage would be off and there would be no further ques-
tion of it. And indeed this came to pass after a short time. In the end,
when the widow of Pieter Koeck was living in Brussels, he courted her
daughter whom, as we have said, he had often carried about in his arms,
and married her. The mother, however, demanded that Breughel should
leave Antwerp and take up residence in Brussels, so as to give up and
put away all thoughts of his former girl. And this indeed he did. He
was a very quiet and thoughtful man, not fond of talking, but ready with
jokes when in the company of others. He liked to frighten people, often
even his own pupils, with all kinds of spooks and uncanny noises. Some
of his most important works are now with the Emperor, for instance a
Tower of Babel [13] with many beautiful details. One can look into it
from above. There is also a smaller picture of the same subject.[14] Further,
there are two paintings of *Christ Carrying the Cross*,[15] which look very
natural, with some comic episodes in them. There is as well a *Massacre
of the Innocents*,[16] in which we find much to look at that is true to life,
as I have said elsewhere; [17] a whole family begging for the life of a
peasant child which one of the murderous soldiers has seized in order to
kill; the mothers are fainting in their grief, and there are other scenes all
rendered convincingly. Finally there is a *Conversion of St. Paul* [18] with
most beautiful rocks. We would be hard put to it to enumerate all the
things he has painted, the weird and fantastic pictures of Hell and of
peasants. He did a *Temptation of Christ* [19] where one looks down from
above, as in the Alps, on towns and countries immersed in clouds, with

[12] The countryside to the east of Antwerp.
[13] Now in Vienna, as are so many of Bruegel's most important works.
The emperor mentioned by van Mander was Rudolf II.
[14] Now in the Rotterdam Museum.
[15] One of them is now in Vienna.
[16] There are two versions of this composition, one in Vienna, the other
in Hampton Court.
[17] In the *Foundation of the Painter's Art*, VI, 54.
[18] Now in Vienna.
[19] Later in Rubens' collection, now lost.

gaps in places which one can see through; [20] he also painted a *Dulle Griet* [21] who is looting at the mouth of Hell. She stares with a vacant expression and is decked out in an extraordinary way. I think this and some other pictures are also in the possession of the Emperor. An art lover in Amsterdam, Sieur Herman Pilgrims, owns a *Peasant Wedding* [22] painted in oils, which is most beautiful. The peasants' faces and the limbs, where they are bare, are yellow and brown, sunburnt; their skins are ugly, different from those of town dwellers. He also painted a picture in which Lent is shown fighting with Carnival,[23] another in which expedients of every kind are tried out against death,[24] and another with all manner of children's games,[25] and countless other small paintings of great significance. Two canvases in water color are to be seen in the house of Mynheer Willem Jacobsz, an art lover who lives near the New Church in Amsterdam. They are a *Peasant Fair* and a *Wedding*,[26] a picture with many comic figures, showing the true character of the peasants. Among the people who bring gifts to the bride there is an old peasant who has a little moneybag hanging from his neck; he is busy counting the money into his hand. These are outstanding paintings. A short time before his death the councillors of Brussels asked him to paint some pieces to show the digging of the Brussels-Antwerp canal. But his death interfered with the work. Many of his compositions of comical subjects, strange and full of meaning, can be seen engraved; but he made many more works of this kind in careful and beautifully finished drawings to which he had added inscriptions. But as some of them were too biting and sharp, he had them burnt by his wife when he was on his deathbed, from remorse or for fear that she might get into trouble and might have to answer for them. In his will he bequeathed to his wife a painting of a *Magpie on the Gallows*.[27] By the magpie he meant the gossips whom he would deliver to the gallows. Another painting showed *Truth Breaking Through*.[28] He considered it his best work. He left behind him two sons who are also good painters. One is called Pieter. He was a pupil of Gillis van Coninxloo and paints portraits from life.[29] Jan, who had learnt the use of water color from his grandmother, the widow of Pieter van

[20] See on this van Mander in the *Foundation of the Painter's Art*, VIII, 25 (below, p. 65).

[21] Now in the Museum Mayer van den Bergh in Antwerp.

[22] Possibly the picture in Vienna.

[23] Now in Vienna.

[24] Now in the Prado in Madrid; see also above, p. 21.

[25] Now in Vienna.

[26] These cannot be identified beyond doubt.

[27] Now in the Darmstadt Museum.

[28] Not identified.

[29] This information was corrected by van Mander in the appendix to the *Schilder-Boeck*: "I have been wrongly informed that Pieter Breughel the Younger paints from life. He copies and imitates his father's works very cleverly."

Aelst, was instructed in the art of painting in oils by Pieter Goedkindt, in whose house were many beautiful things. He traveled to Cologne and thence to Italy. He has earned a great reputation for himself by his landscapes with very small figures, a type of work in which he excels.

Lampsonius [30] addresses Breughel in these words, beginning with a question:

"Who is this new Hieronymus Bosch, reborn to the world, who brings his master's ingenious flights of fancy to life once more so skillfully with brush and style that he even surpasses him?

"Honor to you, Peter, as your work is honorable, since for the humorous inventions of your art, full of wit, in the manner of the old master, you are no less worthy of fame and praise than any other artist."

Lambert Lombard

Our knowledge of the art of the Flemish painter, Lambert Lombard (ca. 1506–1566),[1] who was primarily active in Liége, is still very scanty; but his reputation was great, and his thorough humanistic training secured him an influential position in high circles of the Netherlands and abroad, as well as among the artists sponsored by them. In 1537 he accompanied an English Cardinal, Reginald Pole, on a journey to Rome, where he stayed for two years and made the acquaintance of Giorgio Vasari, who had a great esteem for him.[2] The letter which Lombard wrote to Vasari on April 27, 1565, testifies to his humanistic leanings but also throws a very interesting light on the northern beginnings of that type of serious art-historical research which reached a first climax in the work of Carel van Mander. The first part of the letter contains an elaborate praise of Vasari's Lives (1550), followed by a profuse eulogy of their mutual friend, the painter, poet, historian, and statesman Dominicus Lampsonius (1532–1599), who in the same year, 1565, published a panegyrical biography of Lombard. The latter then proceeds as follows:[3]

Your spirit which from your books I gather to be no less lovable and refined than it is of rare competence in art spurs me on to confide to you a wish (spontaneously[4] and without ceremony), namely my great

[30] Dominicus Lampsonius was the author of laudatory verses attached to artists' portraits published in a small volume by the widow of Hieronymus Cock in 1572 *(Pictorum aliquot celebrium Germaniae inferioris effigies).* Bruegel's portrait is reproduced as the title page of F. Grossmann's *Bruegel, The Paintings.* On Lampsonius see also below on this page.

[1] Adolph Goldschmidt, "Lambert Lombard," *Jahrbuch der preussischen Kunstsammlungen,* XL (1919), 206 ff.; Max J. Friedländer, *Die altniederländische Malerei,* XIII (Leyden 1936), pp. 46 ff.

[2] Vasari-Milanesi VII, p. 589, praising him as a painter and architect.

[3] Translated from the Italian text as reprinted by Giovanni Gaye, *Carteggio inedito d'artisti* . . . (Florence 1840; reprinted Turin 1961), pp. 173 ff. (176 ff.).

[4] "Alla pittoresca."

desire to have available, through your courtesy alone, a design by Margaritone,[5] by Gaddi [6] and likewise by Giotto, in order that I may compare it with certain works of stained glass which exist here in ancient monasteries and with engravings in low relief, made of bronze, which stand for the most part upright.[7] Nonetheless [8] these have impressed me more than certain modern ones made within the last one hundred years; those two, three and four hundred years old that one finds satisfy me more with regard to their style, although they were made in a traditional manner [9] rather than with excellence and true imitation of nature. I remember having seen in Italy the works made around 1400, very disagreeable to the eye for being dry, not at all rich or in good style, and it seems to me (excuse me if I am wrong) that the works of the masters living between Giotto and Donatello appear coarse, just as do those in our lands and all over Germany from that time on down to Master Rogier and Jan of Bruges. These artists opened the eyes of the painters; [but] they, imitating their style and not thinking progressively, have left our churches full of works which do not resemble the good and natural ones but are only garbed in good colors. Later there arose in Germany a certain Bel Martino,[10] an engraver of copper plates, who did not forsake the style of Rogier, his master, but nonetheless did not achieve the quality of Rogier's fine colors because he was more used to the black-and-white of his prints, which appeared to be miraculous in his time and are today still held in great esteem by our more conservative artists; [11] for although his works are dry they yet have a certain grace. From this Bel Martino have come all the famous German artists, first of all that wholly enchanting Albrecht Dürer, a pupil of the same Bel Martino, who followed the style of his master but approached nature more closely, even though not entirely, in his manner of designing draperies, and who discovered a bolder and less dry procedure, supported by the knowledge of geometry, optics, rules and proportions in the design of figures. Truly, we must render him undying thanks for leading us to the gate of perfection in art; he worked by the sweat of his brow for this goal, as much with his writings as with his works of art, as all Italy knows well. Who doubts that if this admirable mind, endowed with such a divine hand and so many other gifts, had applied itself to the study of the relics of antiquity,

[5] Margaritone d'Arezzo.

[6] Presumably neither Taddeo nor Agnolo Gaddi, but Vasari's Gaddo Gaddi.

[7] "Sopra la punta di piedi." Apparently figurative funerary monuments in engraved bronze which were then still plentiful in Flanders.

[8] I.e., in spite of their old age.

[9] "Per usanza."

[10] Martin "Hübsch," i.e., Schongauer. Lombard's admiration for Schongauer is reflected in some of his works (passion scenes in St. Denis, Liége).

[11] "Nostri mansueti artefici."

those stupendous figures from Montecavallo,[12] that perfect Laocoon and the terrifying poses and foreshortenings of those two youths shackled by the serpents, that great, fleshy and muscular Hercules,[13] the slender, vigorous, soft Apollo,[14] certain figures of licentious old men [15] or Bacchus, and, among the women, so many beautiful figures of Venus—what beautiful designs would not have remained for us in his books on human proportion? But as no man has yet been born that can embrace everything, nature keeps reserves in order not to leave the ages bare and not to show herself step-motherly toward others who come later. Hence I firmly hope that from your hands will issue forth some day, with the grace of God, a grammar and truly fundamental treatise on art. . . .

If I could obtain from you some simple drawing of one of the Byzantine figures of Margaritone de . . . (blank),[16] as mentioned above, I should judge that I had received from you a great favor and privilege.

LIEGE, APRIL 27, 1565. Yours with brotherly affection,

LAMBERTO LOMBARDO.

To the excellent artist and historian Ser Giorgio Vasari of Arezzo, painter of Florence, Florence.

Maerten van Heemskerck

Among the Dutch contemporaries of Pieter Bruegel and Lambert Lombard, Maerten van Heemskerck (1498–1574) occupies an important place, and while his art cannot be compared with that of Bruegel with regard to depth and inner scope it is of the utmost historical significance in many respects. His paintings were much better known in his time than were those of Bruegel, both in the Netherlands and abroad, and his innumerable drawings, engraved by a veritable army of engravers, yielded nothing to Bruegel's in popularity and were in many ways related to the same realm of Erasmian Catholic thought which through Ortelius and Coornhert had exerted a considerable influence upon the Flemish master's ideas and designs. In addition, Heemskerck's topographical and archaeological Roman drawings play a very great role in any effort to arrive at a thorough knowledge of the monuments of ancient and 16th century Rome. His recent reputation has risen notably as we attempt to define Netherlandish Mannerism more clearly, and to evaluate

[12] The Dioscuri of the Piazza del Quirinale.
[13] Presumably Hercules Farnese.
[14] Presumably Apollo Belvedere.
[15] "Certi liberi padri," such as Silenus?
[16] See note 5.

it more justly than before. Van Mander's [1] account of his life and art belongs with the outstanding chapters of the Schilderboeck *by virtue of its judicious balance between characterization of style and straightforward narrative.*

We often find that our most eminent painters have made their obscure birthplaces renowned and universally celebrated, simple villages though they frequently were. What corner of the world is there in which the village of Heemskerck in Holland is not famous, for here it was that the skillful painter, Marten Heemskerck, was born in the year 1498. His father's name was Jacob Willemsz van Veen, and he was a peasant or farmer.[2] Marten, naturally inclined toward the art of painting from his early youth, received his first artistic training in Haarlem, from a certain Cornelis Willemsz,[3] the father of Lucas and Floris who likewise were rather good painters and had travelled in Italy visiting Rome and other places. Marten's father, who probably thought that there was not much in painting, took him back home and put him to work on the soil of his farm, much to the distress of the boy who was thus prevented from continuing his apprenticeship. It was therefore with great reluctance that he attended to such farmer's work as milking and the like; and one day, returning from his duties with a pail of milk on his head, he—not unintentionally—ran into a branch of a tree and spilled the milk. His father, incensed by the spilling and loss of the good milk, ran after him threatening him with a stick. Marten spent the following night hidden in a haystack. In the morning, his mother provided him with a knapsack and a little money, and on the same day, after having passed through Haarlem, he arrived at Delft where he once more took up his artistic endeavors with a certain Jan Lucas; there, he applied himself to drawing and painting with such industry that he made great strides in his art within a very short period. At this time, Jan Scorel had become very famous because he had imported from Italy an extraordinarily beautiful and novel manner of painting which made a great impression on everyone, and on Marten in particular; wherefore the latter did not rest until he was accepted as a pupil by this master at Haarlem.[4] Here he applied himself to art once more with such diligence that he finally caught up with his prominent master; in fact, to such a degree had he adopted

[1] Van Mander-Floerke, I, 338 ff. My translation was first published in E. G. Holt, *A Documentary History of Art* (Garden City, N.Y.: Doubleday Anchor Books, 1957), pp. 343–353.

[2] His portrait by Heemskerck is in the Metropolitan Museum in New York, dated 1532. L. Preibisz, *Martin van Heemskerck* (Leipzig 1911), pl. I; M. J. Friedländer, *Die altniederländische Malerei*, XIII (Leyden 1936), pl. XLII.

[3] No work of his is known; his name is mentioned in documents between 1481 and 1540.

[4] Scorel had fled to this town in 1527 from Utrecht where a local war had broken out. Heemskerck was thus at least twenty-nine years old when he became a "pupil" of Scorel who was only three years older than he.

Scorel's style that it was difficult to distinguish their work. His master—
or so some people say—became disturbed lest his reputation be impaired,
and dismissed his pupil, apparently out of jealousy. Marten then moved
to the house of Pieter Jan Fopsen at Haarlem, the same house in which
the late Cornelis van Berensteyn used to live; and at this very place
he did several paintings, including the life-size figures of *Sol* and *Luna*
depicted on the bedstead in a back room. There he also did *Adam* and
Eve, likewise in natural size, being (it is said) nudes done from life.[5] The
wife of the aforementioned Pieter Jan Fopsen who was fond of Marten
did not like people to call him just Marten; she said to those who came to
visit the painter that he should be called Master Marten since he fully
deserved it.[6] From there he went to live in the house of a certain Joos
Cornelisz, a goldsmith, also at Haarlem. Among many other works of his
was a superbly painted altarpiece of St. Luke which he gave to the
painters of Haarlem as a farewell present upon his journey to Rome.[7]
This picture shows St. Luke seated and painting from life Mary with
the Child on her lap; it is an excellent work, beautifully painted, sin-
gularly outstanding and quite unique, though a little too hard in the
contours of the lighted parts, in the manner of Scorel.[8] Mary has a grace-
ful and lovely face, her attitude is fine, and the Child is most affable;
over her lap hangs a cloth which, after the Indian fashion, is nicely
decorated in various colors and with sundry ornaments, most graceful and
not to be improved upon. St. Luke, whose face was modelled after that
of a baker, is a very fine figure, most effective, and seems to exhibit a
great zeal to match his patron. The palette which he holds in his left
hand seems to stand out from the panel; the whole work is arranged in
such a way as to be viewed from below. Behind St. Luke stands a person
who looks like a poet and wears upon his head a wreath of ivy. (This may
easily be a self-portrait of Marten as he looked at that time.) However, I
could not tell whether by that he wished to indicate that painting and
poetry have much in common and that painters should be of a poetic
and imaginative mind, or whether he wished to convey the idea that
the story of St. Luke was itself a piece of fiction. In the same picture is
an angel holding a burning torch, very well painted. I would not know
of any other work of Marten's that shows lovelier faces than does this
one. The architecture consists mainly of flat walls. From above hangs a

5 Probably the panel in the Frans Hals Museum in Haarlem, no. 264,
which was formerly attributed to Scorel. Preibisz, pl. II.

6 Obviously, Heemskerck was not yet master in the guild of St. Luke
when this happened.

7 Now in the Frans Hals Museum in Haarlem, Friedländer, pl. XXXVIII.

8 On this criticism (also leveled against Lucas van Leyden's *Last Judg-
ment*, see above, p. 35 . . .) see P. T. A. Swillens, "Carel van Manders kritiek
op de schilderijen van Jan van Scorel en diens tijdgenoten," *Miscellanea Prof.
Dr. D. Roggen* (Antwerp 1957), 267 ff.

cage with a parrot in it.[9] Upon the lower part of the architecture he had painted an ornate scroll which looks as though it had been fastened there with wax and which contains the legend: "This panel has been given in memory of Marten Heemskerck who painted it. In honor of St. Luke he has wrought it, and donated it to his fellow painters. We should thank him by day and by night for his kind gift which is before us; and let us pray, with all our fervor, that God's grace be always with him. Finished on May 23, in the year 1532." Quite deservedly, this panel is still kept by the magistrate of Haarlem in the south room of the Prince's Quarters where it is visited and highly praised by many people. He did it when he was thirty-four years old as is borne out by a comparison of its date with the year of his birth. He then went to the city of Rome to which he had long been attracted, in order to see the works of antiquity and of the great Italian masters. Having arrived there, he stayed in the service of a cardinal to whom he had been given an introduction.[10] He did not sleep away his time nor did he spend it in company of the Netherlanders with drinking and the like, but made drawings of many things, antiques as well as works by Michelangelo, furthermore many ruins, ornaments, and decorative details from antiquity such as are seen in great quantities in that city which is comparable to a painter's academy.[11] Whenever the weather was favorable, he would go on a walk to make drawings. One day when Heemskerck had again gone on one of those study errands, an Italian whom he knew managed to steal into his room, cut two canvases out of their frames, and carry them off, together with drawings taken out of their boxes. When Marten came home he was greatly saddened; but since the Italian had made himself suspicious, he went after him and recovered most of his works. However, because he was always very faint hearted, he feared that the Italian might take revenge on him; therefore he did not dare to stay in Rome any longer and undertook to return to the Netherlands. He had spent no more than three years in Rome,[12] but within this short period he had done many good drawings, and also made quite a bit of money which he took home with him. Arriving at Dordrecht with a letter addressed to the father of one of his former young friends in Rome, he was to call at an inn (at the site of the present Brewery of the Little Anchor). In those days, it was a cutthroat den where travelling merchants

[9] This detail was later cut out of the panel and has not survived. See E. K. J. Reznicek, "De reconstructie van 't 'Altaer van S. Lucas' van Maerten van Heemskerck," *Oud Holland,* LXX (1955), 233 ff.

[10] Most probably Willem Enckenvoort, Cardinal of Utrecht, who died in 1534.

[11] For his many drawings of this period see: Christian Hülsen and Hermann Egger, *Die römischen Skizzenbücher von Marten van Heemskerck,* 2 vols., Berlin 1913–1916.

[12] On the duration of Heemskerck's stay in Rome see Hermann Egger in *Mededeelingen van het Nederlandsch Instituut te Rome,* V (1925), 119 ff.

and other people were being murdered. There he was invited to stay for the night (an art patron, by the name of Pieter Jacobs, was also anxious to put him up); but finding a boat, he departed that same evening, and lucky he was, for in that house was found a whole pit full of corpses when the affair came to light. One of the daughters of that assassin had fled to Venice where she lived in the house of a bachelor, the famous painter Hans von Kalkar. Summoned before the Great Council, she truthfully admitted that she had felt compelled to leave that horrible house because she could not stand witnessing such atrocities, but also that she had considered it immoral to inform against her parents; whereupon she was acquitted. Heemskerck, now having returned to his native country, had changed his former manner of painting in the style of Scorel; but, according to the judgment of the best painters, he had not improved it, save for the fact that he had ceased to give such hard contours to the lighted parts. When one of his pupils told him that people thought he had achieved better results when he painted like Scorel than he did after his return from Rome, he replied: "My son, at that time I knew not what I was doing." However that may be, the difference of style can be studied from the two shutters of the altar of the Clothiers [13] (in the big hall of the aforementioned Prince's Quarters) which, on the inside, show the *Nativity* and the *Adoration of the Magi,* two splendidly painted scenes which contain many details, including various portraits of simple folk and also his own.[14] On the outside, one finds the *Annunciation to Mary* in which the heads, painted from life, are very well executed. The angel is clad in a very original and graceful fashion; the lower lappets of his garb are purple, and they were painted by Jacob Rauwaert who at that time lived with Heemskerck as I have heard him tell myself. From this work one can gather how good an architect Heemskerck was and how fond he was of good ornamentation, quite in contrast to the common saying (which he himself was quoting a great deal) that "a painter who wants to do good work should avoid ornaments and architecture." Also, in this work one can make an unusual observation: the angel is reflected on the shiny marble floor as if he were standing on ice, something which actually happens on polished marble. Heemskerck did many large paintings for churches. In the Old Church at Amsterdam, there were two double shutters from his hand, showing on the inside, scenes from the Passion and the Resurrection, on the outside, representations in coppery monochrome; this work received high praise. The central panel was a *Crucifixion* by Scorel.[15] In the Great Church at Alkmaar,

[13] Contract dated January 4, 1546. It now belongs to the Royal Gallery in The Hague but is on loan to the Frans Hals Museum in Haarlem. Preibisz, Pl. V and VI. See also note 31.

[14] The bearded face in the left middle-ground.

[15] Destroyed in 1566.

the high altar was a work of Marten's; [16] the central panel was a *Cruci-fixion,* the inside shutters showed the Passion, their outside the Legend of St. Lawrence—a very good work of art. Many of his paintings were shipped to Delft where one could see several panels of his, in the Old as well as in the New Church.[17] In St. Agatha's was an altarpiece with the *Adoration of the Kings* which he had arranged in such a way as to make one king appear on the central panel, and one on either of the wings; on the outside was the *Erection of the Brazen Serpent,* painted *en grisaille.*[18] This was a particularly excellent work which netted him an annuity of one hundred guilders for life; he was altogether much bent upon procuring for himself a number of life grants. In the church of the village of Eertswoude in North Holland, he did two double shutters for the high altar whose center part was carved in wood; on the inside he painted the *Life of Christ,* and on the outside the *Life of St. Boniface,* all of it divided into many compartments, and very attractive in painting and coloring.[19] He likewise did the high altar of the church at Medem-blik.[20] For the Squire of Assendelft he painted two altar wings, one with the *Resurrection,* the other the *Ascension.*[21] He also did paintings in the chapel of the Assendelft family in the Great Church at The Hague.[22] One could go on indefinitely enumerating all the other altarpieces, easel paintings, epitaphs, and portraits done by him; for he was industrious by nature, worked incessantly, and was skillful in handling his various tasks. Among other excellent easel paintings of his, there was one espe-cially good, full of details and rather large, which represented the Four Last Things: *Death, Last Judgment, Eternal Life,* and *Hell.*[23] This con-tained many nudes, and figures in various poses, as well as a multitude of human emotions: pain of death, joy of heaven, sadness and horror of Hell. The picture had been commissioned from him by his aforemen-tioned pupil Jacob Rauwaert, an excellent connoisseur in his time, who paid him in return a whole pile of double ducats, counting them out before the painter until he cried "stop." Furthermore, I saw, first in the house of the art lover Pauwels Kempenaer, and later in that of the

[16] Documents from 1538 (contract) to 1543 (final payment) exist. Since 1581 it has been in the Cathedral of Linköping, Sweden; see B. Cnattingius and A. L. Romdahl, *Maerten Heemskercks Laurentiusaltare i Linköpings Dom-kyrka* (Stockholm 1953).

[17] One of these could be the large *Ecce Homo* triptych of 1559–1560, now in the Frans Hals Museum at Haarlem, which comes from Delft, as does a shutter of a triptych in the Rijksmuseum in Amsterdam, dated 1564.

[18] Now in the Frans Hals Museum in Haarlem, dated 1551. Heemskerck's portrait of the rector of the monastery of St. Agatha, Johannes Colmannus, is in the Rijksmuseum in Amsterdam (Preibisz, pl. XL).

[19] Not identified.

[20] Not identified.

[21] Not identified.

[22] Not identified.

[23] Now in Hampton Court, dated 1565.

excellent connoisseur Melchior Wijntgens, a small oblong painting representing a Bacchanal, or Feast of Bacchus, which was engraved almost identically.[24] This may easily be the best piece of painting he ever did after his return from Rome since it is very *morbido,* i.e. smooth in its nude parts; in it one can observe the frolics characteristic of pagan feasts of that sort, what with drunkenness and similar things taking place. Aernout van Berensteyn owns a very beautiful landscape by his hand, with a St. Christopher and an excellent background.[25] In short, he was universally gifted, well versed in every respect, outstanding in the rendering of nudes. The only thing he might sometimes be blamed for is that dryness or leanness of his figures which is so often found with us Netherlanders, and also an occasional lack of that certain graceful charm in the faces which—as I have pointed out elsewhere—is so great an asset to an artist's work. In composition he was excellent, in fact, his designs have spread practically over the entire world; he was also a good architect as becomes quite evident from all of his works. Indeed, one could go on indefinitely enumerating the prints made from his compositions,[26] and all those nice and ingenious allegories which were thought up for him by that spirited philosopher, Dirck Volkertz Coornhert, and published by Marten in print. Heemskerck himself was not an engraver [27] but he did many excellent designs for various engravers, among others, for the aforementioned Coornhert whose spirit, mind, and hands were sufficiently able and skillful to comprehend and to execute anything that a person could possibly understand and accomplish. This man did several things in etching [28] and engraving,[29] and in particular, very neat and lovely small scenes from the life of the emperor, with the exception of the print representing the capture of the king of France which was done by a certain Cornelis Bos.[30] Some time after Marten had returned from Rome as a bachelor, he married a beautiful young girl by the name of Marie, a daughter of Jacob Coningh. In honor of the wedding, the rhetoricians performed a comedy or farce. This wife of his died in her

24 The picture is now in the Vienna Gallery. It is based on an engraving by Marcantonio Raimondi after Raphael or Giulio Romano which was copied in the reverse by Cornelis Bos in 1543 (in turn, copied by Jan Theodor de Bry).

25 Not identified.

26 For the more than 600 engravings after Heemskerck's drawings see Th. Kerrich, *A Catalogue of the Prints which have been Engraved after Martin van Heemskerck* . . . (Cambridge 1829), and Preibisz, pp. 53 ff. See also H. R. Hoetink, "Heemskerck en het zestiende eeuwse spiritualisme," *Bulletin Museum Boymans-van Beuningen,* XII (1961), 12 ff., and W. Stechow, "Heemskerck, the Old Testament, and Goethe," *Master Drawings,* II (1964), 37 ff.

27 The correctness of this statement is open to some doubt, see Preibisz, p. 54. Heemskerck was also the author of several woodcuts (*ibid.,* pp. 102 ff.).

28 The earliest date on etchings by Coornhert after Heemskerck is 1549.

29 Dates from 1548 to 1559.

30 Published by Hieronymus Cock in Antwerp, 1556 and 1558.

childbed eighteen months after. Three or four years later, he painted the aforementioned shutters which are now seen in the Prince's Quarters at Haarlem, attached to the *Slaughter of the Innocents* by Cornelis Cornelisz.[31] In second marriage he took an old maid [32] who was neither beautiful nor clever but wealthy; nonetheless, she cast such greedy eyes upon other people's property that she bought many things without paying for them—or, as they say, found them before they were lost—to the great discomfort of Marten who entreated everyone not to shame her, and who, being an honest and upright man, indemnified everybody. He was a church warden in Haarlem [33] for twenty-two years, up to his death. When in 1572, the city of Haarlem was besieged by the Spaniards, the Council permitted him to stay with Jacob Rauwaert in Amsterdam. He was by nature acquisitive and thrifty, and he was also very faint hearted, in fact, he was so timid that he would climb on top of the church spire in order to watch the parade of the militia because he was afraid of the shooting, thinking he might not be safe elsewhere. He was forever worried lest he become poor in his old age; therefore, up to the day of his death, he used to carry around, hidden away in his clothes, a goodly number of gold coins. After the fall of Haarlem, the Spaniards took hold of many of his works under the pretext that they intended to buy them, and sent them to Spain; in addition, the fury of image-breaking has infamously destroyed many other excellent works of his, with the result that in our time not many of them are found in this country. Since Marten, a very wealthy man, left no children, he instituted many fine bequests before he died. Among others, he ordered the income from a piece of land to be given every year as a dowry to a young couple who was to be married upon his grave, an institution which is still being maintained.[34] In the cemetery at Heemskerck, he ordered a pyramid, or obelisk, of blue stone, to be erected on the grave of his father; [35] on its top, one finds the sculptured portrait of his father, and it also contains the epitaph in Latin and Dutch, as well as a little boy standing on burning skeleton bones, leaning upon a torch, and putting his right foot on a death's head —apparently an emblem of immortality. Underneath is written: *Cogita mori.* At the bottom is his coat-of-arms which shows, in its upper part on the right, one half of a double eagle, and on the left, a lion. The lower

[31] See note 13. The picture by Cornelis Cornelisz (1591) now belongs likewise to the Royal Museum in The Hague and is on loan to the Frans Hals Museum in Haarlem.

[32] Her name was Marytgen Gerritsdochter (see note 34).

[33] At St. Bavo (the "Great Church").

[34] This bequest was drawn up by Heemskerck and his second wife on April 16, 1558; an additional entry (June 21, 1568) stipulated that the girls must be married to honest boys who did not drink. The last marriage of this kind was in 1787.

[35] This was executed in 1570 and is still in existence; reproduced in *Noordhollandsche Oudheden,* II, 1, p. 91, and in *Eigen Haard,* 1901.

part contains a bare arm with a quill or a brush in its hand. The upper part of the arm is winged, and the elbow rests on a turtle, and this seems to me to illustrate the advice of Apelles to the effect that one should neither be too lazy in one's work nor overburden one's mind with too much labor (which was said with respect to Protogenes as I have related elsewhere).[36] Toward the upkeep of this pyramid, Marten set aside the income from another piece of land; in case of its neglect, friends of his were entitled to lay hands on that property. He had a very nice way of drawing with the pen, his hatchings were very neat, his touch loose and fine. At Alkmaar, in the house of his nephew, Jacques van der Neck, one finds his self-portraits in oil from various periods of his life, beautiful pictures, well done and interesting.[37] After Marten had been a shining example of the art of his time, he departed this transitory life in the year of our Lord 1574, on the first day of October, at the age of seventy-six, having lived two years less than his father. His body was buried in the northern chapel of the Great Church at Haarlem.[38] But as he himself brought great light to art, so art in turn will not suffer his name to sink into darkness as long as the art of painting is held in the esteem and respect of man.

Cornelis Ketel

The few mistakes which occur in van Mander's accounts of the lives of artists of the earlier part of the 16th century are not apt to find any parallels in his discussion of his contemporaries, least of all in his Life of Cornelis Ketel, a trusted friend who repeatedly expressed his own admiration for van Mander. Ketel is perhaps best known today for his excellent portraits, and his important position in the history of Dutch group portraiture in particular; but to van Mander, who in good Mannerist fashion rather looked down on portraiture (see below, p. 56), the primary greatness of Ketel lay in his allegories, which are of the same highly sophisticated nature as van Mander's own literary exercises in this field (below, p. 70) and which were probably inspired by masters of the Pléiade such as Ronsard (below, p. 153). Few of these works by Ketel have survived (some of them in engravings) but van Mander's very long Vita of Ketel, of which only small portions appear here,[1] is crowded with admiring descriptions of them. Van Mander's special preoccupation with Ketel's attempts at painting satisfactory pictures without brush, with

[36] In *Het Leven der oude antijcke Schilders,* edition of 1617, fol. 14b.

[37] A self-portrait by Heemskerck, dated 1553, is now in the Fitzwilliam Museum in Cambridge (Preibisz, pl. XII). See also note 14.

[38] In accordance with his will, dated May 31, 1572. He appointed the mayors Jan van Suijren and Hendrick van Wamelen executors of his will. For their labors, they should receive two panels, *Christ on the Cross,* and *The Last Judgment,* or if they did not care for them, ten Burgundian dollars each.

[1] Van Mander-Floerke II, 202 ff.

"fingers, feet, and thumbs alone," is highly characteristic of the Man-nerist predilection for virtuoso work.

. . . Finally, Ketel just painted without tools a large picture, about life size; it shows a figure, nude but for an ox hide around him, holding in his hand a hammer which signifies Steady Labor. Above his head fly two children: Genius and Ardor. Genius inspires him to paint without brush, with hands and feet only.[2] The second child, Ardor brought forth by [this] thought, tickles his brain with a little feather and points to a mirror, thus indicating that such an enterprise must be carried out with the help of Intelligence and Sight. Amor, holding a flame in his right hand, seems to urge him to work; with his left hand he spurs on the heart with a golden arrow which signifies Zeal. Intelligence guides the foot as it paints, with the help of Sight which is represented by the mirror; indi-cating that Intelligence cannot achieve this without Sight, nor Sight without Intelligence. Pictura, holding a panel on her lap and, in her left hand, the palette with pigments, permits Envy to be painted with the foot; and Envy looks as though spite was gnawing her heart in two. Pictura is accompanied by Industry and Tolerance, or Patience; they suggest that through steady work much can be accomplished, with the help of Time, which the painter has not failed to show flying in the air, an hourglass in one hand, a scythe in the other. For an explanation, Ketel made this poem:

> Where Genius and Ardor spur the brain,
> Where with his flame and arrow Amor works
> And man is stimulated by deep thought,
> What seemed impossible will be achieved.

> Patience and Industry, in steady work,
> Reveal experienced Intelligence
> If Eye and joyful Ardor lend their help.
> What though the hand or foot was used as brush?

> Pictura sees and willingly permits
> That with the foot is here portrayed for us
> Evil Invidia, begrudging all.
> Her heart all racked by spite and murd'rous thoughts.

The Conclusion:

> Time flies and threatens with his dreaded scythe
> To mow us down when we are least prepared;
> Therefore, whoever is inclined to reap,
> Let him for sowing use th' allotted time.

VIRTUE CONQUERS [3]

[2] A portrait by Ketel painted without brush has survived (dated 1601, reproduced in *Zeitschrift für bildende Kunst*, LXIII [1929], 205).
[3] Ketel's device.

This is surely the best picture done by him without tools. Envy is painted entirely with the foot, the rest with fingers and thumb. Particularly admirable is the neatness with which the flying children are done; their nude figures are reflected in the Mirror of Time. In sum, it is an excellent and wonderful work, painted for the art-loving Willem Jacobsen in Amsterdam.[4] On the frieze of this large picture, painted without brush, one reads the following verses in which ostensibly the painting says of itself:

> See what never has been done:
> Fingers, feet, and thumbs alone
> Ketel used in painting me;
> Brushes never did I see.

Hendrick Goltzius

Van Mander's admiration for Ketel was matched by that for his friend, fellow citizen in Haarlem, superb engraver, and highly versatile and extremely gifted draughtsman, Hendrick Goltzius, who had just then begun his career as a somewhat minor painter. The following excerpts[1] pass by van Mander's account of Goltzius's life and concentrate upon a few passages dealing with some main works by Goltzius in various media and offering apt characterizations, including the one on the master's protean versatility. While van Mander does not specifically dwell on Goltzius's extraordinary contributions to the rise of nature study and landscape in art around 1600, he shows in his own paintings as well as in some of his poems that Goltzius's pioneering efforts in this field were not lost on him. (See also below, pp. 63 ff.).

. . . Now as to his [Goltzius's] works, it is first of all his prints which give eloquent testimony to his great excellence in the art of design. I remember having seen in Bruges, about 1580, some of his engravings after drawings by Adriaen de Weerdt which, though done at such an early date, made a very good impression and were quite beautiful.[2] I was particularly pleased with some prints of the Story of Lucretia which he himself had designed and engraved.[3] Among others there was a banquet in which he had very cleverly rendered some modern cos-

[4] Mentioned by van Mander as owner of paintings by Bruegel, Cornelis van Haarlem, and Jacques de Gheyn. The picture here described was listed as being dated 1601 and belonging to a merchant by the name of Keller in Frankfurt in the early nineteenth century (J. D. Fiorillo, *Geschichte der zeichnenden Künste* [Hannover 1817], II, 514; and G. Rathgeber, *Annalen der niederländischen Malerei* . . . [Gotha 1844], II, 17).

[1] Van Mander-Floerke II, 240 ff. On Goltzius see the admirable book by E. K. J. Reznicek, *Die Zeichnungen von Hendrick Goltzius* (Utrecht 1961).

[2] Unidentified; it is probable that this refers to some engravings after A. de Weert signed by Dirck Coornhert, in which the young Goltzius collaborated.

[3] Hirschmann 171–174 (Bartsch 104–107).

tumes; this contributed greatly to the excellence of the print and in my opinion differed from what was then customary with our Netherlanders. When I came to live at Haarlem in 1583 I made his acquaintance and showed him several drawings by Sprangher which fascinated him greatly. And this also I must report of him, that from his early days he has not only tried to reproduce the beauty and the various shapes of nature but also most admirably trained himself to imitate the various manners of the best masters such as Heemskerck, Frans Floris, Blocklandt, Federigo,[4] and finally Sprangher, whose spirited style he rendered very closely. Indeed very soon after, he engraved that masterpiece, Sprangher's *Feast of the Gods,* which overflows with sweet and tasty Nectar, and secures immortality for both the designer and the engraver.[5] Also, when I had settled at Haarlem, I saw in the vestibule of his house some large upright canvases in which he had cleverly made from his own invention, with greasy coal or black chalk, the Seven Planets, excellently done, with well designed nudes, and looking like grisailles.[6] At that time I also saw a large oblong canvas done by him in oil *en grisaille,* representing the story of the Roman who puts his hand in the fire,[7] extremely well composed and executed; it was made to fit a given space in a room of a large beautiful house which then belonged to the mayor of Haarlem, Gerrit Willemsen, but is now owned by Goltzius himself, and, if I am not mistaken, the painting is still there. I could mention here many of his prints, including the early series of Roman Heroes [8] which is sufficient proof of his heroic strength as a draughtsman and of the capacity of his burin; but for brevity's sake I shall bypass much and report on six pieces which he did after his return from Italy.[9] For as he called to mind the various styles he had encountered, he decided to express with his own hand these different styles, but after his own invention; and what is particularly astonishing is that he accomplished this within a very short time because he wanted the prints to be ready for the Frankfort Fair. When they were completed, but hardly seen by anyone, he thought up a few good jokes, particularly with regard to the *Circumcision,* which is engraved in the manner of Dürer and contains Goltzius's self-portrait.[10] He had his portrait and his monogram burnt out with a hot coal or iron and then patched up again, whereupon he treated the print with smoke and generally in such a way as to make it look very old and as if it had been around for a long time. When the print, thus disguised and masquerading, was seen in Rome, Venice, Amsterdam, and elsewhere, artists

4 Federigo Zuccari.
5 Hirschmann 322 (Bartsch 277), dated 1587.
6 Unidentified.
7 Mucius Scaevola.
8 Hirschmann 161–170 (Bartsch 94–103).
9 Hirschmann 9–14 (Bartsch 15–20), dated 1593 and 1594.
10 Hirschmann 12 (Bartsch 18), dated 1594.

and experienced connoisseurs saw it with great wonderment and pleasure; some paid a high price for it, delighted to have secured such a completely unknown print by the great Nuremberger. . . .

The same happened with the piece of the *Adoration of the Magi* which was done in the manner of Lucas van Leyden; [11] and it is most amazing that engravers who thought themselves great experts on the style and technique of those masters were also deceived by this. All of which shows the power of favor and disfavor, as well as of prejudice among men; for in this way, several people who tried to disparage or depreciate Goltzius's art, unwittingly put him above the best old masters and above himself. And this was also done by those who used to say that better engravers than Albert and Lucas would never appear and that Goltzius could not be compared with them. . . .

Together, all these things prove that Goltzius is a strange Proteus or Vertumnus in his art, able to re-create in his mind all shapes and styles. . . .

What he can do as a draughtsman and designer with the pen I leave to the connoisseurs to judge. As to my opinion, I have seen nothing better or even equally good; thus I certainly do not expect to see in the future greater wonders in the work of others. On parchment he has done various pieces, large and small, including a *Bacchus, Ceres, and Venus,* in which Cupid, by fanning a fire, causes a reflection to appear on the figures.[12] . . . Later Goltzius conceived the idea of drawing with the pen on a canvas which was primed or prepared with oils; for, however large the parchment was, it remained too small for his great ideas and his great spirit. . . . I do not believe that anyone is as able and competent as he is to draw at once with the pen a figure, even a whole composition freehand, without any preparatory design, with such perfection, and to complete it meticulously and in such grand spirit. . . .

Michiel van Mierevelt

The following brief passage from van Mander's Life of Michiel Mierevelt [1] *(1567–1641) has been included because of its extremely characteristic attitude toward the art of portraiture, which in the opinion of nearly all articulate representatives of Mannerism occupied a rank far below the painting of historical subjects of all descriptions. Van Mander's subsequent "smoothing down" of his first blunt statement is not only amusing but also indicative of his eminent fairness and tolerance.*

. . . In composition, figure style, and other matters he followed

[11] Hirschmann 13 (Bartsch 19).
[12] This drawing, dated 1593, is now in the British Museum in London (Reznicek no. 129), and is also mentioned by van Mander in the *Grondt der Schilder-Const* (see below, p. 62).
[1] Van Mander-Floerke II, 214.

with much talent the manner of his teacher.[2] This I have seen in various works which he had designed and executed in his early days, when he worked on his own, and which pleased me greatly.[3] Therefore I believe that by concentrating exclusively or at least predominantly on the painting of figure compositions he could have achieved excellent results, as he undoubtedly still could today. But in our Netherlands, and especially at this present time, we have this lack, and this calamity, that there is little work to be done in figure composition that could provide our young people and our painters with the opportunity for such practice, through which they might achieve distinction in historical scenes, figures, and nudes. For what they are commissioned to do is mostly portraits from life; and so most of them, lured by profit or simply in order to make a living, start and continue on that bypath of the arts (that is, portraiture from life), without having the time or the desire to look and search for the road of historical or figure painting which leads to the highest perfection. Thus many a fine and noble mind has remained without fruit and quenched, to the great detriment of Art. I know that this word "side-road" or "bypath" could be taken amiss and considered too harsh by some, and so I probably ought to smooth it down a bit with a soft polecat brush or a feather; therefore I shall admit that one can certainly do a good job of a portrait and that a face, being the noblest part of the human body, provides a fine opportunity to make manifest and prove the virtue and powers of Art, as many of the aforementioned great masters have indeed done, and as our own Mierevelt (or Michiel Jansen) is still doing; he surely does not yield to anyone in the Netherlands. . . .

Lodovico Guicciardini

Lodovico Guicciardini's Descrittione di tutti i Paesi Bassi, *written in 1561 but first published at Antwerp in 1567,[1] contains the first comprehensive survey of Netherlandish Art (not only painting) from 1400 to his own time. It makes use of the first edition of Vasari's* Vite *(1550) but in turn contributes importantly to its second edition of 1568. Guicciardini's account of the artists of the 15th century does not add very much to what we know from other sources (although he was the first writer to make extensive use of Lucas de Heere's data concerning Hubert van Eyck). His brief accounts of contemporary Netherlandish artists have not yet been fully utilized. The following passage is significant for its combination of pride in the reputation of the artists hailing from Guicciardini's adopted residence and in the decisive role his homeland Italy played in their training.*

. . . Almost all of these aforementioned painters, architects, and

2 Anthonie van Blocklandt.

3 Only an occasional example of this early style has survived.

1 Translated from *Descrittione di M. Lodovico Guicciardini, Patritio Fiorentino, di tutti i Paesi Bassi* (Antwerp 1567), p. 101.

sculptors have been in Italy; some in order to learn, others to see works of ancient art and to make the acquaintance of people who excel in their profession, others to seek adventure and to make themselves known. After having satisfied their desires they return in most cases to their native country with new experience, ability, and honor; and from there they spread, having become masters, to England, all over Germany, and particularly through Denmark, Sweden, Norway, Poland, and other northern countries, including even Russia, not mentioning those who go to France, Spain, and Portugal, in most cases called there on high salaries by princes, republics, and other rulers—a fact which causes no less wonderment than it reflects honor upon them.

Carel van Mander, Theoretical Writings

Foundation of the Painter's Art

It has been emphasized before that Carel van Mander, in contrast to Vasari, was a theoretician of very considerable importance as well as a historian of art. His Foundation of the Painter's Art (Grondt der Schilder-Const), *published together with his* Lives *and his two other theoretical treatises in the* Painter's Treatise (Schilder-Boeck) *of 1604, is the rhymed work of a learned writer in the northern tradition of the "Rederijkers" (Rhetoricians) but shows a thorough familiarity with the Italian production, both in the field of practice and of theoretical endeavors. Van Mander knew and used the writings of Alberti (through the German adaptation by W. Rivius), of Leonardo, and Lomazzo; but although he had failed to visit Venice during his stay in Italy (1573–1577), he never tired of recommending to his readers—and it was the painters to whom he addressed himself—the synthesis of Florentine-Roman "disegno" and Venetian color. At the same time, his preoccupation with the lives of the older Netherlandish masters (the "old modern" masters) led him to observe carefully and with admiration their solid technique and to recommend its chief virtues for emulation. All this traditional material is combined with novel observations and ideas with which van Mander prepared the ground for much that was to be part of the glory of 17th century Netherlandish art, particularly in the realm of landscape, in which he secured for himself a respected place as both a painter and a poet. The following excerpts [1] were chosen with the in-*

[1] These excerpts rest mainly on the Netherlandish text as reprinted, with German translation and excellent commentary, by R. Hoecker, *Das Lehrgedicht des Karel van Mander (Quellenstudien zur holländischen Kunstgeschichte,* VIII [The Hague 1916]). Several tests have shown the reliability of this text through comparison with the original of the second edition of 1618. Attempts to translate in verse form have proved futile, and the exigencies of his *ottava rima* system have also often made van Mander's meaning somewhat opaque. The author's notes *in margine* have been quoted here only when they add significantly to the text.

*tention of emphasizing both the traditional and the progressive aspects
of this work.*

I, 66. I would fain encourage you outright to travel if I were not
afraid that you might go astray. For Rome is the city where before all
other places the Painter's journey is apt to lead him, since it is the capital
of Pictura's Schools; but it is also the right place for spendthrifts and
prodigal sons to squander their money. It is risky to permit such a trip
to our young people.

I, 68. But one must fall in love with the beauty of that land and with
the Italian people who are the progeny of Janus and who have always
much praised our art; on the whole they are neither treacherous nor
thievish but subtle and very polite, even though they are loud-mouthed
and tight-fisted. But there is hardly a nation under the sun that has no
special faults and merits.

I, 71. Some time, when you are in Italy, you—like the falcons—ought
to surrender your eyes to the beautiful Circe with all her roguery; [2] with
regard to your work this means that you should paint, in fresco, some
landscapes next to your grotesques. For the Italians always assume that
we are as good in this as they are in painting figures, though I hope that
here, too, we shall steal a march on them.

I, 72. Indeed I hope that on this point I am not unduly hopeful. They
can already see this coming true on canvas, stone, and copper plates. Be
alert, my young friends, take courage, even though there will be many
disappointments, apply yourself, so that we can achieve our goal—namely,
that they can no more say (as is their custom): The Flemings cannot paint
figures.

I, 75. Finally: See to it that you do not return without having reaped
the benefits you were seeking there. From Rome bring home skill in
drawing, and the ability to paint from Venice, which I had to bypass
for lack of time; [3] for I, too, have journeyed on many roads, of which—
deferring my admonitions—I shall briefly report to you.

V, 4. For the composition of a figure consists of many members of one
body, all encompassed within the one "superficium"; [4] but the entire
story has established its own composition by combining the appropriate
figures. Now for putting these together correctly there exist seven *motus*
or methods of movement.

V, 5. First, standing upright; then, bending down; to the right side;

[2] Falcons are captured by a decoy method for which Netherlanders had
long been famous; thus they "surrender their eyes" to a roguish "Circe" as
painters should to the Circe which is Italy (an identification based on the sup-
posed residence of Circe on Italian soil).

[3] It is certain that van Mander never visited Venice.

[4] *In margine:* "superficium is the contour; what the story or composition
is." This summary was mistranslated by Hoecker. The content of verses 4–5 is
indebted to Quintilian and Alberti-Rivius.

to the left; walking away from us; moving toward us; and finally, in the round, i.e., occupying the place in the form of a circle; but one should at all events adjust himself to the boundaries [of the picture] and avoid the impression that the figures support the frame or lie as if crammed into a box.

V, 12. Our composition will enjoy a fine appearance, to our own delight, if we insert into it a vista of small figures farther back and a distant landscape for our eyes to plunge into. Therefore we should see to it that our figures are sometimes represented sitting down in the middle of the foreground so that above them one can look back for miles.

V, 13. But our composition will hold little charm unless our backgrounds are done particularly well; it is in this field that the Italians employ us though we are foreigners, for they consider the Netherlanders excellent landscape painters. They may perhaps praise us for this but maintain they are superior in figure painting.[5]

V, 21. Within the entire composition—this is important—the figures must show variety in movements, appearance, action, shape, nature, character, and disposition; [6] and as we said of the seven methods of movement, some figures should face us with both legs forward or walk in that direction, while the heads and bodies of others should be seen from the side.

V, 22. Some should show their heels from behind, some sit, lie, crawl, climb up, walk down, arise, kneel; sometimes figures should seem to be falling down, if the occasion warrants, or sneaking around, others looking aloft, leaning on something, or stooping down. It is also fitting to mingle draped figures with half-clad and nude ones.

V, 23. Many painters have hit on a method of composition to which I shall by no means object—namely, to encompass the entire scope of their story within one circular movement, in such a way that one part of the figures which represent the story remains standing in the center of the picture, like an image which is being looked at or worshipped by a crowd.[7]

V, 24. But in my opinion [8] the composition can hardly gain in charm by having half bodies of people, horses, bulls, calves, or other figures run into the frame, unless an object extends in front of them, either of stone [9] or something else, so that one can assume this to cover up the rest for the eye.

[5] See also Francisco de Hollanda, pp. 33–35, Klein & Zerner, *Italian Art, 1500–1600: Sources and Documents* (Englewood Cliffs, N.J.: Prentice-Hall, Inc., 1966).

[6] From Leonardo.

[7] From Alberti-Rivius.

[8] *In margine:* "This I write down as my honest opinion, and not in order to disparage great masters who have not heeded it."

[9] The translation of 1702 substitutes "steenen" (stones) for the original "steemen" (stems? or misprint) as required by the rhyme scheme.

V, 65. One can also expand scenes with few actors in various ways. If, for instance, one would like to add to the lonely group of Abraham's Sacrifice, one could invent spiritual figures, each of which would lend him support in carrying out the action; to wit, Faith, Hope, and Charity. **V, 66.** Faith might hold down Isaac fettered with a rope, Hope tender the sacrificial knife to Abraham, who stretches out his hand, for he hoped: I might receive him back since God is able to raise up even the dead,[10] and Faith [had] made him bring Isaac to this place. To Charity and her children may be commended the fire because they burnt there like coals of fire.

V, 67. Another example is the Annunciation by Zuccaro, amplified by Angels and Prophets; [11] and in the *Life of Rosso,* as related by Vasari,[12] we read of a Madonna painting in which the serpent lies crushed under Her feet and our first parents sit fettered against the Tree of Sin while Mary pulls Sin, in the shape of an apple, out of their mouths.

V, 68. And as a token that she was clothed in sun and moon (also in Rosso's picture) there flew above in the air Phoebus and Diana, two nude figures. Such things should not only be used in order to enrich pictures but should also receive a name: Allegories,[13] or poetic devices which indicate a meaning through signs.

VII, 31. The terrible conflagration, which strikes fear in man's heart, in arising causes with its sparks a fiery crackle; and the thicker and blacker the dark sail of the night is, the lighter shine its powerful flames which also throw a colorful reflection on houses, temples, and other buildings, and are terrifying to look at in the water as well.

VII, 32. Those who well depict with colors Vulcan's anger and such terrible misery have great power in the realm of art; for depending on the food or material with which he nourishes his vehement flames which, hard to tame, fly skyward, they receive their appropriate colors, tending toward red, purple, blue, or green.

VII, 33. Not only the flames but also the smoke fills the air with different colors. Indeed, it looks like the horrible vapors of the Styx, where Hydra and Cerberus together with many other ugly monsters rage and roar; [14] thus the painters must be observant of such things when they intend to make a conflagration look terrifying or to stoke the fire in a poetic rendering of Hell.

VII, 34. Candle light, which is a rare thing, is difficult to represent

10 *In margine:* "Hebr. 11, 19."

11 Fresco in S. Maria Annunziata (Collegio Romano) in Rome (torn down in 1626); engraved by Cornelis Cort in 1571 (Bierens de Haan no. 26).

12 Vasari-Milanesi V, 164; van Mander, *Leven der Italiaansche Schilders,* 61vb.

13 "Wtbeeldingh" can mean "representation" but also "allegory," as defined in this passage.

14 Virgil, Aen. VI, 384 ff.

in art. A good effect is achieved by putting in the foreground a dark figure which is in a shadow from top to toe, and by having the light but touch the outline of skin, hair, or drapery; also one must see to it that the shadow extends throughout from a point- or dot-like light.

VII, 35. Likewise, when one represents Vulcan and the Cyclopes with naked limbs, who with all their might caused Mount Aetna to tremble when they forged Jupiter's lightnings, one might put one of these figures against the light so that he is quite covered by a shadow, and here and there blend the light of the fire with its contours wherever it is appropriate.

VII, 36. But those who are standing behind the fiery sparks must wear the bright livery of reflection which they receive from the glowing iron work; this reflection also colors the rocks of the cave with shadows and fiery lights, and is thrown upward from below against the strained wild faces of the men who look grimly after their rough business.

VII, 42. But why do I deal here with strangers? [15] I should certainly remember Congiet,[16] that Netherlandish Italianate painter, who was master of all the colors wherever he put them to work; none of them ever dared to transgress his rules in the least, but had to do and to be whatever his intentions commanded.

VII, 43. And wherever the colors were yet unable to live up to the farthest limits of his imagination, he boldly approached, with the son of Jupiter, the carriage of the King of the Planets; for in order that his fire or light might come to life he executed it cleverly with gold, and thus his fires glow and glisten, and his lights shine and twinkle like stars.

VII, 44. With colors he can admirably render the burning of Pluto's City or the destruction of Troy, and how Judith, at night, exhibits the head of Holofernes in the light of torches and flares; [17] likewise lanterns in the streets thronged by crowds in the distance, as in the Lottery picture which the administrators of the lunatic asylum in Amsterdam commissioned to him,[18] not to mention his other things which one can see elsewhere.

VII, 45. And since Pictura is now as favorably inclined toward Batavia as she once was toward Sicyon,[19] Nature has poured out the cornucopia of her gifts in the lap of two who live in the port city of Haerlem. One of them is a painter proper,[20] and one of his works in Amsterdam is the

[15] In the preceding verses van Mander deals with works by Raphael (Liberation of St. Peter) and Bassano.

[16] Gillis Coignet or Congnet.

[17] Cf. the paintings of this subject by Abraham Bloemaert in Frankfurt and Vienna.

[18] Rijksmuseum, Amsterdam, no. 705, dated 1592.

[19] Home of the painter Pausias.

[20] Cornelis Cornelisz van Haarlem. See O. Hirschmann in *Oud Holland*, XXXIII (1915), 81 ff. Van Mander's description is faulty.

Cave of Plato,[21] whose artistic importance is unusually great.

VII, 46. In it one sees reflections scattered everywhere. But a group of prisoners are lying in the dark and fighting with arguments over shadows of figures caused by lamp light; some are free and look at figures and shadows; others, farther away from them, fix their eyes firmly upon the sky without looking down. But to explain the meaning of this piece I leave to those who own it.

VII, 47. The other artist [22] nature has induced to turn entirely to the practice of line and Clypean work [23] (though quite recently also painting) and made him known as a unique Phoenix with golden feathers; [24] and what metal would not yield to the unique gold, or what light not to the unique Sun, to which alone Phoenix is fully devoted—he who bears the name of the Tree of Victory? [25]

VII, 48. By his hand one saw, done on Attalian [26] skin in artistic line work, Find-Wine,[27] Give-Lust,[28] Lose-Care [29] and Overflow [30] with two white doves; in order not to let them feel cold in the midst of their pleasure, Cupid was blowing into the fire and kindled the flames whose reflected light fell upon Echo's offspring [31] and the figures.

VII, 49. This Daedalian piece, in which the lovely Charites delight, may at this time decorate the Hesperian Garden; [32] and for those who envy another's honor, Fama's trumpet means double misery; for this work, full of art's mystery, can—like Zeuxis' Wrestlers [33]—be much more easily censured than equaled.

VII, 50. When the dark night is gone and the bright day finds us having a delightful time lying and sitting pleasurably on green meadows, reflection begins to do its work; for we partake of the green of foliage, grasses, and plants on our faces and uncovered skin.[34]

VII, 51. Likewise, where faces or nude bodies stand in the shadow of wool, silk, or linen, reflection will have its way. If the material is yellow

[21] Engraved by Jan Saenredam in 1604 (Bartsch 39); the subject is from Plato, *The Republic*, VII, 514 ff.

[22] Hendrick Goltzius.

[23] Engraving.

[24] *In margine:* "Pliny [X, 3] writes that the phoenix has some golden feathers or plumes." "Goltsche pennen" (golden feathers) is a pun on Goltzius.

[25] Phoenix = date palm.

[26] Attalian = Pergamene; parchment. This is the drawing of 1593 in London (Reznicek no. 129) which is also mentioned in van Mander's *Life of Goltzius*, see above, p. 55: an illustration of "Sine Cerere et Baccho friget Venus."

[27] Bacchus.

[28] Cupid.

[29] Venus.

[30] Ceres.

[31] Stones (Ovid, Met. III, 399).

[32] Italy.

[33] *In margine:* "Plin. lib. 35 cap. 9." Zeuxis himself is supposed to have said of this picture: "invisurum aliquem facilius quam imitaturum."

[34] From Leonardo.

or red, the flesh tone will be partially affected by such reflexes, and where muscles blend into each other one can see highlights as if flesh tone were standing against flesh tone.[35]

VII, 52. On round columns one can also see a reflection light up; furthermore on bases, white eggs, and marble spheres, the more so if light objects are near them; also on gold and silver bowls, vases, clear transparent ice, wine-filled glasses which throw highlights on the table cover. To all of this painters must pay attention.

VII, 53. Still many more objects clearly show the luster and highlights caused on them by reflections, as an industrious observer can learn from nature, the painter's mistress, in each individual lesson. An example of how glossy fish, tin, and copper reflect each other is found in the paintings of Lange Pier.[36]

VII, 54. This man admirably rendered stalks with color, and in this regard everything seemed alive, both the leaves and the fruits. One could almost imagine grasping with his hands some dishes which stand in the dark and which show this effect of reflection, as one can see to one's delight in a picture belonging to an art patron in Amsterdam.

VII, 55. In sum, he was superior in the art of clever treatment of reflections; indeed, he was a great, able, and cunning deceiver of human eyes and a resourceful impostor. For one imagines seeing all sorts of things, yet it is nothing but color which he was able to mix in such a way as to make the plane seem round, the flat in relief, the mute eloquent, and the dead alive.

VIII, 9. I advise you to pay attention to foreshortening and diminution as one can observe it in nature. Even if there is no architecture involved —which demands firm rules—you must know how to direct your eyes correctly to the horizon or vanishing point, i.e., to the upper water level: whatever is below it one views from above, and the rest is viewed as in a slant from below.

VIII, 10. The background [37] must not be laid on too weakly, and not so softly in the shadows as in the highlights; consider the mass of blue air that interferes between object and eye and quite blurs any attempted clarity and palpability. Only rarely and occasionally should one use the effect of sunlight breaking through the clouds and pouring forth over towns and mountains.

VIII, 11. Besides, one should paint scenes of darkness, sometimes complete, sometimes partial, with the towns lying in the shadow of the clouds; also one should calculate that in their reflection on water the

[35] *In margine:* "Large flat reflections are sometimes appropriate but one must see to it that the small highlights on nude figures do not look dry or otherwise objectionable."

[36] Pieter Aertsen.

[37] V. 10–12 from Leonardo.

colors of the sky are not slighted. It makes a fine effect if one follows the old custom of sometimes blending the clouds below softly with the sky above, sometimes having the sun shine forth.

VIII, 12. But I shall speak separately of wild, stormy weather, when the sea rages and the brooks burst forth like fountains. I now sometimes wonder when I think of what is said of Apelles' colors: [38] how could they have "flashed and thundered," there being so few of them? Now that we have so many of them, and pure ones, too, for a more competent rendering of such extraordinary things, why does not our ambition impel us more strongly to follow his example?

VIII, 13. Sometimes you should depict the raging wet waves, stirred up by Aeolus' messengers, black thunder clouds, ugly and misshapen, and crooked lightning which through a dark-skied, stormy tempest is hurled from the hand of the highest god so that all animals that bear a mortal soul seem fear-stricken before such power.

VIII, 14. With colors one should also try to render snow, hail, rain squalls, sleet, hoarfrost, and steaming, depressing mists; all these things are necessary for the depiction of melancholy winter days, when sometimes, trying to see towers and houses in towns and villages, one cannot see farther than a stone's throw.

VIII, 19. First of all, it is proper to make the foreground always solid in order to cause the other grounds to recede quickly, and also plan to depict a large object in front, as was done by Brueghel and others of great fame who bear the palm in landscape painting; for in the works of these worthy people one often sees in front powerful tree trunks. Let us follow their lead in this matter with equal zeal.

VIII, 20. Now I must needs speak of one thing which will add importantly to the perfection of our work, namely that, beginning in front of the picture, we should firmly unite all grounds with each other, just as we see the waves in Neptune's realm rolling into each other; thus, one should make the grounds meander along rather than heap pile behind pile.

VIII, 24. There were few Italians who painted landscapes but they were excellent and almost without rivals. They often open up only one vista [39] in perspective and put in very solid grounds and towns; besides by Tintoretto, this has been revealed to us by the wondrously great Titian, whose woodcuts can teach us much in this field, as can the works of that painter from Brescia.[40]

VIII, 25. Next to these I might proudly praise the beautiful colors and

[38] *In margine* is a general reference to Pliny for this; he means the famous passage (XXXV, 50; 96): "pingit et quae pingi non possunt, tonitura, fulgetra, fulgura," for the first part of which see Ortelius (above, p. 37).

[39] This restriction (overlooked by Hoecker) is repeated *in margine:* "The Italians . . . often make only one vista in perspective."

[40] Gerolamo Muziano.

excellent design of the paintings and prints of the clever Brueghel. As if we were [with him] in the cliffs and rocks of the Alps, he teaches us to paint, without too much trouble, how one looks down into dizzy abysses, at steep crags, cloud-kissing pine trees, vast distances, and rushing streams.

VIII, 37. Although one should try assiduously and in many ways, from nature or after good models, to sketch foliage on colored paper in wash technique, hoping to achieve something good with time, yet in this endeavor, studious Art looks but like somebody dreaming; for foliage, hair, sky, and draperies are all spirit, and the spirit teaches us how to make them.

VIII, 38. One might well use different kinds of foliage and pay special attention to various colors: to the yellow and green oak leaves, to the pale willow blades. The crowns of the trees should not be shown entirely rounded as though they were clipped over a comb. Also one should depict the branches as growing out of all sides of the trunks, the strongest below, the weaker ones farther up.

VIII, 39. One should also find handsome tree trunks, thick below but becoming slender as they rise. Bare white birches, chestnut, and linden trees should sometimes be distinguishable; also show the rough bark of the oak wound about and wreathed with green, and strong stems, fit for the attaching of sails into which the wind may blow, all clothed in their green leaves.

VIII, 40. To design the trees well is a demanding task, both in the form of lower bushes and high-rising stems, some more yellow, others more green; the foliage should be made to turn over as it rises. But the leaves should not be made too fine and small in order to avoid the impression of dryness; and when you paint your foliage see to it that they are mingled with slender small shoots which are softly bending, here upward, there downward.

XII, 1. If it can be considered appropriate to liken drawing to the human body with its various limbs, then is painting no less suitably likened to the Spirit or the Soul; for through colors the dead strokes of drawings are enabled to move and live, and thus they are truly awakened from the dead.

XII, 4. I dare neither praise nor censure what is done by some who have had much practical experience, have a firm hand, and are well versed (so that they cannot easily be misled on crooked paths, and their art has made them worthy of the name "master"): namely, to draw off-hand and nimbly on the ground that which they have previously fashioned with care in their mind.

XII, 5. Swiftly and without much trouble they go to work with brush and colors, and with blithe courage; and painting thus, these fellow-artists cleverly put down their things in underpainting and sometimes

quickly repeat this process for improvement. Thus those who have abundant imagination act daringly and correct only an occasional flaw.
XII, 6. In this manner they proceed with their work joyfully, carrying out their undertaking with honor. Now, this may well be fitting for an Augustus of painting, who steadily advances in his art and expands his realm through his proud brushwork. But although in this way one can learn to handle colors courageously and fearlessly, it is nevertheless not the proper thing for everyone to do.
XII, 7. There are others who with much trouble and difficulty gather together their things one by one out of piles of sketches and drawings, and from that they draw, neatly and clearly, all they have joined together in their minds upon the primed ground with a fluid, thinly tempered pigment or with neat strokes of the pencil, wiping it clean and spotless.
XII, 8. Indeed, they make all things very firmly and conscientiously, inner as well as outer contours at their measured pace, without failing the slightest detail. There is nothing wrong with this, nor is it at all unpleasant; rather it is a great help in painting, and in order to make it pleasing in every way and to prevent dimming, each of their well-tempered colors is at once applied to its right place.[41]
XII, 16. Our more recent ancestors used to cover their panels with thicker white grounds and to scrape them as smooth as possible. They also employed cartoons which they transferred upon that fine even white layer; these they were in the habit of tracing through after having rubbed something black on the reverse, and then they redrew the design neatly with black chalks or pencils.
XII, 17. But the loveliest thing was that several of them took some finely ground charcoal, mixed with water (or even dry), and modeled their forms very meticulously and properly; over this they put, with great forethought, a thin priming, through which, however, one could still see everything, and this priming was done in flesh tones.[42]
XII, 18. When this was dry they saw their forms clearly before their eyes, almost half completed; whereupon they would lay on everything neatly and finish it all in one process,[43] with great labor and care; they did not put on their colors thickly but thinly and economically, very finely applied, luminously and clearly, minutely drawn with a brush made of fine white hair.
XII, 19. Oh rare Dürer, Germany's renown! In Frankfurt's monastery

[41] *In margine:* "Each color to be put in its place from the start in order to prevent dimming."

[42] *In margine:* "They drew their things on the white ground and then put over it an oil-like priming."

[43] "Ten eersten op" (repeated *in margine*) is sometimes translated "alla prima," which would not fit the procedure of the old masters; "all in one process" seems to be a more cautious suggestion. Cf. verse 8 and notes 41 and 46.

one can see his clean, noble art shine forth, worthy of fame.[44] Yes, and Brueghel and Lucas [45]—all those flowers and veritable Ne Plus Ultras! In their time, they—and Johannes, the greatest of them all—surrounded the realm of the painters with a solid dike so that nobody should easily overtake them.[46]

XII, 20. In such excellence they were well matched. They laid on their colors beautifully, neatly, and pleasingly, and they never heaped them on their panels as thickly as is done today, when one can touch and feel the work from all sides almost as a blind man would; for in our time the pigments lie so uneven and rough that one could very nearly mistake them for being carved in stone relief.

XII, 21. Neatness is praiseworthy; it offers the eye sweet nourishment and makes it tarry long, particularly if it is firmly combined with good taste, spirit, and cleverness, and if it does not lose its perfection when seen either from afar or close by. Such things keep our minds ensnared, and through insatiable eyes make our hearts cling to them in steady enjoyment.[47]

XII, 22. Of the great Titian we know, through the very useful writings of Vasari,[48] how in the prime of his maturing life he was in the habit of executing his beautiful works with unbelievable neatness and industry. These were not open to any objection or disdain but pleased everyone, whether he was viewing them from a distance or close by.

XII, 23. But eventually he turned to treating his works very differently —namely, with flecks of color and rough brushstrokes; this had a very natural effect if one stood somewhat removed from it but not if one viewed it closely. This method was followed by various masters but they have not accomplished anything great with it excepting a few tolerably good things.

XII, 24. They meant to equal the well-trained master and have but vainly deceived themselves; for they thought his works were accomplished without labor, whereas in reality the greatest endeavor of art had been copiously bestowed on them. For one can see that his paintings are overlaid and covered with colors in several sessions, and there is more effort behind them than one would think.

XII, 25. This method of execution, employed by Titian on the basis of an especially good judgment and understanding, is esteemed and admired as beautiful and pleasing; for in it, as Vasari says, the effort is concealed under great art, and such painting could almost be thought

44 The Heller Altarpiece, see below, pp. 91 ff.

45 Lucas van Leyden.

46 *In margine:* "Brueghel, Lucas, and Jan van Eyck are instances of doing things neatly all in one process."

47 *In margine:* "Neatly done things which yet are done spiritedly are praiseworthy and keep the onlooker in long speculation."

48 Vasari-Milanesi VII, 452.

to be alive. As has been said, his works seem to be improvised and are yet done with great exertion.

XII, 26. Thus I have endeavored to put before your eyes, oh noble novices of the art of painting, two different but appropriate manners, so that you can wholeheartedly steer your course toward the goal which most spurs on your spirit. But I would advise you to start out with the difficult method, and with an industrious mind to train yourself in a clean manner and firm foundation.

XIV, 31. With good luck I might have produced more chapters (or else expanded those I have); but Architecture, with its appertaining matters such as Geometry and Perspective, have all been very lucidly brought out in print in our language.[49] Also, my own interests and domestic necessities take the pen out of my hand and keep intruding, or else I might have added a thousand other things.

XIV, 32. Young men who want to paint, let this be agreeable to you and serve you well. Do not despise the path of Virtue, though it be hard of access; for look: ultimately it leads to happiness through the sweet profit brought by success. Of this you will find examples in the *Lives and Acts of the Painters;* and thus I believe that while you read [them] you will at the same time learn how to paint.

<div align="center">END OF THE PRINCIPLES OF THE ART OF PAINTING</div>

Interpretation of Ovid's Metamorphoses

Van Mander's Interpretation of Ovid's Metamorphoses (Uytleggingh op den Metamorphosis Pub. Ovidii Nasonis) *is another part of the Painter's Treatise of 1601, its dedication is dated March 14, 1604. It continues a long medieval tradition of commentaries on this most famous ancient source for painters of all nations, but with a very significant difference: it eschews all elements of Christianization of the old fables which formed the very* raison d'être *for the medieval interpretations. It is true that many of van Mander's rationalistic explanations are by no means new and were offered by some medieval writers along with the Christianized ones; nevertheless, his comprehensive treatment is of considerable importance for our understanding of many works of art of van Mander's own time and throughout the 17th century. It has hardly begun to be utilized for this purpose, partly because it has not been translated from the Dutch since Joachim von Sandrart's* Teutsche Academie *(Part II, 1679).*

The first excerpt is taken from the dedication of the work to a

[49] *In margine:* "To wit, the books by Pieter van Aelst on geometry and perspective, Hans Bloem on architecture, and others."

certain Gedeon Fallet; the second is a sample from fol. 7v of the 1618 edition of the Schilder-Boeck *(this part actually printed in 1616).*

What the learned Philostrates [1] of Lemnos said is credible and true: Those who neither embrace nor appreciate the art of painting sin against the truth of history and the advice of the poets, since both of these [2] pursue the same aim of depicting and describing for us the experiences and actions of men renowned for their virtues. This opinion finds support in the consensus of Simonides and Plutarch who call painting mute poetry, and poetry a speaking picture.[3] For just as the painter, with his colors and brushstrokes, represents the stories of the past as if they were happening at present, so does the poet with eloquent reasoning and his variety of words; thus they only differ in the material of their presentations and representations. Therefore the author who narrates the course of his stories in good form deserves our thanks, but neither less nor more than the painter who puts before our eyes his picture cleverly carried out in shapes which move our hearts; whereby is proved that they aim at the same mark. And even though one of these sisters, daughters of Nature, was born without speech, she is not considered less pleasing for it, nor is she disparaged; for the wise Greeks did not like much empty talk. . . .

I submit that in my explanation of these Metamorphoses I have used some care and discretion, and I have avoided something that others, in other languages, have done but which in my opinion is not permissible: namely, to lend a religious meaning to these pagan stories and interpret them as referring to Christ. For these matters have nothing whatever in common. After all, the poet did not know [anything about] Christ; nor do his fables have the task of announcing Christ; for it is written: "For we have not followed cunningly devised fables, when we made known unto you the power and coming of our Lord Jesus Christ." [4] As I said before, they serve very well to improve morals, to guide a man to an upright, virtuous, honest life as a citizen, and to become acquainted with various aspects of nature; but one ought not to press such things too far.

In many cases I have followed this procedure: I give first the story upon which the fable is based; then, its natural meaning; and finally, the didactic and moral explanation. . . . I think I have made so many

[1] *Recte:* Philostratus; paraphrased from his *Icones;* see E. Panofsky, *Idea* (Florence 1952), p. 11.

[2] I.e., poets and painters.

[3] On the history of this concept see W. Rensselaer Lee, "Ut pictura poesis," *Art Bulletin,* XXII (1940), 197 ff., and M. Baxandall, "Bartholomeus Facius on Painting," *Journal of the Warburg and Courtauld Institutes,* XXVII (1964), 90 ff.

[4] 2 Peter, 1, 16.

disclosures or discoveries that the essence and meaning not only of the present book but also of many other poetical works will be easily comprehended and understood, not without profit nor devoid of much edifying and useful instruction. . . .

OF DAPHNE

The transformation of Daphne into a laurel tree [5] was invented because there is much laurel in the Tempe Valley. She is called the daughter of Peneus, a river that flows through that same valley. The meaning of this is as follows: Daphne, fleeing from unchaste love, signifies that a maid who carefully guards her virginity remains youthful and preserves a lastingly good sweet odor just as the laurel, lastingly green, emits a good odor; for in the same way, the maiden-like chastity must remain untouched in order to achieve early bloom in honor. And even as the laurel, when thrown into a fire, makes a huge noise, seeming to fight the flame although it is being consumed by it, such must also be the way of an honest virgin: she, too, must resist the flame of unchastity with screams when her honor is forcibly and dastardly tempted or violated.

Some have it that Ovid thought up this fable in order to please Augustus, suggesting by Apollo, Augustus, and by Daphne, Livia. The pagans of old called the laurel the tree of Apollo; and even as Apollo was considered to be the god of soothsaying and oracle, laurel leaves were believed to be fit for soothsaying and for interpreting dreams; therefore they put laurel branches under their pillows in order to dream the truth when they went to sleep. Thus the poet felt all the more justified to build his fable upon this [belief] and to give it an aura [of truth].

Handbook of Allegory

Van Mander's Handbook of Allegory (Uytbeeldinghe der Figueren . . .) *was published as the last part of the* Painter's Treatise (Schilder-Boeck) *in 1604 and is here translated from the edition of 1618 (this part actually printed in 1616; fol. 111 ff.) in excerpts. Like the* Interpretation of Ovid's Metamorphosis *it has been neglected, remaining untranslated; but it can serve as an important commentary on the kind of late Mannerist allegory that van Mander admired so much in the works of Cornelis Ketel (see above, p. 51) and strove to imitate in some of his own designs. A connection with similar elaborate allegorical conceits in Italy and in France is evident. (See below, p. 153, for Ronsard).*

[5] W. Stechow, *Apollo und Daphne* (Leipzig-Berlin 1932), (*Studien der Bibliothek Warburg,* ed. F. Saxl, XXIII; reprinted with appendix, Darmstadt 1965).

OF THE GOAT AND HER MEANING

The goat signifies good hearing; and some believe that she inhales and emits breath through her ears as well as through her nostrils.

The goat—and this also include the satyrs—signifies unchastity.

The goat signifies the whore, who destroys the young people even as the goat gnaws off and ruins the young green sprouts.

OF THE DOG AND HIS MEANING

The dog signifies the right teacher who without fear must constantly bark, watch over man's soul, and punish man's sins.

By the dog one indicates fidelity; for the dog is most faithful and never forgets a kindness shown him.

A dog tied up signifies the soldier who keeps faith with his captain and is bound to his oath.

The dog, who (according to Cicero) has an outstanding sense of smell, is placed with the allegory of smell or stands for it.

The third book begins as follows:

In the above I have to some extent cleared the way for my young painters in order that they, without any special learning, can depict matters of significant meaning in images which all peoples with languages of their own, so far as they are at all intelligent or somewhat experienced, should be able to divine and understand; together with advice how to imagine and depict some special meaningful figures. In this respect one has to be of a quick mind, imaginative and alert, and not timid and diffident. For, as the ingenious Coornhert [1] once remarked upon these very subjects and meanings: there is no gallows standing before your door. By which he meant to say: it is everyone's privilege to use his mind and intelligence in these matters. There is little or nothing to be lost here: if I make up my mind to depict some examples of such images or allegorical shapes for my own better satisfaction, then I shall put forth some of them to the best of my ability. Among the common people one finds many who are amazed when they see this kind of writing without letters, with signs or figures, in the manner of the devices or verses often used by the rhetoricians [2]—although these things cannot be read or comprehended as with the language and are not so outstanding as the old Egyptian manner of the hieroglyphs or emblems. The Egyptians were wont to let things take their beginning from above—that is, on their

[1] Dirk Volkertsz. Coornhert (1522–1590), statesman, philosopher, Erasmian Catholic theologian, poet, and engraver.

[2] The "Rederijkers," members of the literary and theatrical laymen's clubs so characteristic of the Netherlandish scene in the 16th and 17th centuries. Van Mander was himself a member of a Haarlem group of "Rederijkers."

pyramids or tomb tops; sometimes they also had to be read from left to right, at other times from right to left. However in my opinion several things could just as well be placed from below upward as from above downward, as can be seen from the following common saying about the circular course of the world or of the world's ways:

"Peace brings livelihood; livelihood, wealth; wealth, pride; pride, strife; strife, war; war, poverty; poverty, humility; humility brings peace."

Now in order to depict this one has to gather from the preceding book each object according to its meaning and to render and organize these things either from above downward or from below upward.

First, peace may be represented by the caduceus of Mercury or by a beehive-shaped helmet or an olive branch. Livelihood can be indicated by a coulter, a ship's rudder, hammer, trowel, spool, and such necessary utensils, and these one could place upon the aforementioned beehive-like helmet or another peace emblem as proof that peace brings forth and supports livelihood. Above livelihood one may render wealth characterized by a purse. From the bag, or upon this purse, may rise three peacock feathers indicating pride. On the peacock feathers, loosely scattered arrows for discord or strife, with a two-headed body upon strife. A drawn bow with an arrow on the string for war. Clackdish, beggar's dish, bottle and plate for poverty that results from war. Upon poverty one may place humility, characterized by a foot stepping on a garland or a crown. This foot would then once more be followed by peace, as above; but it is unnecessary to show this again since everyone knows that it has to begin again from below, with peace as represented before.

"To listen or attend with alertness and to be slow in speaking is a sign of wisdom." This can be depicted as follows: first, one should represent a winged ear; next, a human tongue on a snail or a turtle, and, for wisdom, a serpent or the head of Medusa.

"A quick hand brings wealth; a slow one, poverty." This can be depicted by a winged hand which holds a purse, and a hand lying on a snail or a turtle which holds a rattle or clackdish. . . .

Many of these things were brought from Egypt to Greece, and hence to Tuscany and Italy, where some of them have appeared in print. . . .

2

Germany

In spite of the fact that Netherlandish architecture and sculpture of the 15th and 16th centuries have been somewhat unduly neglected by scholars and the general public alike, it is hardly an exaggeration to say that the real glory of the art of that region and period was painting. This emphasis is amply—perhaps too amply—reflected in our selection, in which only print-making occupies a modest second place. For German art, however, such a distribution would be palpably unjust; not so much for the early 16th century, with its great triad of Dürer, Grünewald, and Holbein, as for the 15th century. Here painting, in strong contrast to the situation in the Netherlands, does not occupy an overwhelming position and does not develop from decade to decade in an unbroken procession of masterpieces; rather, it develops in a fascinatingly erratic fashion, comparable to a journey through vast valleys and over a few dazzling heights. But in sculpture, particularly the wood sculpture of altarpieces, German art of that century not only reached some of its greatest summits but also maintained a consistently high level. We shall therefore place greater emphasis on it than on painting; and fortunately, the preserved documents relating to sculpture facilitate this task.

Egidius of Wiener Neustadt

During the 15th century many German and Austrian artists worked in foreign countries. In Italy, German sculptors played a remarkably active role, not only as wood carvers but also as workers in stone; naturally this was particularly true of the northern parts of the peninsula although the great sculptural enterprises in Tuscany, too, absorbed many German talents. The case of Master Egidius of Wiener Neustadt, who worked in Padua between 1422 and 1438, gains additional interest by virtue of the fact that he executed there at least one "vesper image," the representation of the group of Mary seated with the dead Christ in her lap. It is a characteristic example of the devotional image which was a near-exclusive specialty of German and Austrian sculptors in the 14th and 15th centuries and not popular at all with Italian sculptors until the young Michelangelo seized upon it—with the result that even the much earlier northern versions have become known under the Italian term "Pietà." The polychromed limestone group by Master Egidius was commissioned in 1429 and finished in 1430, as the following document proves.[1]

Master Bartolommeo the baker, son of Master Gregorio the baker, from the parish of San Biagio, and Master Zilius[2] the sculptor, son of

[1] Translated from the contract in Latin (original in the Archivio Civico, Padua), as reprinted by Werner Körte, "Deutsche Vesperbilder in Italien," *Kunstgeschichtliches Jahrbuch der Bibliotheca Hertziana*, I (1937), 1 ff. (133).

[2] Dialect form for Egidius.

the late Johannes of Vienna, residing in the parish of S. Maria del Torresino [3] at Padua, have mutually arrived at this arrangement and contract: Said Master Zilius shall be held and obliged to make and complete for Master Bartolommeo an image of the Blessed Virgin Mary with the Crucified in her arms,[4] similar to the white image of our Mother, the Virgin Mary, which is placed under the confessio in the [crypt of the] main church or cathedral at Padua,[5] but somewhat larger; this work he promises to deliver, carefully executed with colors and all other requirements, by next Palm Sunday.[6] As payment for this work, said Master Bartolommeo binds himself to pay twenty gold ducats; [of this] he agrees to pay six ducats at once in order that the stones necessary for the carving can be transported here from the district of Verona; and if he [7] neglects through his own fault and negligence to live up to this obligation he shall be bound to make up for all losses which the patron declares upon his oath to have suffered for that reason.

Lucas Moser

That German painters found the going sometimes rough during the early 15th century, even though—or perhaps because—they were among the most progressive of contemporary artists, is sharply illustrated by the inscription which Lucas Moser added to his signature on the small but brilliant altarpiece which he painted (on parchment pasted on wood!) in 1431 for the parish church of the little town of Tiefenbronn in Baden:

Cry, art, cry, grieve bitterly,
No one now will care for thee.

We shall encounter similar complaints again (below, pp. 131 and 133).

3 "In contrata turrisellarum."

4 This vesper image has been preserved in S. Sofia in Padua; see Körte, *op. cit.*, p. 38 ff., and Wolfgang Lotz, "Der Bildhauer Aegidius von Wiener Neustadt in Padua," *Studien zur Geschichte der europäischen Plastik, Festschrift Theodor Müller* (Munich 1965), p. 105 ff.

5 This image (a statue or another vesper image), probably a work by the same artist, has not been reliably identified as yet, but see the suggestion made by W. Lotz, *op. cit.*, p. 112.

6 The rather prompt execution of the work is borne out by the inscription on its base which reads (in three Latin hexameters): "The baker, Bartolomaeus, who lives in the parish of S. Blasius, had this work carved on the 15th of August of the year 1430." "Had this work carved" reads in the original "me insculpsit"—another proof of the fact that the names connected with works of art in this fashion are often those of the patron rather than the artist.

7 The sculptor.

Michael Pacher

On December 13, 1471, the Tyrol master Michael Pacher, one of the few artists equally great as sculptor and as painter, signed the contract for the large double-transformation altarpiece to be erected in the small pilgrimage church of St. Wolfgang, not far from Salzburg.[1] The work was finished ten years later and still stands at its original site. The second party to the contract was the Abbot of Mondsee. The document is typical of the basically medieval situation we encountered before in Dieric Bouts's contract for the Louvain Altarpiece (above, p. 10); many of the phrases which define the obligations of both parties, including that of conforming to the previously submitted and approved design, occur almost verbatim in many other agreements of this kind. With so much sculpture involved (besides the painted panels), the questions of transport and erection play a larger role than in most of the Netherlandish examples which were restricted to painting; to this must be added the matter of painting and gilding the carved figures.

Here is recorded the pact and contract concerning the altar at St. Wolfgang, concluded between the very Reverend, Reverend Benedict, Abbot of Mondsee and of his monastery there, and Master Michael, painter of Bruneck, on St. Lucy's day of the year 1471.

Item, it is first to be recorded that the altar shall be made conforming to the elevation and design which the painter has brought to us at Mondsee, and to its exact measurements.

Item, the predella shrine shall be guilded on the inside and it shall show Mary seated with the Christ Child, Joseph, and the Three Kings with their gifts; and if these should not completely fill the predella shrine he shall make more figures or armored men, all gilt.

Item, the main shrine shall show the Coronation of Mary with angels and gilt drapery—the most precious and the best he can make.

Item, on one side St. Wolfgang with mitre, crozier, church, and hatchet;[2] on the other St. Benedict with cap, crozier, and a tumbler, entirely gilded and silvered where needed.

Item, to the sides of the altar shall stand St. Florian and St. George, fine armored men, silvered and gilded where needed.

Item, the inner wings of the altar shall be provided with good paintings, the panels gilded and equipped with gables and pinnacles, representing four subjects, one each.

[1] Translated from the German text as reprinted by Ignaz Zibermayr, "Michael Pacher's Vertrag über die Anfertigung des Altars in der Kirche zu St. Wolfgang," *Mitteilungen des Instituts für Österreichische Geschichtsforschung,* XXXIII (1912), 468; original in the Landesarchiv Linz.

[2] The hatchet is the one specifically listed item which Pacher omitted.

Item, the other ones likewise gilded and of the best in painting.

Item, the outer wings—when the altar is closed—shall be done with good pigments and with gold added to the colors; the subject from the life of St. Wolfgang.

Item, the figures on top of the shrine shall be made as shown in the design, covered with colors and gold.

Item, when the altar is prepared he shall have it brought to Oberhall at his own cost, and then in person, at our cost and risk, to Braunau; and from there we shall have it shipped to St. Wolfgang at our cost; but whatever might be damaged on the transport he shall repair.

Item, at St. Wolfgang, while he completes and sets up the altar, we shall provide his meals and drink, and also the iron work necessary for setting up the altar, as well as help with loading wherever necessary.

Item, the contract is made for the sum of one thousand two hundred Hungarian guilders or ducats or other currency on a guilder basis.

Item, if the altar is either not worth this sum or of higher value, and there should be some difference of opinion between us, both parties shall appoint equal numbers of experts to decide the matter.

Item, it has been expressly stipulated that the altar shall not cost more than those one thousand two hundred guilders, in good faith and without deceit.

Item, on this account we have given him fifty Hungarian guilders and ducats.

Item, if he needs more money he shall make out due receipt.

Item; the money that we are giving him for work on this altar Master Michael shall have guaranteed by good men while the work proceeds; likewise, when the altar has been completed and shipped here, if we do not pay him the aforementioned sum at once, we shall, if needed, give him written security.

Felix Faber

The Latin treatise which the Dominican Felix Faber (Fabri; ca. 1441–1502), a native of Switzerland, wrote in 1488 in praise of his adopted home town, Ulm,[1] *belongs to the most important early northern "city biographies." For the art historian it holds many disappointments— with the one exception of the section translated here from the original Latin. The civic pride which Faber felt before the half-finished gigantic*

[1] Translated from *Fratris Felicis Fabri Tractatus de Civitate Ulmensi* . . . , ed. Gustav Veesenmeyer, in *Bibliothek des litterarischen Vereins in Stuttgart,* **CLXXXVI** (1889), 38 ff.

parish church, to which the people of Ulm had already dedicated one hundred and eleven years of supreme effort and which was not to be completed until the 19th century, inspired him to an extraordinary effort of his own as a writer. His report contains many details which one would be hard put to find in any other document of this kind; among them I mention the passage on the "light of which proper beauty consists," the high esteem for the pieces of sculpture taken over from the older church, and the excitement caused by the excavations in the cemetery.

. . . Thus the work [of the building of the parish church] grew under their [the citizens'] hands, and within 111 years—that is, from the year of its foundation in 1377 to the present year 1488—it developed into an amazing temple which is admired by all the world. But the spectators admire not so much the huge structure as they do the high-mindedness and courage of the founders who in so small a community dared to erect, without the support of strangers, without any help and solicitation, such a grand edifice whose immense and lofty bell tower rises today to the glory of God's majesty as though it would touch heaven. The recently completed interior of the church glistens with such splendor that visitors entering it and admiring its beauty call it the house not of mortals but of divine hosts. A great deal of the beauty of this church is also due to the sculpture from the old parish church which was carved by old masters and has been relocated on the porches and on the lintels of the doorways.[2]

This church has nine unique features in comparison with all other parish churches in the whole of Christianity.

First, it is larger than any other parish church; for it is not a collegiate or episcopal or abbey church but a simple parish church, yet larger than many episcopal churches and more majestic than most cathedrals. True, I do not dare to compare it with the temple of the Sophia at Constantinople, most famous in all the world, once served by nine hundred priests, a marvelous work built of precious materials which is now—alas—under the filthy rule of Mahomet; but that church was a cathedral.

Second, our church is more beautiful than all the others, not so much with regard to the decoration of the walls, the structure of the pavements, stone sculpture, paintings, or altars, but to the splendor of its light of which proper beauty consists.[3] For I have seen many churches of greater splendor in structure and materials, but none that is pervaded by such floods of light, none so bright in all its corners as this one;

2 Such older ensembles have been preserved on the northwest (1356) and southeast (ca. 1360) portals. See Kurt Gerstenberg, *Das Ulmer Münster* (*Deutsche Bauten*, VII [Burg 1926]), pp. 18 ff. See also note 5.

3 "Pulchritudo formalis."

nowhere has it a dark corner or an obscure section or a dim area such as one usually finds in large churches; and its chapels are not concealed but easy of access and well lighted.

Third, there are more altars here than in all other parish churches: for it has fifty-one altars, all well provided and fully recognized; and they are fitted out not by princes or nobles or strangers but by the citizens of Ulm themselves, and just as they are the patrons of the church, so they alone maintain all altars. And there are many altars which have five or at least four or three privileges.

And from this follows, fourthly, that no parish church pure and simple has so numerous a clergy as has the one in Ulm.

Fifth, this church is richer in offerings than all others. Whoever wants to know the number of offerings which the people of Ulm make every day into the offering box or at the basin for its erection should think of the daily wages of the artisans working there and of those who bring the stones from remote places; their acquisition and transport is tremendously expensive because the stones of this church are not broken in the soil of Ulm but must be transported there from remote places. One should also think of the magnificent status of the parish priest, for he does not have the status of just any parish priest or canon but of a full bishop since he has at his service five clergymen and many attendants, yet has no other salary or benefice than the spontaneous offerings of his congregation. It is for this reason also that the parish usually has an outstanding man, a gentleman and a scholar, who is worthy of so high an office.

Sixth, I daresay that this church has a larger congregation than all other churches of Christianity, for, however large it is, yet on festival days it is packed right up to the altar, and if there were no additional chapels,[4] it could not hold the crowd. Normally more than 15,000 people take communion in it during Easter time.

Seventh—and it follows from the above—this church is more provident than all others in the dispensing of the sacraments. For no other parish can be found in which so many children are baptized every day; on an average, five children daily are baptized in the baptistry of this church which is decorated with regal ornaments, and all that are baptized are registered and inscribed. The same holds of confession and communion, and rarely a Sunday passes on which, in addition to official masses, there are no communion services for pregnant women or the sick and probationary.

The eighth point which follows pertains to burial places . . . there are two large cemeteries. . . . The grave-diggers report that when they dig into the ground [in the outer cemetery] they constantly come upon

4 "Monasteria" properly speaking are burial chapels built on the outsides of churches; it is not quite clear what the term refers to here.

very strong walls, presumably the foundations of the former parish church; this was doubtless a splendid building as is shown by the beautiful pieces of sculpture which were transferred from there and inserted into the walls of the modern church above all doors, except the main west door next to the bell ropes, which has recent sculpture; all the others come from the old parish church.[5] When they dig in the inner cemetery they find subterraneous buildings and empty vaults and other things of unknown origin. People are usually amazed by these matters; and the cinerarium of that cemetery was once the storehouse of the monks of Saint George under the chapel of Saint Valentine.

The ninth special feature of this parish church is the great affection and love its parishioners hold for it. . . .

The tenth and last point is that the parish priest of that church enjoys great privileges in favor of the church. . . .

Adam Kraft

The contract between one of the great German sculptors working at the turn of the century, Adam Kraft of Nuremberg, and Hans Imhoff, the donor of the famous stone tabernacle commissioned for the Church of St. Lawrence, was concluded on April 25, 1493.[1] It follows the pattern of many similar agreements but contains some passages—which are among the few here quoted—for which one would look in vain in medieval documents properly speaking. A distinction is here made between those parts which are clearly visible to the onlooker and those which are not, and it is stated explicitly that the latter do not have to be executed as "subtly" as the former—though still "well and solidly." One witnesses here the emergence of a type of craftsmanship which is judged by the beholder's eye rather than sub specie eternitatis—*the (perhaps more practical) equivalent of the artistic reasoning which led Donatello to carve his Campanile statues in a bold summary technique.*

. . . First of all, it shall be made to stand next to the pier beside the altar of St. Lawrence, on the right side; its base shall be worked out solidly but not expensively, since not much of it can be seen under the gallery. After that, a gallery shall be made over the center of and around the base, with two stairs leading up to the gallery, one on each side of the pier, approximately three or four steps high, with a railing all

[5] See note 2 above. This sweeping statement has not been duly investigated; however, Gerstenberg dates the southwest and northeast portals "ca. 1370–1380," which leaves the question open since the new church was not begun until 1377.

[1] Excerpts translated from the German text as printed in: Hans Konrad Röthel, *Das Sakramentshaus von Adam Kraft* (Berlin 1946), p. 24 ff. (*Der Kunstbrief*, no. 20). The original is in the Freiherr von Imhoff Family Archives, Nuremberg.

around; these stairs, the gallery, and all of the railing shall be carved with great subtlety and excellent craftsmanship, and whatever part of the base rises above the gallery shall also be done with subtle craftsmanship since it will be clearly visible. . . . The main body, together with all its scenes, figures, crowning parts, capitals, and all other afore-named pieces shall be made throughout with the finest and purest craftsmanship since it will be most fully exposed to the beholder's eyes. . . . [The four scenes above this] shall likewise be made well and solidly but yet not so subtly as the lower parts, for it will be placed higher up and not so clearly visible to the beholder. . . . The afore-named master Adam has promised to said Hanns Imhoff to complete this work, with God's help, within more or less the next three years, as counted from the date of this contract,[2] and for such work said master Adam shall not have the right to ask more than seven hundred guilders altogether. . . . Written on Thursday, the day of the Holy Evangelist Saint Mark, in the year since the birth of our beloved Lord Jesus Christ 1493.

Tilmann Riemenschneider

The special interest which attaches to the contract concluded be-tween the great Würzburg sculptor Tilmann Riemenschneider and the officials of the Church of St. Jacob in Rothenburg on the Tauber for the Altar of the Holy Blood on April 15, 1501,[1] is due to the exactness and completeness of its stipulations, particularly with regard to the reliefs on the wings, and to the fact that the altarpiece was ordered after the shrine had already been executed or at least partly executed [2]—by a different craftsman. The altar contains no painted parts whatever.

Be it known that the prudent, honorable, and wise Jeremias Ofner, Hanns Kumpff—both of the inner council—and Lorentz Tenner—of the outer council, and all three at this time, upon call and order of the prudent, honorable, and wise mayor and council of the town of Roten-burg on the Tauber, building commissioners of the parish church of Saint Jacob in that place—have hired and commissioned the prudent and wise master Till Riemenschneider, sculptor from Würzburg, to carve and execute the figures listed below in the shrine which Erhart Harschner has been hired [3] to make upon the central front altar on the west gal-

2 It was indeed completed in 1496.

1 Translated from the German text as given by Justus Bier, *Tilmann Riemenschneider, Die reifen Werke* (Augsburg 1930), p. 171 f. The original is in the Communal Archives, Rothenburg on the Tauber.

2 See the following note; the exact relationship between the two masters is not entirely clear.

3 Payments to Harschner run from 1499 to 1502; he visited Würzburg in March, 1502.

lery [4] of the aforesaid parish church. To wit: below in the predella next to the sacrament niche, two angels, one kneeling, about one and one half feet high [5] and two others placed on its side; further, in the shrine the Last Supper of Jesus Christ with His Twelve Apostles and all other things pertaining to it, each figure about four feet high; [6] also, on the right wing in relief the representation of Palm Sunday when Christ rides in on the ass, together with the other figures and things pertaining to it, the height of the relief of this figure to be about three fingers [inches?]; and on the left wing he shall carve, likewise in relief, the story where Christ is on the Mount of Olives, together with the Disciples and the Jews coming upon Him, the relief as high as in the aforementioned scene of Palm Sunday; and above the shrine, in the top part, he shall carve in the center two angels, kneeling toward each other, who hold the Holy Cross, and also above the Cross two hovering angels,[7] all of this in the size as needed according to the preliminary drawing; [8] and on the sides of the cross, on the right, the figure of the Virgin Mary, and on the left, the Angel Gabriel in the attitude of announcing the angelic message to her virgin heart; and above the cross in the middle of the tabernacle the figure of the Man of Sorrows, about three feet high. And this he shall carve and complete with great care; to wit, the two angels in the predella and the Supper in the shrine, also the four angels belonging with the Cross, between now and the next day of the Apostle James; [9] and the other scenes and figures between now and the very next Christmas.[10] For all of this work he shall be paid and receive from the aforementioned church supervisors fifty guilders Rhenish.[11] But if, at the time of the placing and installing of the figures in the shrine, it should become manifest that Master Till made the reliefs and figures in such a way as to merit more than those fifty guilders, the matter shall be judged by the aforementioned commissioners and the venerable, prudent, honorable, and wise gentlemen: Martin Schwarz, warden for the Minorites, Hermann Prell, Hans Gundloch, Seitz Wucherer, and Heinrich Trub, who have been present at the signing of this commission and contract; and Master Tillman shall be satisfied with it in good faith, with avoidance and ex-clusion of all cunning and fraud. To make all this legal and manifest, two identical copies of this have been made out, cut apart in indenta-

[4] The entire west gallery is called "The Holy Blood" here as in other documents.

[5] They came out higher: 21-22 inches.

[6] They came out smaller: Judas measures ca. 35 inches.

[7] These were not executed.

[8] This "Visierung" is lost.

[9] July 25, 1501. These figures (minus the two hovering angels, see note 7) did not arrive in Rothenburg until July 3, 1502.

[10] Delivered in July 1504 and January 1505.

[11] Last payment January 12, 1505, together with a bonus of ten guilders.

tion, and one handed to each party as a reminder. Actum on Thursday after Holy Easter in the year after Christ's Birth, 1501.

Johannes Butzbach

The little booklet on famous painters (Libellus de praeclaris picturae professoribus) *which the Benedictine monk Johannes Butzbach at Maria Laach wrote in 1505 for the nun and paintress Gertrud of the convent of Nonnenwerth,*[1] *conjures up an almost touching image of the small and philistine world of monastic life in its most untroubled form on the eve of the Reformation. It should be noted that this idyl was written, and this kind of painting greatly admired, in the year in which Albrecht Dürer went on his second Italian journey.*

In more recent times, during the reign of Benedict XI,[2] a certain Zetus,[3] by painting with great talent the stories of the martyrs at Avignon,[4] is said to have restored art to its ancient dignity; and in this our own age, thou and several other recent painters of great talent have exalted it even more. Thus, in the art of engraving, Israel, a citizen of Bocholt,[5] is very highly praised, while everyone admires thee as the most gifted in the art of painting. Furthermore Johannes, Abbot of Saint Mary of the Martyrs near Treves,[6] and Conrad, once Abbot of Rinkau,[7] both experts in this most noble art, have painted some famous works in their monasteries. And our overseer Crisantus, also called Benedictus,[8] has turned out to be highly gifted in the art of painting miniatures, and his refinement has been extolled with great praise by some very skillful masters. In his praise someone has composed the following distich:

> Fame in the art of Apelles to thee, o brother, has fallen;
> Zeuxis, Parrhasius: both must cede thee the crown.

[1] Translated from the Latin text as published by Alwin Schultz, "Johannes Butzbach's Libellus de praeclaris picturae professoribus," *Jahrbücher für Kunstwissenschaft*, ed. A. von Zahn, II (1869), 60 ff., here 71 f.

[2] *Recte:* Benedict XII.

[3] Giotto.

[4] The probable source of Butzbach's information was Jacopo Filippo Foresti's *Supplementum chronicarum* of 1485. (See Otto Kurz's note to Julius Schlosser-Magnino, *La letteratura artistica, Appendice* [Florence 1937], p. 18.) However, Foresti in turn had misinterpreted Platina's report of 1474, which says expressly that the Pope "Zotum . . . ad pingendas martyrum historias in aedibus ab se structis conducere *in animo habuit*" (*Liber de Vita Christi ac omnium pontificum*, ed. G. Gaida, p. 272); Giotto died in 1336. See now Enrico Castelnuovo, *Un pittore italiano alla corte d'Avignone* (Turin 1962), p. 26.

[5] Israel van Meckenem.

[6] Either Johannes of Breda (abbot 1477–1492) or Johannes of Trier (1492–1509); nothing is known about them as painters.

[7] Unknown.

[8] Also mentioned (somewhat more extensively) in Butzbach's more famous autobiography, *Odeporicum (Journeyman's Book)*.

Our late brother Henricus,[9] precentor, vestryman, gardener, porter,[10] and barber, who was a pupil of the former and highly skilled in his art, died last year; by his hand are many initials in choral books, illuminated with leaves, figures, and ornaments. Near the first of these, which he produced as the first specimen of his talent, one finds our following verse:

> Our brother Henricus, a monk at Laach,
> The son of Coblenz, that illustrious town,
> This letter painted; may he rest in peace
> In all eternity. Amen.

Albrecht Dürer

In Albrecht Dürer, Matthias Grünewald, and Hans Holbein the Younger, German art reached heights such as it had not seen since the days of the sculptors of Strassburg, Bamberg, and Naumburg, and was not to see ever after. But whereas Grünewald's immediate impact was restricted to a relatively small area and a very short period, and Holbein's, though of much greater radiation in space and time, was still mostly limited to Germany and England, Dürer's was universal, owing to his all-embracing activity and authority both as an artist and as a writer, to his travels in Italy and the Netherlands, and to the easy transportability of his greatest works—his engravings and woodcuts.

The following excerpts from his family chronicle, letters, diaries, and theoretical writings are intended to illustrate the vastness of his scope, his insatiable curiosity, his steadfast endeavors to share his god-sent gifts and insights with all who were willing to partake in them, his modesty tempered by pride in high artistic standards, his religious sincerity, his civic responsibility, and his ingratiating sense of humor. His early fame and some plain good luck have collaborated in preserving for us a large number of his personal notes and letters; to his success as a theoretician and art teacher—a veritable praeceptor Germaniae, *indeed* praeceptor mundi—*he deliberately sacrificed endless hours of his creative life, with the result that generations have profited by his efforts and that his very language has contributed to the history of scientific German what Luther's contributed to the history of religious and didactic German. What he had borrowed from the Italians in his art and his writings—and it was a great debt indeed—he repaid to the world with interest.*

[9] Cf. *ibid.*, where he is mentioned as Henricus de Confluentia (Coblenz).
[10] "Fenestrarius": not "glazier" but the brother in charge of the "fenestra" through which the monastery communicates with the outside world.

Dürer: Biographical Writings

Late in his life, after Christmas 1523, Dürer put down in writing what he remembered about his ancestors, relatives, and the main events of his early life.[1] This chronicle, which remained a fragment covering only a small portion of its author's life, answers only a fraction of our questions even concerning the period which is covered by it; but it still is a cornerstone of our knowledge of the writer's life, mind, and heart.

In the year 1524 [2] after Christmas, in Nuremberg, I, Albrecht Dürer the younger, have put together from my father's papers the facts as to whence he was, how he came hither, lived here, and drew to a happy end. God be gracious to him and us! Amen.

Like his relatives, Albrecht Dürer the elder was born in the kingdom of Hungary, in a village named Eytas,[3] situated not far from a little town called Jula,[4] eight miles below Wardein; [5] and his kindred made their living from horses and cattle. My father's father was called Anton Dürer; he came as a lad to a goldsmith in the said little town and learnt the craft under him. He afterward married a girl named Elisabeth, who bare him a daughter, Katharina, and three sons. The first son he named Albrecht; he was my dear father. He too became a goldsmith, a pure and skillful man. The second son he called Lasslen; [6] he was a saddler. His son is my cousin Niklas Dürer, called Niklas the Hungarian, who is settled at Cologne.[7] He also is a goldsmith and learnt the craft here at Nuremberg with my father. The third son he called John. Him he set to study and he afterward became parson at Wardein, and continued there more than thirty years.

After that, Albrecht Dürer, my dear father, came to Germany. He was a long time with the great artists in the Netherlands. At last he came hither to Nuremberg in the year, as reckoned from the birth of Christ, 1455, on St. Eloy's day [June 25].[8] And on the same day Philip Pirkheimer had his marriage feast at the Veste, and there was a great dance under the big lime tree. For a long time after that, my dear father,

[1] In the translation by Conway, pp. 34 ff., with a few emendations.

[2] I.e., 1523. The New Year was then reckoned as of Christmas; Dürer wrote this passage late in December of 1523 (E. Flechsig, *Albrecht Dürer*, I [Berlin 1928], p. 4.

[3] Ajtos. Ajto means "door," in German "Tür"; cf. "Dürer" and the "door" of his monogram.

[4] Gyula.

[5] Grosswardein (Nagyvarad, Oradea Mare).

[6] Ladislaus (László).

[7] Lived in Nuremberg, 1481–ca. 1500. Dürer visited him in Cologne in 1520.

[8] He is first mentioned at Nuremberg as early as 1444, perhaps as an apprentice.

Albrecht Dürer, served my grandfather, old Hieronymus Holper,[9] till the year reckoned 1467 after the birth of Christ. My grandfather then gave him his daughter, a pretty upright girl, fifteen years old, named Barbara; [10] and he was wedded to her eight days before St. Vitus [June 8].[11] It may also be mentioned that my grandmother, my mother's mother, was the daughter of Oellinger of Weissenburg, and her name was Kunigunde.

And my dear father had by his marriage with my dear mother the following children born—which I set down here word for word as he wrote it in his book—[18 children, among them:]

3. *Item*, in the year 1471 after the birth of Christ, in the sixth hour of the day, on S. Prudentia's day, a Tuesday on Passion Week [May 21], my wife bare me my second son. His godfather was Anton Koburger,[12] and he named him Albrecht after me. . . .

All these, my brothers and sisters, my dear father's children, are now dead, some in their childhood, others as they were growing up; only we three brothers still live, so long as God will, namely: I, Albrecht, and my brother Endres,[13] and my brother Hans,[14] the third of the name, my father's children.

This Albrecht Dürer the elder passed his life in great toil and stern, hard labor, having nothing for his support save what he earned with his hand for himself, his wife, and his children; so that he had little enough. He underwent moreover manifold afflictions, trials, and adversities. But he won just praise from all who knew him, for he lived an honorable, Christian life, was a man patient of spirit, mild and peaceable to all, and very thankful toward God. For himself he had little need of company and worldly pleasures; he was also of few words and was a God-fearing man.

This man, my dear father, was very careful with his children to bring them up in the fear of God; for it was his highest wish to train them well that they might be pleasing in the sight both of God and man. Wherefore his daily speech to us was that we should love God and deal truly with our neighbors.

And my father took special pleasure in me because he saw that I was diligent in striving to learn. So he sent me to the school, and when

[9] Goldsmith, active in Nuremberg from 1435.
[10] 1452–1514. See Dürer's drawing of her, Winkler 559.
[11] Rupprich's "6. August" is a misprint.
[12] Or Koberger; the famous Nuremberg publisher.
[13] Andreas Dürer (1484–1555), goldsmith in Nuremberg, master in 1514. On his portraits, drawn by Albrecht Dürer, see E. Panofsky in *Master Drawings*, I (1963), pp. 35 ff.
[14] Hans Dürer (1490–ca. 1538), painter and printmaker, after ca. 1525 Polish court painter in Cracow. On his portrait see E. Panofsky, *ibid.*

I had learnt to read and write he took me away from it, and taught me the goldsmith's craft. But when I could work neatly my liking drew me rather to painting than goldsmith's work, so I laid it before my father; but he was not well pleased, regretting the time lost while I had been learning to be a goldsmith. Still he let it be as I wished, and in 1486 (reckoned from the birth of Christ) on S. Andrew's day [November 30] my father bound me apprentice to Michael Wolgemut,[15] to serve him three years long. During that time God gave me diligence so that I learnt well, but I had much to suffer from his lads. When I had finished my learning, my father sent me off, and I stayed away four years till he called me back again.[16] As I had gone forth in the year 1490 after Easter, so now I came back again in 1494, as it is reckoned, after Whitsuntide. And when I returned home Hans Frey treated with my father, and gave me his daughter, Mistress Agnes by name,[17] and with her he gave me 200 florins, and we were wedded; it was on Monday before Margaret's Day [July 7] in the year 1494. . . .

The ten surviving letters (dated between January 6 and October, 1506) which Dürer addressed to his intimate friend Willibald Pirckheimer, the Nuremberg humanist, from Venice during his second stay in that city (fall 1505 to spring 1507) belong to the most precious documents from any era.[1] Dürer, already a European celebrity as a printmaker, now established himself as a great painter among the "peintres les plus peintres" of Europe. His observations on the Venetians in general and on his fellow painters in particular, his continued care for mother and brother, and his humorous banter with Pirckheimer enliven reports on his own activities which are of decisive value to us. Here he deals with such matters as the progress of his main painting, the Feast of the Rosary; the comparison of his present impressions with those received during his first stay in the city eleven years previous; the trip to Bologna in search of ever greater enlightenment on perspective.

[VENICE, FEBRUARY 7, 1506]

First, my willing service to you, dear Sir. If things are going well with you I am glad with my whole heart for you as I should be for myself. I recently wrote to you and hope that the letter reached you. In the meantime my mother has written to me, scolding me for not writing to you; and she has given me to understand that you hold me in displeasure because I do not write to you. She said I must apologize

15 1434–1519; Dürer painted his portrait in 1516 (Nuremberg).

16 The customary "bachelor's journey" which took Dürer (after a visit to the Netherlands?) to Kolmar, Strassburg, and Basel.

17 Agnes Dürer (ca. 1475–1539). On her portraits by Dürer see G. Pauli in *Zeitschrift für bildende Kunst,* XXVI (1915), 69 ff.

1 In the translation by Conway (pp. 48 f., 51, 55, and 58) with some emendations by E. Panofsky (Holt, I, 330 ff.) and myself.

to you most seriously and she takes it very much to heart, as her way is.

Now I don't know what excuse to make except that I am lazy about writing, and that you have not been at home. But as soon as I heard that you were either at home or intended to come home, I wrote to you at once; after that I also very specially charged Kastell [2] to convey my service to you. So I humbly pray you to forgive me, for I have no other friend on earth but you. I don't believe, however, that you are angry with me, for I regard you in no other light than as a father.

I wish you were here at Venice! There are so many nice fellows among the Italians who seek my company more and more every day— so that it warms one's heart—wise scholars, good lute-players, pipers, connoisseurs of painting, and many noble minds, true models of virtue; and they show me much honor and friendship. On the other hand, there are also amongst them some of the most false, lying, thievish rascals, the like of which I should not have believed lived on earth. If one did not know them, one would think them the nicest men the earth could show. For my part I cannot help laughing at them whenever they talk to me. They know that their knavery is no secret but they don't care.

Amongst the Italians I have many good friends who warn me not to eat and drink with their painters. Many of them are my enemies and they copy my work in the churches and wherever they find it; and then they revile it and say it was not in the *antique* manner and therefore not good. Sambelling,[3] however, has highly praised me before many nobles. He wanted to have something of mine, and himself came to me and asked me to paint him something and he would pay well for it. And all men tell me what a God-fearing man he is, so that I am equally well disposed toward him.[4] And those works of art which so pleased me eleven years ago please me no longer; if I had not seen it for myself I should not have believed it from anyone else. You must know too that there are many better painters here than Master Jacob [5] abroad, yet Anton Kolb would swear an oath that no better painter lives on earth than Jacob. The others sneer at him, saying: "If he were good he would stay here," etc.

I have only today begun to sketch in my picture,[6] for my hands were so scabby that I could do no work, but I have got it cured.

Now be lenient with me and don't get in a passion so easily. Be gentle like me; you will not learn from me, I don't know why that is.

[2] Castulus Fugger, representative of the Fugger business in Nuremberg.

[3] Giovanni Bellini.

[4] "Dass ich ihm gleich günstig bin." Conway: "really friendly"; Panofsky: "well disposed from the outset." But "gleich" is more likely to be the equivalent of "equally" than of "at once."

[5] Jacopo de' Barbari.

[6] The "Feast of the Rose Garlands," painted for the main altar of the German colony.

My friend! I should like to know if any of your mistresses has died—
that one close by the water, for instance, or the one like [sketch of a rose],
or [duster], or the [running dog] girl,[7] so that you might supply her
place with another.

Given at Venice at the ninth hour of the night, on Saturday after
Candlemass in the year 1506.

Give my service to Steffen Pawmgartner [8] and to Masters Hans
Harstorfer [9] and Folkamer.[10]

ALBRECHT DÜRER

[VENICE, APRIL 2, 1506]

. . . The painters here, let me tell you, are very unfriendly to me.
They have summoned me three times before the magistrates and I have
had to pay four florins into their treasury.[11] You must also know that I
might have gained a great deal of money if I had not undertaken to paint
the German picture.[12] There is much work in it and I cannot get it quite
finished before Whitsuntide. Yet they only pay me eighty-five ducats for
it, which as you know is no more than is easily spent on living, and then
I have bought some things and sent some money away, so that I have
not much before me now. But don't misunderstand me, I am firmly
purposed not to go away hence till God enables me to repay you with
thanks and to have a hundred florins over besides. I should easily earn
this if I had not got the German picture to paint, for all men except the
painters wish me well.

Tell my mother to speak to Wolgemut about my brother [13] and to
ask him whether he can make use of him and give him work till I come,
or whether he can put him with someone else. I should gladly have
brought him with me to Venice, and that would have been useful both
to me and him, and he would have learnt the language, but my mother
was afraid that the sky would fall on him or such. Pray keep an eye on
him yourself, the women are no use for that. Tell the lad, as you so well
can, to be studious and honest till I come, and not to be a trouble to his
mother; I cannot arrange everything but I shall do all that I can. Alone
I certainly should not starve, but to support many is too hard for me,
for no one throws his money away. . . .

[7] Rose, duster, and running dog stand for names of Pirckheimer's mis-
tresses.

[8] Stephan Paumgärtner, represented as St. Eustace on Dürer's Paum-
gärtner Altarpiece of ca. 1502–1504, now in Munich.

[9] Hans Harsdörfer, member of the Nuremberg Council.

[10] Probably Stephan Volckamer, member of the Nuremberg Council.

[11] Schull = scuola = guild chest.

[12] See note 6, above.

[13] Hans Dürer; see above, p. 87.

[VENICE, SEPTEMBER 8, 1506]

. . . My picture,[14] if you must know, says it would give a ducat for you to see it; it is well painted and beautifully colored. I have earned much praise but little profit by it. In the time it took to paint it I could easily have earned two hundred ducats, and now I have declined much work, in order that I may come home. I have stopped the mouths of all the painters who used to say that I was good at engraving but, as to painting, I did not know how to handle my colors. Now everyone says that better coloring they have never seen. . . .

[VENICE, OCTOBER 13(?), 1506]

. . . In reply to your question when I shall come home, I tell you, so that my lords [15] may also make their arrangements, that I shall have finished here in ten days; after that I should like to ride to Bologna to learn the secrets of the art of perspective, which a man [16] is willing to teach me. I should stay there eight or ten days and then return to Venice. After that I shall come with the next messenger.[17] Oh, how I shall long for the sun! [18] Here I am a gentleman, at home only a parasite. . . .

The "Heller Altarpiece" was Dürer's most ambitious undertaking of the year 1508, and the letters [1] which the painter wrote to his patron, the Frankfurt merchant Jacob Heller, provide us with more exact and more precious insights into its commission and preparation than we have regarding any other work of this magnitude from the same period and region, even though the letters which Heller wrote to Dürer and which provoked the painter's magnificent and epoch-making self-assertion before his patron have not survived. The central panel of the altarpiece, the only part executed by Dürer entirely with his own hand, represented a brilliant synthesis of Assumption and Coronation of Mary; it perished in a Munich fire in 1729 and is known to us only from a 17th-century copy (Jobst Harrich, 1615). The folding wings, executed in Dürer's workshop, were supplemented a few years later by fixed wings painted by "Matthias Grünewald" (now in the Frankfurt and Donaueschingen Museums).

[14] See note 6, above.

[15] The members of the Nuremberg senate.

[16] Hypothetically identified with Luca Pacioli and Bramante.

[17] But he was still in Venice early in 1507, when he bought a copy of Euclid's *Elements of Geometry* in the 1505 edition.

[18] A proverbial expression meaning approximately: "Oh, how I shall wish myself back here!"

[1] In the translation by Conway (pp. 65 ff.) with some emendations by E. Panofsky (Holt, I, 332 ff.) and myself.

[Nuremberg, August 24, 1508]

Dear Herr Heller,

I have safely received your last[2] letter, and I gather from it that you wish me to execute your panel well, which is just what I myself have in mind to do. In addition, you shall know how far it has got on; the wings have been painted in stone colors on the outside, but they are not yet varnished; inside they are wholly underpainted, so that one[3] can begin to carry them out.

The middle panel I have outlined with the greatest care and at cost of much time; it is also coated with two very good colors upon which I can begin to underpaint it. For I intend, as soon as I hear that you approve, to underpaint it some four, five, or six times over, for clearness' and durability's sake, and to use the very best ultramarine for the painting that I can get. And no one shall paint a stroke on it except myself, wherefore I shall spend much time on it. I therefore assume that you will not mind, and have decided to write you my proposed plan of work, [but I must add] that I cannot without loss carry out said work [in such elaborate fashion] for the fee of 130 Rhenish florins; for I must spend much money and lose time over it. However, what I have promised you I will honorably perform: if you don't want the picture to cost more than the price agreed, I will paint it in such a way that it will still be worth much more than you paid for it. If, however, you will give me two hundred florins I will follow out my plan of work. Though if hereafter somebody was to offer me four hundred florins I would not paint another, for I shall not gain a penny over it, as a long time is spent on it. So let me know your intention and when I have heard it I will go to the Imhoffs[4] for fifty florins, for I have as yet received no money on the work.

Now I commend myself to you. I want you also to know that in all my days I have never begun any work that pleased me better than this picture of yours which I am painting. Till I finish it I will not do any other work; I am only sorry that the winter will so soon come upon us. The days grow so short that one cannot do much.

I have still one thing to ask you; it is about the Madonna that you saw at my house; if you know of any one near you who wants a picture pray offer it to him. If a proper frame was put to it, it would be a beautiful picture, and you know that it is nicely done. I will let you have it cheap. If I had to paint it for someone,[5] I would not take less than fifty florins. But as it is already done it might be damaged in the house. So

[2] "Nehren" means "last," not "last but one." (See Rupprich.)

[3] "Man" refers to the "impersonal" execution by assistants which is what actually came to pass (Panofsky).

[4] Great bankers in Nuremberg. See above under Adam Kraft, p. 81.

[5] I.e., on commission.

I would give you full power to sell it for me cheap for thirty florins; indeed, rather than that it should not be sold I would even let it go for twenty-five florins. I have certainly lost much food over it.

Many good nights. Given at Nuremberg on Bartholomew's day 1508.

ALBRECHT DÜRER

[NUREMBERG, NOVEMBER 4, 1508]

DEAR HERR JACOB HELLER,

Recently I wrote you my candid and sincere opinion and you have angrily complained of it to my kinsman, declaring that I twist my words. I have likewise since received your letter from Hans Imhoff. I am justly surprised at what you say in it about my last letter, seeing that you can accuse me of not holding to my promises to you. From such a slander each and everyone exempts me, for I bear myself, I trust, so as to take my stand amongst other straightforward men. Besides I know well what I have written and promised to you, and you know that in my cousin's house I refused to promise you to make a good thing, because I cannot. But to this I did pledge myself: that I would make something for you that not many men can. Now I have given such exceeding pains to your picture, that I was led to send you the aforesaid letter. I know that when the picture is finished all artists will be well pleased with it. It will not be valued at less than three hundred florins. I would not paint another like it for three times the price agreed, for I neglect myself for it, suffer loss, and earn anything but thanks from you.

I am using, let me tell you, quite the finest colors I can get. Of ultramarine I shall want twenty ducats' worth alone, not counting the other expenses. When the picture is once finished, I am quite sure that you yourself will say that anything more beautiful you have never seen; and I dare not expect from beginning to end to finish the painting of the middle panel in less than thirteen months. I shall not begin any other work till it is finished, though it will be much to my hurt. Then what do you suppose my expenses will be while I am working at it? You would not undertake to keep me for that time for two hundred florins. Only think what you have repeatedly written about the materials. If you wanted to buy a pound of ultramarine you would hardly get it for one hundred florins, for I cannot buy an ounce of it good for less than ten or twelve ducats.

And so, dear Herr Jacob Heller, my writing is not so utterly unreasonable as you think, and I have not broken my promise in this matter.

You further reproach me with having promised you that I would paint your picture with the greatest possible care that I ever could. That I certainly never said unless I was out of my senses, for in my whole life-

time I should scarcely finish it. With such extraordinary care I can hardly finish a face in half a year; now your picture contains fully one hundred faces, not reckoning the drapery and landscape and other things in it. Besides, who ever heard of making such a work for an altarpiece? No one could see it. But I think it was thus that I wrote to you—that I would paint the picture with great or more than ordinary pains because of the time which you waited for me.

Besides, knowing you as I do, I feel sure that if I had promised you to do something which you saw yourself would be to my loss, you would not desire its fulfilment. Nevertheless—act in the matter as you will—I will still hold to what I have promised you; for as far as I ever can I will live honestly with everyone. If, however, I had not made you a promise I know what I would do. But I have felt obliged to answer you that you may not think I have not read your letter. I hope when once you see the finished picture, all will come better. So be patient, for the days are short, and this affair as you know admits of no haste, for there is much work in it and I will not make it less. I rest my hopes on the promise which you made to my kinsman [6] at Frankfurt.

You need not look about for a purchaser for my Madonna, for the Bishop of Breslau has given me seventy-two florins for it, so I have sold it well. I commend myself to you. Given at Nuremberg in the year 1508 on the Sunday after All Saints' Day.

ALBRECHT DÜRER

Dürer's deep attachment to Luther, which shortly later led to the great outburst in his Netherlandish diary (p. 103), was first beautifully voiced in the letter he wrote to his friend Georg Spalatin (1484–1545),[1] private secretary and chaplain to the Elector Frederick the Wise of Saxony, early in 1520. Here he also mentions the cessation of payments of his pension, his main practical reason for embarking on the Netherlandish journey a few months later.

MOST WORTHY AND DEAR MASTER,

I have already sent you my thanks in the short letter, for then I had only read your brief note. It was not till afterward, when the bag in which the little book was wrapped was turned inside out, that I for the first time found the real letter in it, and learnt that it was my most

[6] The word used by Dürer here (and in the first sentence of this letter) is "Schwager," which literally means "brother-in-law" but—as Dürer had no brother-in-law, strictly speaking—could also be interpreted as "kinsman" in a wider sense or even as "colleague" and, therefore, as Rupprich has tentatively suggested, as referring to Martin Kaldenbach or to Matthias Grünewald, who was to add a pair of wings to the Heller Altarpiece.

[1] In the translation by Conway (p. 89), with a few emendations.

gracious Lord himself [2] who sent me Luther's little book.[3] So I pray your worthiness to convey most emphatically my humble thanks to his Electoral Grace, and in all humility to beseech his Electoral Grace to take the praiseworthy Dr. Martin Luther under his protection for the sake of Christian truth. For that is of more importance to us than all the riches and power of this world, because all things pass away with time. Truth alone endures for ever.

God helping me, if ever I meet Dr. Martin Luther, I intend to draw a careful portrait of him from the life and to engrave it on copper, for a lasting remembrance of a Christian man who helped me out of great distress. And I beg your worthiness to send me for my money anything new that Dr. Martin may write in German.

As to Spengler's "Apology for Luther" [4] about which you write, I must tell you that no more copies are in stock; but it is being reprinted at Augsburg, and I will send you some copies as soon as they are ready. But you must know that, though the book was printed here, it is condemned in the pulpit as heretical and meet to be burnt, and the man who published it anonymously is abused and defamed. It is reported that Dr. Eck [5] wanted to burn it in public at Ingolstadt, as was once done to Dr. Reuchlin's book.[6]

With this letter I send for my most gracious lord three impressions of a portrait print of my most gracious lord of Mainz, which I engraved at his request.[7] I sent the copper plate with two hundred impressions as a present to his Electoral Grace, and he graciously sent me in return two hundred florins in gold and twenty ells of damask for a coat. I joyfully and thankfully accepted them, especially as I was in want of them at that time.

His Imperial Majesty,[8] of praiseworthy memory, who died too soon for me, also had graciously made provision for me, because of the great and long-continued labor, pains, and care which I spent in his service. But now the Council will no longer pay me the one hundred florins which I was to have received every year of my life from the town taxes, and which was yearly paid to me during his Majesty's lifetime.[9] So I am to be deprived of it in my old age and to see the long time, trouble, and labor all lost which I spent for his Imperial Majesty. As I am losing my sight

[2] Frederick III (The Wise), Elector of Saxony.

[3] Unidentified.

[4] Lazarus Spengler, *Schutzred und christliche Antwort* . . . , 1519.

[5] Dr. Johannes Eck, famous antagonist of Luther, professor of theology at Ingolstadt.

[6] The "Augenspiegel" by Johann Reuchlin was burnt in Cologne in 1514.

[7] Cardinal Albrecht of Brandenburg, Bartsch 102.

[8] Maximilian I, died 1519.

[9] This pension was restored on order of Charles V upon Dürer's solicitation in Cologne, November 12, 1520.

and freedom of hand my affairs do not look well. I don't care to with-
hold this from you, kind and trusted Sir.

If my gracious lord remembers his debt to me of the stag-horns, may
I ask your Worship to keep him in mind of them, so that I may get a fine
pair. I shall make two candlesticks of them.[10]

I send you here two little prints of the Cross from a plate engraved
in gold.[11] One is for your Worship. Give my service to Hirschfeld [12] and
Albrecht Waldner. Now, your Worship, commend me faithfully to my
most gracious lord, the Elector.

<div align="right">Your willing ALBRECHT DÜRER at Nuremberg</div>

*The external reason for Dürer's Netherlandish Journey was his
wish to receive the new Emperor's personal guarantee of payment of the
pension granted him by Maximilian but suspended after the latter's
death (see above, p. 95). However, it is clear that Dürer also saw another
purpose for this undertaking from the very beginning; he envisaged it
as an opportunity for an artistic and a general personal rejuvenation—
which, indeed, it turned out to be. His princely reception by his Nether-
landish fellow artists became the background for a renewed confronta-
tion with the Italian Renaissance—partly through direct contact with
Italians and Italian works of art, partly through the connection with
recent Netherlandish adaptations of the Italian mode—and this was to
be of decisive importance for the last phase of Dürer's art. The great
outburst caused by the false news of Luther's abduction by his enemies
is the greatest testimony to Dürer's innermost conviction we possess; his
descriptions of people and towns, of ceremonies and sightseeing tours, of
portrait sittings and distribution of his prints, large and small expenses,
together with the wonderful drawings that have survived, have given
this diary [1] the status of a classic. Dürer, accompanied by his wife, left
Nuremberg on July 12, 1520, and returned there early in August 1521.*

<div align="right">[AUGUST 5, 1520]</div>

. . . On Sunday, it was St. Oswald's day, the painters [of Antwerp]
invited me to their rooms, with my wife and maid. All their service was
of silver, and they had other splendid ornaments and costly meats. All
their wives were also there. And as I was being led to the table the
company stood on both sides as if they were leading some great lord.
And there were amongst them men of very high position, who all be-

10 Sketches for such a design have survived (Winkler 708 and 709).
11 The "Little Crucifixion," printed from a gold plate, Bartsch 23.
12 Bernhard von Hirschfeld, head chamberlain of Elector Frederick III.
1 In the translation by Conway (pp. 92 ff. and 158 f.), with some emenda-
tions by E. Panofsky (Holt, I, 336 ff.) and myself. The notes are much indebted
to Conway and Rupprich.

haved most respectfully toward me with deep bows, and promised to do everything in their power agreeable to me that they knew of. And as I was sitting there in such honor the Syndic,[2] the town councillor of Antwerp, came, with two servants, and presented me with four cans of wine in the name of the Town Councillors of Antwerp, and they had bidden him to say that they wished thereby to show their respect for me and to assure me of their good will. Wherefore I returned them my humble thanks and offered my humble service. After that came Master Peeter,[3] the town master carpenter, and presented me with two cans of wine, with the offer of his willing services. So when we had spent a long and merry time together till late in the night, they accompanied us home with lanterns in great honor. And they begged me to be ever assured and confident of their good will, and promised that in whatever I did they would be all helpful to me. So I thanked them and laid me down to sleep.

I have also been in Master Quentin's [4] house and also to their three great shooting places. I had a delicious meal with Staiber [5] and another time with the Portuguese Factor [6] whose portrait I drew in charcoal. Of my host, Jobst Plankfelt, I have also made a portrait; [7] he gave me a branch of white coral. Paid two stivers for butter, two stivers to the joiner at the Painters' warehouse.[8] My host took me to the workshop in the Painters' warehouse in Antwerp, where they are making the Triumphal Decorations through which King Karl is to make his entry. They are four hundred arches long, and each is forty feet wide. They are to be set up along both sides of the street, handsomely ordered, and two stories high. The plays are to be acted on them. To have this made by the Painters and the Joiners will cost four thousand florins. In addition all this will be fully draped, and the whole work is very splendidly done.

I have dined again with the Portuguese and also once with Alexander im Hoff.[9] Item, Sebald Fischer [10] bought of me at Antwerp sixteen small Passions for four florins, further thirty-two of the Large Books [11] for eight florins, further six engraved Passions for three florins, further half-sheets,[12] twenty of all kinds mixed together at one florin; of these he took three florins' worth. Further quarter-sheets—forty-five of all kinds

2 Adriaen Herbouts (not Horebouts).

3 Pieter Teels, also a sculptor.

4 Quentin Massys.

5 Lorenz Staiber, Nuremberg organist, on his way to England where he was to be knighted by Henry VIII.

6 João Brandão (Brandon), Portuguese Consul.

7 Drawing now in the Städel'sche Kunstinstitut in Frankfurt (Winkler 747). The portrait of his wife now in the Toledo (Ohio) Museum.

8 The "Eekhof."

9 Imhoff; Nuremberg family, see above, pp. 81 and 92.

10 Unknown.

11 Apocalypse, Large Passion, and Life of Mary.

12 Individual prints of this size.

at one florin—for five and one quarter florins; and whole-sheets—eight of all kinds taken together for one florin—for five and one quarter florins. I have sold my host a Madonna painted on a small canvas for two florins Rhenish. I took the portrait of Felix Hungersberg, the lute-player,[13] for the second time. Paid one stiver for pears and bread, two stivers to the barber. I also paid fourteen stivers for three small panels, besides four stivers for laying the white ground and preparing the same. Further, I dined with Alexander, the goldsmith,[14] and once more with Felix. Master Joachim[15] has once dined with me, and his apprentice once. I made a drawing in half-colors for the painters. I have taken one florin for expenses. I gave the four new little pieces[16] to Peter Wolfgang. Master Joachim's assistant has again dined with me. I gave Master Joachim one florin's worth of prints for lending me his assistant and his colors, and I gave his assistant three pounds' worth of prints. I have sent Alexander the goldsmith the four new pieces. I made portraits in charcoal of these Genoese: Tomasin Florianus Romanus native of Lucca,[17] and Tomasin's two brothers Vincentius and Gerhard by name, all three Bombelli. I have dined with Tomasin thus often jjjjjjjjjjjjj. The treasurer[18] also gave me a child's head painted on linen, and a wooden weapon from Calicut, and one of the light wood reeds. Tomasin too has given me a plaited hat of alder bark. I dined once with the Portuguese, and have given a brother of Tomasin's three florins' worth of engravings. Herr Erasmus[19] has given me a small Spanish "mantilla" and three men's portraits. Tomasin's brother gave me a pair of gloves. I have once more taken the portrait of Tomasin's brother Vincentius, and I gave Master Augustin Lumbarth[20] the two parts of the *"Imagines."*[21] I also took a portrait of the crooked-nosed Italian named Opitius. My wife and maid dined one day at Master Tomasin's house; that makes four meals.

The Church of our Lady at Antwerp is so very large that many masses are sung in it at one time without interfering with each other. They have wealthy endowments there,[22] so the best musicians are employed that can be had. The church has many devout services, much stone work, and in particular a beautiful tower. I have also been in the rich Abbey of St. Michael.[23] There are the most splendid galleries of

[13] Drawing in the Albertina, Vienna, Winkler 749.

[14] Perhaps Alexander van Brugsal.

[15] Joachim Patenier.

[16] Recent engravings.

[17] Tomaso Bombelli, an Antwerp silk merchant.

[18] Lorenz Sterck, later painted by Dürer (Gardner Museum, Boston), was tax collector of Brabant in the Antwerp district.

[19] Erasmus of Rotterdam came to Brussels on August 27, 1520; he stayed in Antwerp with Petrus Aegidius.

[20] Agostino (Lombard) Scarpinello, secretary to Bishop Marliano of Milan.

[21] The celestial maps, woodcuts B. 151 and 152.

[22] "Alldar" means "there," not "altar," as Conway has it.

[23] There is a view of this church in the portrait drawing, Winkler 769.

sculptured stone work I have ever seen; also costly stalls in their choir. But at Antwerp they spare no cost on such things, for there is money enough.

I took the portrait of Herr Niclas Kratzer, an astronomer.[24] He lives with the King of England, and has been very helpful and useful to me in many matters. He is a German, a native of Munich. I also made the portrait of Tomasin's daughter, Mistress Suten [25] by name. Hans Pfaffroth [26] gave me one Philips florin for taking his portrait in charcoal. I have dined once more with Tomasin. My host's brother-in-law entertained me and my wife once. I changed two light florins for twenty-four stivers for living expenses, and I gave one stiver *trinkgeld* to a man who let me see an altarpiece.

[AUGUST 19, 1520]

On the Sunday after our dear Lady's Assumption I saw the great Procession from the Church of Our Lady at Antwerp, when the whole town of every craft and rank was assembled, each dressed in his best according to his rank. And all ranks and guilds had their signs, by which they might be known. In the intervals great costly pole-candles were borne, and their long old Frankish trumpets of silver. There were also in the German fashion many pipers and drummers. All the instruments were loudly and noisily blown and beaten.

I saw the Procession pass along the street, the people being arranged in rows, each man some distance from his neighbor, but the rows close one behind another. There were the goldsmiths, the painters, the masons, the embroiderers, the sculptors, the joiners, the carpenters, the sailors, the fishermen, the butchers, the leatherers, the clothmakers, the bakers, the tailors, the shoemakers—indeed, workmen of all kinds, and many craftsmen and dealers who work for their livelihood. Likewise the shopkeepers and merchants and their assistants of all kinds were there. After these came the shooters with guns, bows, and crossbows and the horsemen and foot-soldiers also. Then followed the watch of the Lords Magistrates. Then came a fine troop all in red, nobly and splendidly clad. Before them, however, went all the religious orders and the members of some Foundations very devoutly, all in their different robes. A very large company of widows also took part in this procession. They support themselves with their own hands and observe a special rule. They were all dressed from head to foot in white linen garments, made expressly

[24] A letter written by him to Dürer on August 24, 1524, from London has been preserved (translated by Conway, p. 28). The portrait here mentioned may be Winkler 808. Holbein also painted a portrait of him (Louvre).

[25] Netherlandish: Zoete, Zoetje (the little sweet one).

[26] He worked for the Portuguese Consul in Danzig; the portrait is Winkler 748.

for the occasion, very touching to see. Among them I saw some very stately persons. Last of all came the Chapter of Our Lady's Church with all their clergy, scholars, and treasurers. Twenty persons bore the image of the Virgin Mary with the Lord Jesus, adorned in the costliest manner, to the honor of the Lord God. In this procession very many delightful things were shown, most splendidly got up. Wagons were drawn along with masques upon ships and other wooden structures. Behind them came the company of the Prophets in their order and scenes from the New Testament, such as the Annunciation, the Three Holy Kings riding on great camels and on other rare beasts, very well arranged; also how Our Lady fled to Egypt—very devout—and many other things, which for shortness I omit. At the end came a great Dragon with St. Margaret and her maidens led by a girdle; she was especially beautiful. Behind her came St. George with his squires, a very goodly knight in armor. In this host also rode boys and maidens most finely and splendidly dressed in the costumes of many lands, representing various Saints. From beginning to end the Procession lasted more than two hours before it was gone past our house. And so many things were there that I could never write them all in a book, so I let it well alone. . . .

[AUGUST 27, 1520]

In the golden chamber in the Townhall at Brussels I saw the four paintings which the great Master Rudier [27] made. And I saw out behind the King's house at Brussels the fountains, labyrinth, and Beastgarden; anything more beautiful and pleasing to me and more like Paradise I have never seen. Erasmus [28] is the name of the little man who wrote out my supplication at Herr Jacob de Bannisis' house. At Brussels is a very splendid Townhall, large, and covered with beautiful carved stonework, and it has a noble, open tower. I took a portrait at night by candlelight of a Master Konrad of Brussels,[29] who was my host; I drew at the same time Doctor Lamparter's son [30] in charcoal; also the hostess.

I saw the things which have been brought to the King from the new land of gold,[31] a sun all of gold a whole fathom broad, and a moon all of silver of the same size, also two rooms full of the armor of the people there, and all manner of wondrous weapons of theirs, harness and darts, wonderful shields,[32] strange clothing, bedspreads, and all kinds of wonderful objects of various uses, much more beautiful to behold

[27] Roger van der Weyden; see above, p. 9.
[28] Erasmus Strenberger, secretary to Jacob de Bonisius, who had been secretary to Emperor Maximilian, wrote Dürer's petition to Charles V concerning the pension.
[29] This is not Konrad Meit.
[30] Johannes Lamparter; his father, Gregor, was imperial councillor.
[31] Mexico.
[32] "Wahr" here stands for "Wehr" (shields).

than prodigies. These things were all so precious that they have been valued at one hundred thousand florins. All the days of my life I have seen nothing that has gladdened my heart so much as these things, for I saw amongst them wonderful works of art, and I marveled at the subtle *Ingenia* of men in foreign lands. Indeed, I cannot express all that I thought there. At Brussels I saw many other beautiful things besides, and especially I saw a fish bone there, as vast as if it had been built up of squared stones. It was a fathom long and very thick, it weighs up to fifteen centner, and its form resembles that drawn here.[33] It stood up behind on the fish's head. I was also in the Count of Nassau's [34] house which is very splendidly built and as beautifully adorned. I have again dined with my Lords.[35]

Lady Margaret sent after me to Brussels and promised to speak for me to King Karl, and she has shown herself quite exceptionally kind to me. I sent her my engraved *Passion* and another copy to her treasurer, Jan Marnix by name, and I took his portrait in charcoal.[36] I gave two stivers for a buffalo ring; also two stivers for opening St. Luke's picture.[37] When I was in the Nassau house in the chapel there, I saw the good picture that Master Hugo painted,[38] and I saw the two fine large halls and treasures everywhere in the house, also the great bed wherein fifty men can lie.[39] And I saw the great stone which the storm cast down in the field near the Lord of Nassau. The house stands high, and from it there is a most beautiful view, at which one cannot but wonder; and I do not believe that in all the German lands the like of it exists.

Master Bernhart, the painter,[40] invited me and prepared so costly a meal that I do not think ten florins will pay for it. . . .

[SEPTEMBER 3, 1520]

The works [41] of Raphael of Urbino have been scattered since his death, but one of his pupils, Thomas Polonier [42] by name, a good painter, desired to see me. So he came to me and has given me an antique gold

[33] A centner equals approximately 110 pounds. This drawing was not copied in either of the existing manuscripts of the diary.

[34] Hendrick III, tutor of Charles V, stadtholder of Holland, Zeeland, and Friesland. The house is reproduced in *L'Art,* I (1884), 188.

[35] The deputation sent by the City of Nuremberg for the Coronation.

[36] Unidentified.

[37] Possibly Roger van der Weyden's painting of St. Luke, now in Boston, then most probably in the chapel of the painters' guild. (See Colin Eisler, *Primitifs flamands, Corpus . . . I, 4, New England,* 1961, p. 86).

[38] The Seven Sacraments and a Crucifix by Hugo van der Goes, mentioned in an inventory of the Nassau House in 1618; now lost.

[39] When they were drunk.

[40] Bernard van Orley.

[41] "Ding" usually refers to works of art. Raphael died on April 6, 1520.

[42] Tommaso Vincidor of Bologna, sent there by Leo X to supervise the manufacture of the "second series" of Raphael's tapestries. He painted Dürer's portrait.

ring with a very well cut stone. It is worth five florins but already I
have been offered the double for it. In return I gave him six florins
worth of my best prints. . . .

[NOVEMBER 24, 1520]

At Zierikzee in Zeeland a whale has been stranded by a high tide
and a gale of wind.[43] It is much more than one hundred fathoms long
and no man living in Zeeland has seen one even a third as long as this is.
The fish cannot get off the land; the people would gladly see it gone,
as they fear the great stink, for it is so large that they say it could not be
cut in pieces and the blubber boiled down in half a year. . . .

[DECEMBER 10, 1520]

Early on Monday we started again by ship and went by Veere and
Zierikzee and tried to get sight of the great fish, but the tide had carried
him off again. . . .

[APRIL 7, 1521]

. . . When I reached Bruges Jan Prost [44] took me in to lodge in his
house and prepared the same night a costly meal and bade much com-
pany to meet me. Next day Marx, the goldsmith,[45] invited me and gave
me a costly meal and asked many to meet me. Afterward they took me to
see the Emperor's house [46] which is large and splendid. I saw the chapel [47]
there which Roger painted, and pictures by a great old master; I gave
one stiver to the man who opens up the place. Then I bought three
ivory combs for thirty stivers. They took me next to St Jacob's and
showed me the precious pictures by Roger and Hugo,[48] who were both
great masters. Then I saw in Our Lady's Church the alabaster Madonna,
made by Michelangelo of Rome.[49] After that they took me to many
churches and showed me all the good pictures, of which there is an

[43] Perennial attraction for artists of the 16th and 17th centuries; see
W. Timm, "Der gestrandete Wal, eine motivkundliche Studie," *Staatliche Museen
zu Berlin, Forschungen und Berichte,* III/IV (1961), 76 ff., and E. F. van der
Grinten, "Le cachalot et le mannequin," *Nederlands Kunsthistorisch Jaarboek,*
XIII (1962), 149 ff. It is probable that Dürer contracted a fatal case of malaria
during the Zeeland journey.
[44] Jan Provost.
[45] Marc de Glasere, goldsmith in the service of Margaret of Austria.
[46] The "Prinsenhof," palace of the Counts of Flanders, residence of the
Dukes of Burgundy.
[47] "Chapel" could mean "altarpiece." The Berlin replica of the "Granada"
triptych by Roger van der Weyden supposedly served as a traveling altarpiece
for Charles V.
[48] Hugo van der Goes; a Deposition from the Cross attributed to him
was in St. Jacob.
[49] Still there; made between 1501 and 1506.

abundance there; and when I had seen Jan's [50] and all the others' works, we came at last to the Painters' chapel, in which there are good things. . . .

[APRIL 10, 1521]

On Wednesday in the morning they took me to the Beffroi of St. John [51] [at Ghent] whence I looked over the great wonderful town, in which I had been taken for something great even before.[52] Then I saw Johannes' picture; [53] it is a most precious painting of high understanding, and the Eve, Mary, and God the Father are especially good. Next I saw the lions and drew one with the silver-point.[54] And I saw on the bridge where men are beheaded, the statues erected as a sign that there a son beheaded his father.[55] Ghent is a fine and wonderful town; four great waters flow through it. I gave the sexton and the lions' keeper three stivers *trinkgeld*. I saw many wonderful things in Ghent besides, and the painters with their Dean did not leave me alone, but they ate with me morning and evening and paid for everything and were very friendly to me. I gave away five stivers at the inn for refreshment. . . .

[MAY 17, 1521]

On Friday before Whitsunday in the year 1521, tidings came to me at Antwerp that Martin Luther had been so treacherously taken prisoner; [56] for he was escorted by Emperor Charles's herald with imperial safe-conduct and to him he was entrusted. But as soon as the herald had conveyed him to an unfriendly place near Eisenach he rode away, saying that he no longer needed him. Straightway there appeared ten horsemen and they treacherously carried off the pious man, betrayed into their hand, a man enlightened by the Holy Ghost, a follower of Christ and the true Christian faith. And whether he yet lives, or whether they have put him to death—which I know not—he has suffered this for the sake of Christian truth and because he rebuked the unchristian Papacy, which strives with its heavy load of human laws against the redemption of Christ; and because we are so robbed and stripped of our blood and sweat, and that the same is so shamefully and scandalously eaten up by idle-going folk, while the poor and the sick therefore die of hunger. But this is above all the most grievous to me, that, maybe, God will suffer us to remain still longer under their false, blind doctrine, invented and

50 Jan van Eyck.
51 Now St. Bavo.
52 "Gleich vor" probably means "even before" (I went there).
53 The Ghent Altarpiece.
54 Winkler 781 (see also 777 and 779).
55 In 1371.
56 On May 4th, Luther had been "abducted," upon his return from the Diet of Worms, by the men of Frederick the Wise of Saxony for his own safety.

drawn up by the men alone whom they call Fathers, by which also the precious Word of God is in many places wrongly expounded to us or not taught at all.

Oh God of heaven pity us! Oh Lord Jesus Christ pray for Thy people! Deliver us at the fit time, preserve in us the right, true Christian faith! Call together Thy far-scattered sheep by Thy voice, called in the Scripture Thy godly Word. Help us to know this Thy voice and to follow no other decoy, so that we, Lord Jesus Christ, may not fall away from Thee. Call together again the sheep of Thy pasture, who are still in part found in the Roman Church, and with them also the Indians, Muscovites, Russians, and Greeks, who have been torn from us by the oppression and avarice of the Pope and by false appearance of holiness. Oh God, redeem Thy poor people constrained by heavy ban and edict, which it nowise willingly obeys, continually to sin against its conscience if it disobeys them. Never, oh God, hast Thou so horribly burdened a people with human laws as us poor folk under the Roman Chair, who daily long to be free Christians, ransomed by Thy blood. Oh highest, heavenly Father, pour into our hearts, through Thy Son, Jesus Christ, such a light, that by it we may know what messenger we are bound to obey, so that with good conscience we may lay aside the burdens of others and serve Thee, eternal, heavenly Father, with happy and joyful hearts.

And if we have lost this man, who has written more clearly than any that has lived for 140 years, and to whom Thou hast given such a spirit of the Gospel, we pray Thee, oh heavenly Father, that Thou wouldst again give Thy Holy Spirit to one, that he may gather anew everywhere together Thy Holy Christian Church, that we may again live united [57] and in Christian manner, and so, by our good works, all unbelievers, as Turks, Heathen, and Calicuts, may of themselves turn to us and embrace the Christian faith. But, ere thou judgest, Oh Lord, Thou willest that, as Thy Son, Jesus Christ, had to die by the hands of the priests, and to rise from the dead and after to ascend up to heaven, so too in like manner it should be with Thy follower Martin Luther, whose death the Pope compasseth with his money, treacherously toward God. Him wilt Thou quicken again. And as Thou, oh my Lord, ordainest thereafter that Jerusalem should be destroyed for that sin, so wilt Thou also destroy this self-assumed authority of the Roman Chair. Oh Lord, give us then the new beautified Jerusalem, which descendeth out of heaven, whereof the Apocalypse writes, the holy, pure Gospel, which is not obscured by human doctrine.

May every man who reads Martin Luther's books see how clear and transparent is his doctrine, when he sets forth the Holy Gospel. Wherefore his books are to be held in great honor and not to be burnt;

[57] "Ein," meaning "united," not "free."

unless indeed his adversaries, who ever strive against the truth were cast also into the fire, together with all their Opinions [58] which would make gods out of men, provided, however, books of Luther's were printed anew again. Oh God, if Luther be dead, who will henceforth expound to us the Holy Gospel with such clearness? What, oh God, might he not still have written for us in ten or twenty years?

Oh all ye pious Christian men, help me deeply to bewail this man, inspired of God, and to pray Him yet again to send us an enlightened man. Oh Erasmus of Rotterdam, where wilt thou stand? [59] Behold how the wicked tyranny of worldly power, the might of darkness, prevails. Hear, thou knight of Christ! Ride on by the side of the Lord Jesus. Guard the truth. Attain the martyr's crown. Already indeed art thou an aged little man, and myself have heard thee say that thou givest thyself but two years more wherein thou mayest still be fit to accomplish something. Turn them to good account for the good of the Gospel and of the true Christian faith, and make thyself heard. Then, as Christ says, shall the Gates of Hell (the Roman Chair) in no wise prevail against thee. And if here below thou wert to be like thy master Christ and sufferedst infamy at the hands of the liars of this time, and didst die a little the sooner, then wouldst thou the sooner pass from death unto life and be glorified in Christ. For if thou drinkest of the cup which He drank of, with Him shalt thou reign and judge with justice those who have dealt unrighteously. Oh Erasmus, take thy stand here so that God Himself may be thy praise, even as it is written of David. For then mayest thou accomplish something, yea verily thou mayest overthrow Goliath. Because God stands by the Holy Christian Church, even as He upholds the Roman Church, according to His godly will. May He help us to everlasting salvation, who is God, the Father, the Son, and Holy Ghost, one eternal God! Amen.

Oh ye Christian men, pray God for help, for His judgment draweth nigh and His justice shall appear. Then shall we behold the innocent blood, which the Pope, Priests, Bishops, and Monks have shed, judged and condemned (*Apocalypsis*). These are the slain who lie beneath the Altar of God and cry for vengeance, to whom the voice of God answereth: Await the full number of the innocent slain, then will I judge.

[JUNE 6, 1521]

. . . On the eighth day after Corpus Christi I went with my wife to Lady Margaret [60] at Mechlin. Took five florins with me for expenses. My

58 "Opinionen" probably refers to the commentaries of the Church Fathers and other sacrosanct "opinions" of the Catholic Church.

59 "Bleiben"; more probably "take one's stand" than "stop."

60 Margaret of Austria, daughter of Maximilian I, after 1507 Regent of the Netherlands.

wife changed one florin for expenses. At Mechlin I lodged with Master Heinrich, the painter,[61] at the sign of the Golden Head. And the painters and sculptors bade me as guest at my inn and did me great honor in their gathering. I went also to Poppenreuter [62] the gunmaker's house, and found wonderful things there. And I went to Lady Margaret's and showed her my Emperor,[63] and would have presented it to her, but she so disliked it that I took it away with me.

[JUNE 7, 1521]

And on Friday Lady Margaret showed me all her beautiful things; amongst them I saw about forty small oil pictures, the like of which for precision and excellence I have never beheld.[64] There also I saw more good works by Jan [65] and Jacob Walch.[66] I asked my Lady for Jacob's little book,[67] but she said she had already promised it to her painter.[68] Then I saw many other costly things and a precious library. Master Hans Poppenreuter asked me as his guest. I have had Master Konrad [69] twice and his wife once as my guests. Also I have had as my guests both the chamberlain Stephan [70] and his wife. Paid twenty-seven stivers and two stivers for fare. I have also drawn with charcoal portraits of Stephan, the chamberlain, and Master Konrad the figure-carver, and on Saturday I came again from Mechlin to Antwerp.

The dream which Dürer drew and described in the following report [1] *must be understood as a reflection of the spiritual upheaval which swept Nuremberg at the height of the Reformation and of its impact upon the political life of Dürer's city.*

In the night between Wednesday and Thursday after Whitsunday, 1525, I saw this appearance in my sleep—how many great waters fell from heaven. The first struck the earth about four miles away from me with terrific force and tremendous noise, and it broke up and drowned

61 Probably Hendrick Keldermans.

62 Hans Poppenreuther from Cologne, gunmaker to Charles V in Malines.

63 Perhaps the oil painting of 1519, now in the Nuremberg Museum.

64 Probably refers to the small panels by Juan de Flandes, of which a series of approximately fifty were in Margaret's collection; about one half of this group survives in Madrid and elsewhere.

65 Jan van Eyck's Betrothal of Arnolfini was then in Lady Margaret's collection. Others think here of Jan Gossaert.

66 Jacopo de' Barbari, from 1510 in the service of Lady Margaret.

67 Sketch book or treatise on proportion, perhaps like the one with which Dürer became fascinated when Jacopo visited Nuremberg ca. 1500.

68 Her court painter, Bernard van Orley.

69 The sculptor Konrad Meit, see below, p. 147.

70 Étienne Lullier.

1 In the translation of Conway (p. 145), with one emendation. The correct date is June 7–8, 1525 (not May 30–31, as Conway has it); see Rupprich, p. 214. The text is found below the water color, Winkler 944 (Vienna, Kunsthistorisches Museum).

the whole land. I was so sore afraid that I awoke from it before the other waters fell. And the waters that fell were very powerful. Some fell further away, some nearer, and they came down from so great a height that they all seemed to fall with an equal slowness. But when the first water that touched the earth had very nearly reached it, it fell with such swiftness, with wind and roaring, and I was so sore afraid that when I awoke my whole body trembled and for a long while I could not recover myself. So when I arose in the morning I painted it above here as I saw it. God turn all things to the best.

<div align="right">ALBRECHT DÜRER</div>

One year later, Dürer sent his Four Holy Men *as a present to the Council of Nuremberg who accepted it gratefully on October 6th, 1526. Whatever its genesis, this work had by now developed into Dürer's religious and political testament. Faith in the basic truth of the Reformation is here combined with a warning against its political exploitation—a warning made crystal-clear by the selection from biblical texts attached to the panels in Luther's translation.*[1]

All worldly rulers in these dangerous times should give good heed that they receive not human misguidance for the Word of God, for God will have nothing added to His Word nor taken away from it. Hear therefore these four excellent men, Peter, John, Paul, and Mark, their warning.

Peter says in his second epistle in the second chapter: There were false prophets also among the people, even as there shall be false teachers among you, who privily shall bring in damnable heresies, even denying the Lord that bought them, and bring upon themselves swift destruction. And many shall follow their pernicious ways; by reason of whom the way of truth shall be evil spoken of. And through covetousness shall they with feigned words make merchandise of you: whose judgment now of a long time lingereth not, and their damnation slumbereth not.

John in his first epistle in the fourth chapter writes thus: Beloved, believe not every spirit, but try the spirits whether they are of God: because many false prophets are gone out into the world. Hereby know ye the Spirit of God: Every spirit that confesseth that Jesus Christ is come in the flesh, is of God: and every spirit that confesseth not that Jesus Christ is come in the flesh is not of God: and this is that spirit of antichrist, whereof ye have heard that it should come; and even now already is it in the world.

In the second epistle to Timothy in the third chapter S. Paul writes: This know also, that in the last days perilous times shall come. For men

[1] In the translation of Conway (p. 134), who quotes from the King James Bible.

shall be lovers of their own selves, covetous, boasters, proud, blasphemers, disobedient to parents, unthankful, unholy, without natural affection, truce-breakers, false accusers, incontinent, fierce, despisers of those that are good, traitors, heady, high-minded, lovers of pleasures more than lovers of God; having a form of godliness, but denying the power thereof: from such turn away. For of this sort are they which creep into houses, and lead captive silly women laden with sins, led away with divers lusts, ever learning, and never able to come to the knowledge of the truth.

S. Mark writes in his Gospel in the twelfth chapter: He said unto them in his doctrine, Beware of the scribes, which love to go in long clothing, and love salutations in the market places, and the chief seats in the synagogues, and the uppermost rooms at feasts; which devour widows' houses, and for a pretence make long prayers: these shall receive greater damnation.

Dürer: Theoretical Writings

The problem of a successful reconciliation and a fruitful synthesis of the irrational and the rational elements of artistic imagination and practice, first seen with full clarity by Dürer himself, occupied him throughout the larger part of his mature life. From about 1500, when he was vaguely initiated by Jacopo de Barbari into the most recent Italian discoveries concerning the scientific base of art ("art" as against "craft" in Dürer's formulation), until the last days of his life, this problem caused him much anxiety.[1] The fragmentary and unpublished state of many of his written thoughts on the matter clearly reflects this anxiety which was fully resolved only on the artistic level, in the "Melancolia" engraving of 1513. At the time of Dürer's death, only the Course in the Art of Measurement (Underweysung der Messung) *and the less significant* Theory of Fortification *had been published (1525 and 1527, respectively); the* Four Books of Human Proportion (Vier Bücher von menschlicher Proportion) *were seen through the press by friends shortly after his death in 1528. Influential and important though they are, they are but fragments of a much larger plan. Some of his most original thoughts concerning the very essence of art appear only in preliminary form in various drafts.*

Soon after his return from the second Italian journey, on which he received instruction in the "art of secret perspective" from the great unknown in Bologna (see above, p. 91), he jotted down the following brief synopsis, in which the first five points are taken from Piero della Francesca, and the remaining eleven from Euclid:[2]

[1] Erwin Panofsky, *Dürers Kunsttheorie* . . . (Berlin 1915); and *Albrecht Dürer* (Princeton 1943), pp. 242 ff.

[2] Conway, p. 223 and translation on p. 210; Panofsky, *Dürers Kunsttheorie*, pp. 14 ff., 42 ff.

Perspective is a Latin word, meaning *a Seeing-through.*
To this same Seeing-through belong five things:
Correct cause of five things regarding sight:

> The first is the eye that sees,
> The second is the object seen,
> The third is the distance between these two,
> The fourth: one sees everything by means of straight lines,
> that is to say, the shortest lines,
> The fifth is the dividing from one another of the things seen.

Herefrom arises firstly this observation: If the line—as is stated above under the fourth heading, to wit, that all things are seen by straight lines, yet these same radii are, in the distance, separated from each other, so that they become distinct from one another, in such a way that a cone is formed by them, whose point enters the eye.[3]

The second observation: One can only see those things to which the sight can reach.

The third observation: Where the sight cannot reach by means of straight lines (as stated above under the fourth heading) things cannot be seen, because sight is not effected through crooked lines.

The fourth observation: All things seen by radii which open out widely look [large].

The fifth observation: All things contained between narrow radii look small.

The sixth observation: All things seen by similar radii, whether they be large or small, far off or near, look the same size.

The seventh observation: All things seen by high radii look high.

The eighth observation: And those seen by low radii look low.

The ninth observation: All things included within the radii on the right side appear to be on the right side.

The tenth observation: And what the radii on the left side include seems to be on the left side.

The eleventh observation: [here the passage ends abruptly.]

Shortly before 1512 Dürer wrote down a more elaborate outline of the general treatise he was planning. This outline, with abbreviations, follows here as an example of the comprehensiveness of his vision and also for the sake of the magnificent formulation of his attitude toward God, art, and man given in its introductory sentence.[4]

[3] The "muddle" (Conway) of this sentence is original; Dürer was "feeling his way."

[4] In the translation by Conway and Panofsky as quoted in Holt, I, 307 ff. with some omissions.

JESUS MARIA

By the grace and help of God I have here set down all that I have learnt in practice, which is likely to be of use in painting, for the service of all students who would gladly learn. That, perchance, by my help they may advance still further in the higher understanding of such art, as he who seeks may well do if he is inclined thereto; for my reason suffices not to lay the foundations of this great, far-reaching, infinite art of true painting.

Item. In order that you may thoroughly and rightly comprehend what is, or is called, an "artistic painter," I will inform you and recount to you. For the world often goes without an "artistic painter" in that for two or three hundred years none such appears, and this in great part because those who might have become such were prevented from devoting themselves thereto. Observe then the three essential points following, which belong to the true artist in painting. These are the main points in the whole book.

The First Division of the book is the Prologue, and it comprises three parts.

The first part of the Prologue tells us how the lad should be taught, and how attention should be paid to the quality of his temperament. It falls into six parts. . . .

The second part of the Prologue shows how the lad should be brought up in the fear of God and in reverence, that so he may attain grace, whereby he may be strengthened in intelligent art and attain to power. It falls into six parts. . . .

The third part of the Prologue teaches us of the great usefulness, joy, and delight which spring from painting. It falls into six parts:

First, it is a useful art, for it is of godly sort and is employed for holy edification.

Second, it is useful, for if a man devote himself to art, much evil is avoided that would otherwise occur if one were idle.

Third, it is useful, for no one, unless he practices it, believes that it is so rich in joys in itself; it has great joys indeed.

Fourth, it is useful because a man gains great and lasting memory by it if he applies it aright.

Fifth, it is useful because God is thereby honored when it is seen that He has bestowed such genius upon one of His creatures in whom such art dwells. All wise men will hold you dear for the sake of your art.

Sixth, the sixth use is that if you were poor, you might by such art come to great wealth and riches.

The Second Division of the book treats of painting itself; it also is threefold.

The first part speaks of the freedom of painting: in six ways.

The second part speaks of the proportions of men and buildings and what is needed for Painting: in six ways.

The third part speaks of all that which is seen when represented in one view; to do this [is taught] in six ways.

The Third Division of the book is the Conclusion; it also has three parts.

The first part tells in what place such an artist should dwell to practice his art: in six ways.

The second part tells how such a wonderful artist should charge highly for his art, and that no money is too much for it; moreover, it is divine and rightful: in six ways.

The third part speaks of praise and thanksgiving unto God who has thus bestowed His grace upon him, and unto others for His sake. [?]

The following pages follow Conway's merger of two drafts jotted down by Dürer in 1512 and 1513 as an outline of what he eventually hoped to present as the gist of the Speis der Malerknaben (Dish—or Food—for Young Painters).[5]

SALUS

The following little book is called *Food for Young Painters*. . . .

Now I know that in our German nation at the present time are many painters who stand in need of instruction, for they lack real art, yet they nevertheless have many great works to make. Forasmuch, then, as they are so numerous, it is very needful for them to learn to better their work. He that works in ignorance works more painfully than he that works with understanding; therefore let all learn to understand aright. Willingly will I impart my teaching, hereafter written, to the man who has little competence and yet would gladly learn; but I will not care about the proud who, according to their own estimate of themselves, know all things, and are the best, and despise all else. By true artists, however, such as can show their meaning with their hand, I humbly desire to be instructed with much thankfulness. Whosoever will, therefore, let him hear and see what I say, do, and teach, for I hope it may be of service and not for a hindrance to the better arts, nor lead you to neglect better things.

This art of painting is made for the eyes, for the sight is the noblest sense of man. Some I know will be curious about these matters because they have neither seen nor heard of such things in our land before. Whosoever therefore comes across this thing, let him choose what he will therefrom and seek improvement therein however he please, so only that the truth abide therein. A thing you behold is easier of belief than

[5] In the translation by Conway and Panofsky as quoted in Holt, I, pp. 311 ff. with some omissions.

[one] that you hear; but whatever is both heard and seen we grasp more firmly and lay hold on more securely. I will therefore continue the word with the work [6] that thus I may be the better understood.

Every form brought before our vision falls upon it as upon a mirror. By nature we regard one form and figure with more pleasure than another, though the thing in itself is not necessarily better or worse. We like to behold beautiful things, for this gives us joy. To pass judgment on beauty is more credible in a skillful painter's speech than in another's. True proportion makes a good figure not only in painting but also in all works, howsoever executed. I shall not labor in vain if I set down that which may be useful for painting. For the art of painting is employed in the service of the Church and by it the sufferings of Christ and many other profitable examples are set forth. It preserves also the likeness of men after their death. By aid of delineation in painting, the measurements of the earth, the waters, and the stars have come to be understood; and many things will still become known unto men thereby. The attainment of true, artistic, and lovely execution in painting is hard to come unto; it needs long time and a hand most free and practiced. Whosoever, therefore, is not gifted in this manner, let him not undertake it; for it comes by inspiration from above.

The art of painting cannot be truly judged save by such as are themselves good painters; from others verily is it hidden even as a strange tongue. It were a noble occupation for ingenious youths without employment to exercise themselves in this art.

Many centuries ago the great art of painting was held in high honor by mighty kings, and they made the excellent artists rich and held them worthy, accounting such inventiveness a creating power like God's. For a good painter is inwardly full of figures, and were it possible for him to live forever he would always have from his inward "ideas," whereof Plato writes, something new to pour forth by the work of his hand.

Many hundred years ago there were several famous painters, such as those named Phidias, Praxiteles, Apelles, Polycleitus, Parrhasius, Lysippus, Protogenes, and the rest, some of whom wrote about their art and very artfully described it and gave it plainly to the light; but their praiseworthy books are, so far, unknown to us, and perhaps have been altogether lost by war, driving forth of the peoples, and alterations of laws and beliefs—a loss much to be regretted by every wise man. It often came to pass that noble *Ingenia* were destroyed by barbarous oppressors of art; for if they saw figures traced in lines they thought it plain black magic. And [in destroying them] they attempted to honor God by something displeasing to Him; for, to use the language of men, God is

[6] That is, the text and the illustrations.

angry with all destroyers of the works of great mastership, which is only attained by much toil, labor, and expenditure of time, and is bestowed by God alone. Often do I sorrow because I must be robbed of the aforesaid masters' books of art; but the enemies of art despise these things.

I hear, moreover, of no writer in later times by whom aught has been written and made known which I might read for my improvement. For though there are some, they hide their art in secrecy, and others write about the things whereof they know nothing. This, then, is all mere noise, for their words are the best [they can do], as he that knows somewhat is swift to discover. I therefore will write down with God's help the little that I have learned. Though many will scorn it, I am not troubled, for I well know that it is easier to cast blame on a thing than to make something better. Moreover, I will expound my meaning as clearly and plainly as I can; and, were it possible, I would gladly give everything I know to the light, for the good of cunning students who prize such art more highly than silver or gold. I further admonish all who have any knowledge in these matters that they write it down. Do it truly and plainly, not toilsomely; and do not lead those who seek and would like to know over devious paths, to the great honor of God and your own praise.

If I then set something burning and ye all add to it with skillful furthering, a blaze may in time arise therefrom which shall shine throughout the whole world. *Item.* The sight of a fine human figure is above all things pleasing to us, wherefore I will first construct the right proportions of a man. Thereafter, as God gives me time, I will write of and carry out other matters. I am well assured that the envious will not keep their venom to themselves; but nothing shall in any wise hinder me, for even the great men have had to undergo the like. We see human figures of many kinds arising from the four temperaments; yet if we have to make a figure, and if it is left to our discretion, we ought to make it as beautiful as we can according to the task, as it is fitting. No little art, however, is needed to make many various kinds of figures of men. Deformity will continually of its own accord entwine itself into our work. No single man can be taken as a model for a perfect figure, for no man lives on earth who is endowed with complete beauty; he might still be much more beautiful. There lives also no man upon earth who could give a final judgment upon what the most beautiful shape of a man should be; only God knows that. How beauty is to be judged is a matter of deliberation. One must bring it into every single thing, according to circumstances, for in some things we consider that as beautiful which elsewhere would lack beauty. "Good" and "better" in respect of beauty are not easy to discern, for it would be quite possible to make two different figures, neither of them conforming to the other, one stouter and the other thinner, and yet we scarce might be able to

judge which of the two may excel in beauty. What beauty is I know not, though it adheres to many things. When we wish to bring it into our work we find it very hard. We must gather it together from far and wide, and especially in the case of the human figure [seen] from before and behind throughout all its limbs. One may often search through two or three hundred men without finding amongst them more than one or two points of beauty which can be made use of. You therefore, if you desire to compose a fine figure, must take the head from some and the chest, arm, leg, hand, and foot from others, and, likewise, search through all members of every kind. For from many beautiful things something good may be gathered, even as honey is gathered from many flowers. There is a right mean between too much and too little; strive to attain this in all your works. In calling something "beautiful," I shall here apply the same standard as is applied to "right." For as what all the world prizes as right we hold to be right, so what all the world esteems beautiful that will we also hold for beautiful and strive to produce.

Item. I do not highly extol the proportions which I here set down, albeit I do not believe them to be the worst. Moreover, I do not lay them down as being just so and not otherwise. You may search out and discover some better method with the aid of these "means," for everyone should look for improvement in his work. Howbeit let him accept this as good until he be truthfully instructed with something better; for one comes nearer the truth than another according as his understanding is stronger, and the models from which he draws excel in beauty. Many follow their taste alone; these are in error. Therefore let each take care that his inclination blind not his judgment. For every mother is well pleased with her own child, and thus also it arises that many painters paint figures resembling themselves. There are many varieties and causes of beauty; he that can prove them is so much the more to be trusted. The more imperfection is excluded so much the more beauty remains in the work.

Let no man put too much confidence in himself, for many see more than one. Though it is possible for one man to comprehend more than a hundred, still that comes but seldom to pass. Usefulness is an important part of beauty; whatever, therefore, is useless in a man is not beautiful. Guard yourself from superfluity. The harmony of one thing with another is beautiful, therefore limping is not beautiful. [But] there is also a great harmony in diversity. Much will hereafter be written about the problems and artifices of painting. For I am sure that many notable men will arise, all of whom will write and teach both well and better about this art. For I myself hold my art at a very mean value, for I know my shortcomings. Let every man therefore strive to better my shortcomings according to his powers. Would to God, if it were possible, that I could see the work and art of the mighty masters to come, who are yet unborn,

for I know that I might be improved thereby. Ah! how often in my
sleep do I behold great works of art and beautiful things, the like
whereof never appear to me awake; but so soon as I awake my memory
loses hold of it. Let none be ashamed to learn, for good counsel helps
us to a good work. Nevertheless, whosoever takes counsel in the arts let
him take it from one thoroughly versed in these matters and who can
prove this with his hand. Howbeit anyone may do this, and it is well
[to do so]: when you have done a work pleasing to yourself, show it to
crude men of little judgment that they may give their opinion of it. As
a rule they pick out the most faulty points, though they have no under-
standing for the good. If you find that they say something true, you may
better your work. Much remains that might be written on these matters,
but for shortness' sake I will make an end, and will enter upon the task
of constructing the figures of man and woman.

*Dürer's most penetrating insights into the essential nature and
aims of art are contained in the so-called "Aesthetic Excursus" in Book
III of the* Four Books on Human Proportions. *What follows are transla-
tions of excerpts from the original text (now in the British Museum),
which was slightly varied in the posthumous edition of the work (1528).
In their present form they were probably written between 1523 and
1528.*[7]

To him that sets himself to draw figures according to this book,
not being well taught beforehand, the matter will at first come hard.
Let him then put a man before him who agrees, as nearly as may be,
with the proportions he desires; and let him draw him in outline accord-
ing to his ability and understanding. For this is held to be good: if a
man accurately follows life in his imitation so that his work resembles
life and is like unto nature, and especially if the thing imitated is beauti-
ful, the work is held to be artistic, and, as it deserves, it is highly praised.

But further, it lies in each man's choice whether, or how far, he
shall make use of all the above written "Words of Difference." For a
man may, if he choose it, learn to work with art, wherein is the truth, or
without art in a freedom by which everything he does is corrupted, and
his toil becomes a scorn to look upon to such as understand. For work
well done is honoring to God, useful, good, and pleasing unto men. But
to labor contemptibly in art is wrong and meet to be condemned, and
it is hateful in small works as in great. Wherefore it is needful for every-
one that he use discretion in such of his works as shall come to the light.
Whence it arises that he who would make anything aright must in no
wise retract aught from nature, neither must he lay what is intolerable
upon her. Howbeit some will make alterations so slight that they can
scarce be perceived. Such are of no account if they cannot be perceived;

[7] In the translation by Conway and Panofsky as quoted in Holt, I, pp.
318 ff. with some omissions.

[to alter] over much also answers not. A right mean is best. But if in this book I have gone to extremes, I have done so in order that it might be better perceived in small things. Let not him, who wishes to proceed to some great thing, imitate this my roughness, but let him make his work smoother, that it be not brutish but artistic to look upon. For the differences are not good to look upon, when they are wrongly and unmasterly employed.

It is not to be wondered at that a skillful master beholds manifold differences of figure, all of which he might make if he had time enough, but which, [for lack of time] he is forced to pass by. For such ideas come very often to artists, and their minds are full of images which it were possible for them to make. Wherefore, if to live many hundred years were granted unto a man who makes skillful use of such art and were gifted therefor, he would (through the power which God has granted unto men) have wherewith daily to pour forth and make many new figures of men and other creatures which had not been seen before nor imagined by any other man. God therefore in such and other ways grants great power unto artistic men. . . .

He that desires to make himself seen in his art must display the best he can, so far as it is suitable for this work. But here it must be noted that an artist of understanding and experience can show more of his great power and art in crude and rustic things, and this in works of small size, than many another in his great work. Powerful artists alone will understand that in this strange saying I speak truth. For this reason a man may often draw something with his pen on a half-sheet of paper in one day or cut it with his little iron on a small block of wood, and it shall be fuller of art and better than another's great work whereon he has spent a whole year's careful labor, and this gift is wonderful. For God sometimes grants unto one man to learn and to understand how to make something good; the like of whom, in his day, no other can be found, and perhaps for a long time none has been before him, and after him another comes not soon. Of this we behold examples in the days of the Romans in the time of their splendor. Little is now produced in our work like unto the works of art which were made by them and whereof we can still behold the wrecks.

But if we were to ask how we are to make a beautiful figure, some would give answer: according to the judgment of men. Others would not agree thereto; neither should I. For who will give us certainty in this matter without true knowledge? I believe that no man lives who can grasp the ultimate in beauty of the meanest living creature, let alone of man who is an extraordinary creation of God, and unto whom other creatures are subject. I grant, indeed, that one man will conceive and make a more beautiful figure than another and will explain good natural cause thereof so as to be convincing in his reasoning, but not to such an

extent that there could not be anything more beautiful. For this enters not the mind of man; God alone knows such, and he to whom He were to reveal it would know it likewise. Truth only comprehends which might be the most beautiful form and measurement of a man and none other.

Men deliberate and hold numberless differing opinions about these things and they seek after them in many different ways, although the ugly is more easily attained than the beautiful. Being then, as we are, in such a state of error, I know not how to set down firmly and with finality what measure approaches absolute beauty. But glad should I be to render such help as I can, to the end that the gross deformities of our work might be and remain pruned away and avoided, unless anyone desires to produce deformities for a special purpose.

But it seems to me impossible for a man to say that he can point out the best proportions for the human figure; for the lie is in our perception, and darkness abides so heavily within us that even our gropings fail. Howbeit if a man can prove his theory by geometry and manifest forth its fundamental truth, him must all the world believe. For then one is compelled, and such an one must be fairly recognized as endowed of God to be a master in such matters; and the demonstrations of his reasons are to be listened to with eagerness and still more gladly are his works to be beheld.

However, because we cannot altogether attain perfection, shall we therefore wholly cease from our learning? This bestial thought we do not accept. For evil and good lie before men, wherefore it behooves a rational man to choose the better. Thus to revert to the question as to how a "better" figure may be produced, we must first order the whole figure well and nobly with all its limbs, and we must see next that every limb, regarded in itself, be made aright in all smallest as in greatest things, if it so be that thus we may extract a part of the beauty given unto us and come so much the nearer to the true goal. So then, as aforesaid, since a man is one whole, made up of many parts, and since each of these parts has its particular nature, equal care must diligently be given to anything whereby they might be marred, so that this might be avoided and that the true, natural character of each part might be most carefully maintained; nor must we swerve therefrom if we can help it. . . .

Item. For different kinds of figures different kinds of men are to be copied. Thus you find two species of mankind, whites and Negroes; in these a difference in kind can be observed as between them and ourselves. Negro faces are seldom beautiful because of their very flat noses and thick lips; similarly their shinbones and knees, as well as their feet, are too bony, not so good to look upon as those of the whites; and so also is it with their hands. Howbeit I have seen some amongst them whose

whole bodies have been so well built and handsome otherwise that I never beheld finer figures, nor can I conceive how they might be bettered, so excellent were their arms and all their parts. Thus one finds amongst the species of men types of every kind, which may be used for figures of diverse sort according to the temperament. So the strong are hard in body like unto lions, whilst the weak are softer and not so rugged as the strong. Therefore it is not seemly to give a soft character to a very strong figure, or to a weak figure a hard character, though as to "thin" and "fat" in figures some allowance must be made. And in sundry differences figures "soft" and "hard" may be used according to circumstances, as a man sees fit. Life in nature shows forth the truth in these things. Wherefore regard it well, take heed thereto, and depart not from nature according to your fancy, imagining to find aught better by yourself; else would you be led astray. For verily "art" is embedded in nature; he who can extract it, has it. If you acquire it, it will save you from much error in your work. Moreover, you may demonstrate much of your work by geometry. But what we cannot demonstrate, that must we leave to good opinion and to the judgment of men. Still, experience avails much in these matters. The more closely your work abides by life in its form, so much the better will it appear; and this is true. Wherefore nevermore imagine that you could or would make anything better than God has given power His created nature to produce. For your might is powerless as compared to the creation of God. Hence it follows that no man shall ever be able to make a beautiful figure out of his own [private] imagination unless he has well stored his mind by much copying from life. That is no longer to be called private but has become "art" acquired and learnt by study which seeds, waxes, and bears fruit after its kind. Thence the gathered, secret treasure of the heart is openly manifested in the work, and the new creature, which a man creates in his heart in the form of a thing.

Hence it arises that a well-practiced artist has no need to copy each particular figure from the life. For he sufficiently pours forth that which he has for a long time gathered within him from without. Such a man has whereof to make good things in his work. Howbeit very few come unto this understanding, though many there be who with great toil produce much that is faulty. For him therefore who by a right understanding has attained a good practice it is quite possible to make something good, as far as that is within our power, without any model; yet it will turn out still better if he study from the life. But to make a good thing is impossible for the unpracticed hand, for these things come not by chance. It also happens, though but seldom, that a man becomes so sure of hand by great experience gathered from long and diligent practice, that he out of his own understanding, acquired by great pains, can produce without any model which he might copy something better than

another can do who sets before himself many living men to imitate because he lacks understanding.

Therefore we must take very great care and prevent that deformity and uncouthness introduce themselves into our work. We should therefore avoid bringing useless things into pictures, provided they are to be beautiful, for this is a fault. Take an instance from the blind, lame, withered cripples, and halt. All this is ugly through defect. Superfluity, likewise, must be avoided as if one were to draw a man with three eyes, three hands and feet. The more the ugliness of the aforesaid things is left out and the more things upright, strong, pure, and fitting, which all men commonly love, are made instead thereof, so much the better will the work turn out to be, for such things are held beautiful.

But beauty is so much hidden in men and so uncertain is our judgment about it, that we may perhaps find two men both beautiful and fair to look upon, and yet neither resembles the other in any single point or part, whether in measure or kind; we do not even understand whether of the two is the more beautiful, so blind is our knowledge. Thus, if we give an opinion on the matter it lacks certainty. Howbeit in some points the one may still surpass the other even though this be imperceptible to us.

Wherefore it follows that no powerful artist should abandon himself to one manner only; but he should be practiced in several styles and in many kinds, and should have understanding therein. Then he will be able to make whatever sort of picture is required of him. Likewise, of the aforesaid instances, a man may know how to make wrathful, kindly, and all other figures, and every figure may be made good in itself. If then someone came to you and would have of you some wicked saturnine or martial figure, or one of charming, lovely mien to indicate Venus, you, if you are practiced in the doctrines set forth before, shall easily know what measurements and kind you should employ for each. Thus all sorts of human species can be outwardly indicated by measurement [so as to show] which are of fiery, airy, watery, or earthy nature; for the power of art, as aforesaid, masters every work.

True artists perceive at once which work is a powerful one, and therefrom arises a great love in the mind of him that understands. This they know who have learnt aright and they know what is good practice therein; for knowledge is truthful but opinion betrays oft. Therefore let no one put too much belief in himself, lest he err in his work and fail. It is very needful for one who busies himself about these things to see many good figures and especially such as have been made by the famous good masters, and that he hear them discourse thereof. Howbeit you must ever observe their faults and consider how they might be bettered. Moreover, as aforesaid, permit not yourself to be persuaded to one style alone, that of any one master; for every man tends to make

that which pleases him, like unto himself. Howbeit if you consider many of them, choose the best thereof for your imitation; for the error is simply inherent in all opinions. So that, how well soever our work be done, it might still be done better always. Even as it is with men, how handsome soever a man may be, a still more handsome might yet be found.

Let each accept that which is more certain either that he learn it from some one, or that he search it out from nature for himself. But let him beware that he learn not from such as can talk well about the thing, but whose handiwork has ever been faulty and feeble, of whom I have seen many. For if you follow them they will lead you astray, as their work and want of art testify. For there is a great difference between talking of a thing and making the same. Howbeit it does not therefore follow that if a man of no understanding tell another a truth he should refuse to believe it; for it is possible that a peasant might tell you the error of your work, but he could not set you right therein and teach you how you should better the same.

A man who has not learnt anything about this art before and who desires to make a beginning from this book must read this with great diligence and learn to understand what he reads; and, taking a little at a time, he must practice himself well in the same, until he can do it, and only then must he go on to do something else. For understanding must begin to grow side by side with practice, so that the hand have power to do what the will in the understanding commands. By such means certainty of "art" and practice waxes with the time; and these two must go together, for the one is aught without the other. Further, it must be noted how well a common man knows the better from the worse; yet no man can more perfectly judge a picture than an understanding artist who has often proved this through his work.

Now a man might say: who will devote continual labor and trouble, with consuming of much time, thus in a tedious wise to measure out a single figure, seeing that it often happens that he must make, it may be, twenty or thirty different figures in a short time? In answer to which, I do not mean that a man should at all times construct everything by measurements; but if you have well learnt the theory of measurements and attained understanding together with practice, so that you can make a thing with free certainty of hand, and know how to do each thing aright, then it is not always needful always to measure everything, for the art which you have acquired gives you a good eye-measure, and the practiced hand is obedient. And thus the power of art drives away error from your work and restrains you from making falsehoods; for you know art, and by your knowledge you gain confidence and full command of your work so that you make no touch or stroke in vain. And this skill brings it to pass that you have no need to think long if your head is

stored full with art. And thus your work appears artistic, graceful, powerful, free, and good, and will receive manifold praise because rightness is infused into it.

But if you lack a true foundation it is impossible for you to make aught aright and well, although you had the greatest practice of the world as to freedom of hand. For this is rather a slavery when it leads you astray. Wherefore, as there must be no freedom without art, so is art lost without practice. Hence, as aforesaid, the two must go together. It is therefore needful that a man learn to measure most artfully. He that can do so well makes wonderful things. The human figure cannot be outlined with rule or compass, but must be drawn from point to point, as above explained; and without true measurement no one can in any wise accomplish anything good.

It might come to pass that a man, who will transfer these above measurements of figures to some large work, might go wrong through his [own] want of skill, and then might lay the blame upon me, saying that my designs were right for small things but they were misleading for large works. Such, however, cannot be the case, for the small cannot be right and the large wrong, or the small bad and the large good; therefore the argument cannot be divided in this wise. For a circle, whether small or large, abides round, and so it is with a square. Each proportion therefore remains equal to itself whether the scale be large or small, even as in music a note answers to its octave, the one high the other low, yet both are the same note.

In 1523 Dürer decided to publish the Course in the Art of Measurement *together with the* Four Books on Human Proportions *as one volume and to dedicate it to his friend Willibald Pirckheimer. To the unknown person who had written the draft of this dedication for him* [8] *Dürer dispatched the following highly characteristic request, supplemented on an extra sheet with his reaction to the preliminary draft forwarded to him by that person.*[9]

DEAR SIR,

Will you have the goodness to arrange the preface as I here indicate?

1. I desire that nothing boastful or arrogant appear in it.
2. That there be no thought of Envy.
3. That nothing be dealt with that standeth not in the book.
4. That nothing be introduced which is stolen from other books.

[8] Conway still accepted Pirckheimer as the addressee of these two letters but Lange-Fuhse and Rupprich (p. 100) have plausibly proposed the unknown person (perhaps Hans Ebner) who wrote the draft of Dürer's dedication to Pirckheimer (Conway, pp. 254 ff.).

[9] Conway, p. 228.

5. That I write only for our German youth.

6. That I give the Italians very high praise for their naked figures and especially for their Perspective.

7. That I pray all such as know anything instructive for art to publish it.

<p align="center">* * *</p>

GRACIOUS SIR,

I beseech you in all affection not to be indignant or angry with me, neither to think that I mean to correct you, because I desire to have somewhat altered in this preface and somewhat omitted. For, if I publish the book and give an account of it, I feel that nothing, however good, ought to be brought into the preface, about which the book itself does not contain a word. Now, as this book deals with nothing but Proportion, I desired to keep all references to Painting for the book which I intend to write upon that subject. For this Doctrine of Proportions, if rightly understood, will not be of use to painters alone, but also to sculptors in wood and stone, goldsmiths, metal-founders, and potters who fashion things out of clay, as well as to all who desire to make figures.

Secondly, I should also prefer that no mention be made of envy, for I fear that, so far from exciting envy, I shall be laughed at for this book.

Thirdly, I neither will nor can give any better reason for all the Proportions set down in the whole book and in the sequel—why I make them so and not otherwise—save that in fact I do so make them.

Erasmus of Rotterdam on Dürer

Of the contemporaries of Dürer who had something significant to say about his personality and his art, Erasmus of Rotterdam is the most famous although hardly the most expert. He did write one important paragraph on Dürer [1] *which emphasizes clearly and cleverly the fact that Dürer was greater in his prints than in his paintings. The last sentences touch on a criticism which was to swell to a loud chorus in later centuries. The treatise is written in the form of a dialogue between "Ursus" and "Leo."*

(**Ursus:**) I admit that Apelles was the prince of his art, upon whom no reproach could be cast by other painters except that he did not know

[1] In the translation by Erwin Panofsky (*Albrecht Dürer*, 4th ed., [Princeton 1955], p. 44), of Erasmus' *De recta Latini Graecique sermonis pronuntiatione*, published in Basel in 1528, pp. 68 f., from which text the last four sentences here have been added to Panofsky's quotation. The entire passage is also reprinted by H. Rupprich, *Dürers schriftlicher Nachlass*, I (Berlin 1956), p. 297.

when to take his hand off the panel—a splendid kind of blame. But Apelles was assisted by colors, even though they were fewer and less ambitious—still by colors. But Dürer, though admirable also in other respects, what does he not express in monochromes—that is, in black lines? Light, shade, splendor, eminences, depressions; and, though derived from the position of one single thing, more than one aspect offers itself to the eye of the beholder. He accurately observes proportions and harmonies. Nay, he even depicts that which cannot be depicted: [2] fire, rays of light, thunder, sheet lightning, lightning, or, as they say, the "clouds on a wall"; [3] all the sensations and emotions; in fine, the whole mind of man as it reflects itself in the behavior of the body, and almost the voice itself. These things he places before the eye in the most pertinent lines—black ones, yet so that if you should spread on pigments you would injure the work. And is it not more wonderful to accomplish without the blandishment of colors what Apelles accomplished with their aid?

(**Leo:**) I did not realize that there is so much erudition involved in the art of painting, which now barely provides a living for the artist.

(**Ursus:**) It is nothing new to find famous artists in restricted circumstances. And yet the art of drawing was once counted among the liberal arts, and only outstanding men were allowed to teach them, and in any case only gentlemen; [4] in fact it was forbidden to entrust this to slaves. It must be blamed on the princes, not on art, if it lacks its rewards.

Joachim Camerarius on Dürer

A much more personal note is struck in the preface which Joachim Camerarius (Cammermeister) wrote for his Latin translation (1532–1534) of the first two books of Dürer's Four Books of Human Proportions.[1] *Camerarius, professor at the new Nuremberg gymnasium and a close friend of the artist, gave us an invaluable account of Dürer's physical and mental features; the following excerpts restrict themselves to the former, one paragraph on the latter, and to an anecdote which, even if it may be somewhat embroidered, contains enough truth to be cherished.*

Nature bestowed on him a body remarkable in build and stature and worthy of the noble mind it contained; that in this too Nature's Justice, extolled by Hippocrates, might not be forgotten—Justice, which,

[2] This topos was first used by Pliny (Nat. Hist. 35, 96) and applied to Apelles; Ortelius used it in his characterization of the art of Pieter Bruegel (see above, p. 37) and van Mander took it up again (above, p. 64).

[3] That is, in Erasmus' own words, "something most similar to nothing or a dream" (Panofsky).

[4] On this see also Hilliard, below, p. 169.

[1] In the translation by Conway (pp. 136 f.), with a few emendations.

while it assigns a grotesque form to the ape's grotesque soul, is wont also to clothe noble minds in bodies worthy of them. His head reminded one of a thoroughbred,[2] his eyes were flashing, his nose was nobly formed and, as the Greeks say, $T\epsilon\tau\rho\alpha\gamma\omega\nu o\nu$. His neck was rather long, his chest broad, his body not too stout, his thighs muscular, his legs firm and steady. But his fingers—you would vow you had never seen anything more elegant.

His conversation was marked by so much sweetness and wit that nothing displeased his hearers so much as the end of it. Letters, it is true, he had not cultivated, but the great sciences of Physics and Mathematics, which are perpetuated by letters, he had almost entirely mastered. He not only understood principles and knew how to apply them in practice, but he was able to set them forth in words. This is proved by his Geometrical treatises which, as far as I can see, leave nothing to be desired within the scope judged appropriate by him. An ardent zeal impelled him toward the attainment of all virtue in conduct and life, the display of which caused him to be deservedly held a most excellent man. Yet he was not of a melancholy severity nor of a repulsive gravity; nay, whatever conduced to pleasantness and cheerfulness, and was not inconsistent with honor and rectitude, he cultivated all his life and approved even in his old age, as is shown by what is left of his writings on Gymnastic and Music. . . .

I cannot forbear to tell, in this place, the story of what happened between him and Giovanni Bellini. Bellini had the highest reputation as a painter at Venice and indeed throughout all Italy. When Albrecht was there he easily became intimate with him, and both artists naturally began to show one another specimens of their skill. Albrecht frankly admired and made much of all Bellini's works. Bellini also candidly expressed his admiration of various features of Albrecht's skill, and particularly the fineness and delicacy with which he drew hairs. It chanced one day that they were talking about art, and when their conversation was done Bellini said: "Will you be so kind, Albrecht, as to gratify a friend in a small matter?" "You shall soon see," says Albrecht, "if you will ask of me anything I can do for you." Then says Bellini: "I want you to make me a present of one of the brushes with which you draw hairs." Dürer at once produced several, just like other brushes, and, in fact, of the kind Bellini himself used, and told him to choose those he liked best, or to take them all if he would. But Bellini, thinking he was misunderstood, said: "No, I don't mean these but the ones with which you draw several hairs with one stroke; they must be rather spread out and more divided, otherwise in a long sweep such regularity of curvature and distance could not be preserved." "I use no other than these," says

2 "Caput argutum" (Vergil, Georg. III, applied to a thoroughbred horse).

Albrecht, "and to prove it, you may watch me." Then, taking up one of the same brushes, he drew some very long wavy tresses, such as women generally wear, in the most regular order and symmetry. Bellini looked on wondering, and afterward confessed to many that no human being could have convinced him by report of the truth of that which he had seen with his own eyes. . . .

Eobanus Hessus on the Sebaldus Tomb

The praises of the city of Nuremberg, lifelong residence of Dürer and the home of many other great artists, have been sung by many eloquent authors. The Urbs Noriberga Illustrata Carmine Heroico [1] *of Helius Eobanus Hessus (1488–1540), written in 1532, deserves our attention as a typical humanistic counterpart to Felix Faber's treatise on Ulm of 1488 (above, p. 78). In contrast to Faber's somewhat lumbering prose, it is composed in elegant hexameters, and in contrast to Faber's straightforward and catalogue-like description of the splendors of his chosen monument, it presents us with a highly polished, glistening gem of an ecphrasis. Its object is the bronze tomb of St. Sebaldus erected by Peter Vischer and his workshop in the church consecrated to the same saint in Nuremberg (1508–1519). A similar poem by Hessus is dedicated to Adam Kraft's Tabernacle in St. Lawrence (see above, p. 81); in neither case did the poet take the trouble to inform the reader about the artist responsible for the monument. Hessus' name, which is rarely mentioned today, lives on primarily through a magnificent portrait drawing by Dürer, on whose death Hessus composed another poem.*

In this temple stands the famous monument of Sebaldus, whom the multitudes consider a great saint. It is reported that he, coming from a remote region, was the first to teach the Christian faith to the inhabitants of our land; to honor his services and the pious cults he has merited, the pious care shown by our fathers has inspired this salute first prepared by this author for himself and his family.

And therefore they erected to him, in memory of his services, this splendid sepulcher with which no other can vie for excellence of either craftsmanship or spirit or artistic refinement. The beautiful mass is wrought in glittering metal throughout by the artist's hand. From the ground it rises with all its variety of natural forms, interrupted by architraves which intermingle with all kinds of undulating ornaments done in meticulous bronze work. At the top it comes together again and contracts in the beautiful roof with its various cast figures, yet not too closely crowded so that the highest point does not form too sharp a

[1] Translated from Helius Eobanus Hessus, *Noriberga Illustrata und andere Städtegedichte,* ed. Joseph Neff (*Lateinische Litteraturdenkmäler des XV. und XVI. Jahrhunderts,* ed. Max Herrmann, XII [Berlin 1896]), pp. 43 ff., v. 1036 ff.

pyramid but rather suggests three pyramidal cones. All around, capitals have been added to the columns, as well as short bases and round mouldings and slender abaci on which stand images of saints or humans; you can see an interplay of artfully shaped girls and of constantly changing forms, small serpents crawling, some figures of girls nude to the waist, while from the middle down their bodies end in dragon tails. What other statues shall I enumerate, of women and men, some nude, others clothed in arms or other garments? What shall I say of so many animals, of so many cast lions' bodies? Of the thousand figures of nude infants? Not even the muse would be capable of such labor or of doing justice in words to this immortal work, which neither Praxiteles nor Myron nor Polycletus, no Chares or Scopas could duplicate. Although fame commends these masters of the noble art of working in metal, greater glory shall fall to our times. For as that earlier age was crude and more ignorant, so it behooves us to grow with our growing years, to add better things to our heritage, and happily excel the ancients in the field of art.

Matthias Grünewald

In order to find some comprehensive information concerning Matthias Grünewald, the second member of the great German triad of the early 16th century, we have to turn to a book published as late as 1675, Joachim von Sandrart's German Academy of the Arts of Architecture, Sculpture, and Painting.[1] *Sandrart (1606–1688) remains one of our most important sources for many Netherlandish and German artists of the seventeenth century whom he met on his many travels in Italy, the Netherlands, and Germany. He was also capable of some significant, if necessarily somewhat less reliable research on much older artists, and his painstakingly and lovingly compiled report on Grünewald is perhaps his most spectacular achievement in this field. It was not his fault that he was unable to hand down the master's actual name, which was Matthis Gothardt-Neithard; the painter had been so thoroughly forgotten soon after his death that not even Sandrart's well-chosen sources were sufficiently informed about these matters.*

Matthaeus Grünewald, also known as Matthaeus of Aschaffenburg, is second to none among the greatest of the old German masters in the arts of drawing and painting: on the contrary, he must be regarded as an equal, if not superior, to the very best of them. It is regrettable that the works of this outstanding man have fallen into oblivion to such a degree that I do not know of a single living person who could

[1] The translation was made by H. W. Janson (in Holt, I, 354 ff.) from the edition of the *Teutsche Academie der Edlen Bau-, Bild- und Mahlerey-Künste* by A. R. Peltzer (Munich 1925), pp. 81 ff.

offer any information whatever, be it written or oral, about the activities of the master. I shall, therefore, compile with special care everything that I know about him, in order that his worth may be brought to light. Otherwise, I believe his memory might be lost completely a few years hence.

Already fifty years have passed since the time when there was in Frankfurt a very old but skillful painter by the name of Philipp Uffenbach [2] who had once been an apprentice to the famous German painter Grimer. [3] This Grimer was a pupil of Matthaeus of Aschaffenburg and had carefully collected everything by him that he could lay his hands on. In particular he had received from his master's widow all manner of wonderful drawings, most of them done in black chalk and in part almost life-size. After the death of Grimer, all of these were acquired by Philipp Uffenbach, who was a famous and thoughtful man. At that time I went to school in Frankfurt not far from Uffenbach's house, and often did him small service; whereupon, if he was in a good mood, he would show me these beautiful drawings of Matthaeus of Aschaffenburg, which had been assembled into a book. He himself was an ardent follower of this master's manner, and would expound to me the particular merits of those designs. After the death of Uffenbach, his widow sold the entire volume for a good deal of money to the famous amateur, Herr Abraham Schelkens of Frankfurt, who placed it in his renowned collection so that the genius of its author might be remembered for all time to come. There the drawings repose among many other magnificent works of art, such as the best of ancient and modern paintings, rare books, and engravings, which it would take too long to enumerate in detail. I would like to refer the reader to this collection, where every art lover may inspect and enjoy the drawings.

This excellent artist lived in the time of Albrecht Dürer, around the year 1505, a fact that can be inferred from the altar of the *Assumption of the Virgin* in the monastery of the Predicants at Frankfurt. [4] The altar itself is the work of Albrecht Dürer, but the four outer wings, painted in *grisaille,* were done by Matthaeus of Aschaffenburg. On them are shown St. Lawrence with the grill, St. Elizabeth, St. Stephen, and another subject that escapes me. [5] They can still be seen in their original place at Frankfurt, and are painted with the greatest delicacy. Especially praiseworthy, however, is the *Transfiguration of Christ on Mount Tabor,* painted in water colors; this scene contains an exquisitely beautiful cloud

[2] Painter, engraver, and etcher, 1566–1636.

[3] Either Adam or Hans Grimmer.

[4] See above, p. 91.

[5] For St. Stephen read St. Cyriacus; this panel, together with *St. Lawrence,* is now in the Städelsche Kunstinstitut in Frankfurt. *St. Elizabeth* and the other *Female Saint* (still unidentified) are in the Museum at Donaueschingen.

in which appear Moses and Elijah, as well as the disciples kneeling on the ground.[6] The design, the coloring, and every detail of the panel are so excellently handled that there is nothing to equal it anywhere; in fact, its manner and character are entirely beyond compare, so that the picture is a never-ending source of enchantment.

The same distinguished author produced further three altar panels, each having two wings painted on either side, which used to stand in three separate chapels on the left-hand side of the choir of Mayence Cathedral. The first of these showed the Madonna with the Christ Child on a cloud, attended by a large number of saints standing on the ground, including St. Katherine, St. Barbara, St. Cecilia, St. Elizabeth, St. Apollonia, and St. Ursula, all of them drawn so nobly, naturally, charmingly, and correctly, and so beautifully colored, that they appeared to be in heaven rather than on earth.[7] The second panel showed a blind hermit walking across the frozen Rhine river with the aid of a boy; he is being killed by two assassins and has fallen on top of the screaming child. This picture was so rich in expression and detail that it seemed to contain a greater wealth of true observations and ideas than its area could hold. The third panel was slightly less perfect than the other two. All three of them were taken away in 1631 or 1632 during the ferocious war that was raging at that time, and dispatched to Sweden by boat, but unfortunately they were lost in a shipwreck, along with many other works of art.

There is said to be an altar panel by the same hand in Eisenach,[8] containing a remarkable figure of St. Anthony; the demons behind the windows are reputed to be especially well done. Furthermore, the late Duke William of Bavaria, an understanding judge and amateur of the fine arts, had in his possession a very fine small *Crucifixion* by the master,[9] which he was very fond of, without knowing the name of the artist. In it are shown the Virgin, St. John, and a Mary Magdalen kneeling on the ground and praying devoutly. Because of the strange figure of Christ on the cross, who conveys the most powerful sensation of hanging since the weight of His body is borne entirely by the feet, this *Crucifixion* is so extraordinarily close to real life that it appears true and natural beyond all others if one contemplates it for some time with patience and understanding. For this reason a copper engraving in half-folio was made after the picture by Raphael Sadeler in 1605 at the behest of the above-mentioned duke, and some time ago I gave great pleasure to the late Elector Maximilian when I revealed to him the name of the artist.

A series of woodcuts illustrating the Revelation of St. John is sup-

[6] Lost; however, drawings for it seem to have survived (Dresden, Northampton).

[7] Drawings for this work are in Berlin.

[8] Error for Isenheim.

[9] Now in the National Gallery in Washington (Samuel H. Kress Collection).

posed to be by the same master,[10] but it is difficult to obtain. In addition, there was in Rome while I was in that city a life-size picture of St. John with his hands clasped and his glance turned upward as if he were contemplating Christ on the cross. It was extremely moving, done with much devotion and with wonderful grace, and was held in great esteem as work by Albrecht Dürer. I, however, recognized the true author and demonstrated the difference in style, whereupon I was asked to put the artist's name on the picture in oil paint—I was just then doing the portrait of the Pope in that medium—as follows: Matthaeus Grünwald Aleman fecit.[11]

This, then, is everything that I have been able to find out about the works of this excellent German master, apart from the fact that he stayed mostly in Mayence, that he led a secluded and melancholy existence, and that his marriage was far from happy. I do not know where or when he died, but I believe it was around the year 1510.[12] His portrait is shown on plate CC.[13]

Luther on Images

Both Dürer and Grünewald were touched and their art affected by the first waves of the Reformation. And as Dürer was troubled by the political and social consequences of the movement—as proved by the history of his Four Holy Men—*so was Martin Luther himself. We owe it to the iconoclastic excesses of Karlstadt (Andreas Bodenstein) and his group that the reformer, on the whole little interested in the visual arts, defined his views on a matter which troubled so many artists of the time: the question of the very* raison d'être *of religious art. In his refutation of the views and actions of his former colleague, the tract* Against the Heavenly Prophets in the Matter of Images and Sacraments *of 1525, Luther made the following statements,[1] which explain the benevolent attitude he maintained toward the altarpieces painted by his friend Lucas Cranach and others, as a matter quite apart from his fondness for Bible illustrations:*

I approached the task of destroying images by first tearing them out

[10] Confused with Matthias Gerung, who did an Apocalypse series in woodcuts.

[11] Unidentified. Sandrart portrayed Pope Urban VIII at Castel Gandolfo (ca. 1630).

[12] The artist died in 1528.

[13] Unreliable, as are all other identifications of the painter's features.

[1] *Wider die himmlischen Propheten, von den Bildern und Sakrament,* Weimar Luther Edition, XVIII, 62 ff. The present translation is by Bernhard Erling, in *Luther's Works,* XL (Philadelphia: Fortress Press, 1958), pp. 84 ff. See also Hans Frhr. von Campenhausen, "Zwingli und Luther zur Bilderfrage," in *Das Gottesbild im Abendland,* ed. Wolfgang Schöne (*Glaube und Forschung,* XV [2nd ed., Witten-Berlin 1959]), pp. 139 ff.

of the heart through God's Word and making them worthless and despised. This indeed took place before Dr. Karlstadt ever dreamed of destroying images. For when they are no longer in the heart, they can do no harm when seen with the eyes. But Dr. Karlstadt, who pays no attention to matters of the heart, has reversed the order by removing them from sight and leaving them in the heart. . . .

I have allowed and not forbidden the outward removal of images, so long as this takes place without rioting and uproar and is done by the proper authorities. . . . And I say at the outset that according to the law of Moses no other images are forbidden than an image of God which one worships. A crucifix, on the other hand, or any other holy image is not forbidden. Heigh now! you breakers of images, I defy you to prove the opposite! . . .

Thus we read that Moses' Brazen Serpent remained (Num. 21:8) until Hezekiah destroyed it solely because it had been worshiped (II Kings 18:4). . . .

However, to speak evangelically of images, I say and declare that no one is obligated to break violently images even of God, but everything is free, and one does not sin if he does not break them with violence. One is obligated, however, to destroy them with the Word of God; that is, not with the law in a Karlstadtian manner, but with the Gospel. . . . Beyond this let the external matters take their course. God grant that they may be destroyed, become dilapidated, or that they remain. It is all the same and makes no difference, just as when the poison has been removed from a snake. . . .

Nor would I condemn those who have destroyed them, especially those who destroy divine and idolatrous images. But images for memorial and witness, such as crucifixes and images of saints, are to be tolerated. This is shown above to be the case even in the Mosaic law. And they are not only to be tolerated, but for the sake of the memorial and the witness they are praiseworthy and honorable, as the witness stones of Joshua (Josh. 24:26) and of Samuel (I Sam. 7:12). . . .

Hans Holbein the Younger

Hans Holbein the Younger was born later than Dürer by nearly a generation's span. While it had been Dürer's gigantic task to introduce Renaissance ideas and forms into the north almost singlehandedly, Holbein was born into this new world and destined to give it supreme expression in a limited but highly important area. At Basel and London he stood in the full light of a humanistic circle of the greatest distinction, mildly appreciated by Erasmus, more enthusiastically by Sir Thomas More, entrusted with delicate tasks by King Henry VIII. Yet we know very little of his personality outside of what his art tells us, and we must

be content with very few pertinent documents—none from his own hand and none fully illuminating the cryptic language of such works as the portrait of his wife and children, or enlightening us in detail about the enigmatic sarcasm of his Death Dance woodcuts.

Erasmus' brief words concerning Holbein in a letter to Petrus Aegidius [1] *are worth recalling because of the vivid picture they evoke of four outstanding men of the northern Renaissance in simultaneous contact, and also because of the hint at the emergence of England as a haven for artists dissatisfied with the deteriorating conditions on the continent in 1526.*

He who brings you this letter is the man who has painted my portrait. By recommending him I should not want to trouble you although he is an excellent artist. If he desires to visit Quentin,[2] and you do not have the time to take the man there, you may have your servant show him the house. Here the arts are cold; he goes to England in order to scrape together a few angelots. If you wish, you can entrust to him letters to take along.

How bad the situation in Basel had become for the painters is graphically illustrated by a petition [3] *made by their guild to the city council in 1526. The town had been visited by fierce party strife in the wake of early attempts at church reform (the convents had been opened in 1524), by plague, hail storms, and a terrifying powder explosion. The petition ends on the following pathetic note:*

Finally, they [the painters] ask [the council] to consider graciously that they, too, have wives and children, and to see to it that they can stay in Basel, because even so the painters' profession is in a bad way. Several painters have already abandoned their jobs, and if the situation is not improving in this and other respects, one will have to reckon with more of them giving up.

The special favors granted Holbein by Mayor and Council of the City of Basel in 1538 [4] *reflect his vast reputation with the great patrons of his time. Dürer's fame was probably equally great, yet nothing of this kind could have happened to him. Times had changed: Emperor Maximilian had then employed a "craftsman," whereas King Henry VIII now employed an "artist."*

We, Jacob Meyger,[5] Burgomaster, and the Council of the City of Basel, do make known and acknowledge with this letter that:

[1] Letter dated August 29, 1526, here translated from the Latin text as given by Alfred Woltmann, *Holbein and his Time* (London 1872), p. 294, note 5. Petrus Aegidius (Pieter Gillis), Antwerp humanist and friend of Erasmus and Massys, was painted by the latter in 1517 in a pendant to a portrait of Erasmus.

[2] Quentin Massys.

[3] Translated from the German text as given by A. Woltmann, *ibid.*, p. 288, note 2. The iconoclastic catastrophe overtook Basel in 1529.

[4] The translation is by F. E. Bunnett in Woltmann, *ibid.*, pp. 430 f.

From the special and favorable will which we bear to the honorable Hans Holbein, the painter, our dear citizen, since he is famous beyond other painters on account of the wealth of his art; weighing further that in matters belonging to our city respecting building affairs and other things which he understands, he can aid us with his counsel, and that in case we had to execute painting work on any occasion, he should undertake the same, for suitable reward, we have therefore consented, arranged, and pledged to give and to present to the above-named Hans Holbein a free and right pension from our treasury of fifty gulden, though with the following conditions, and only during his lifetime, whether he be well or ill, yearly, in equal parts at the four quarters.

As however the said Hans Holbein has now sojourned for some time with the King's Majesty in England, and according to his declaration it is to be feared that he can scarcely quit the Court for the next two years, we have allowed him under these circumstances to remain in England the two years following this date, in order to merit a gracious discharge, and to receive salary, and have consented during these two years to pay his wife residing among us forty gulden yearly, i.e., ten gulden quarterly, which are to begin from next Christmas, this being the end of the first quarter. With the addition that in case Hans Holbein should receive his discharge from England within these two years and should return to us at Basel and remain here, we should from that moment give him his pension of fifty gulden, and let it be paid to him in equal parts at the end of the quarter. And, as we can well imagine that the said Holbein, with his art and work being of so far more value than that they should be expended on old walls and houses, cannot with us alone reap much advantage, we have therefore allowed the said Holbein, that, unimpeded by our agreement, for the sake of his art and trade, and for no other unlawful and crafty matters, as we have also impressed upon him, he may gain, accept, and receive service money from foreign kings, princes, nobles, and cities; that, moreover, he may convey and sell the works of art which he may execute here once, twice, or thrice a year, each time with our special permission, and not without our knowledge, to foreign gentlemen in France, England, Milan, and the Netherlands. Yet on such journeys, he may not remain craftily abroad, but on each occasion he shall do his business in the speediest manner and repair home without delay and be serviceable to us, as we have before said, and as he has promised.

In conclusion, when the oft-mentioned Holbein will have paid the debt of nature according to the will of God and departed from this

[5] Jacob Meyer "zum Hirschen" (not the donor of the "Darmstadt Madonna," Jacob Meyer "zum Hasen," who had died in 1531). In 1532, the same mayor and council had tried in vain to lure Holbein back to Basel from London, where he had gone for good earlier in the same year.

valley of tears, then shall this warrant, pension, and present letter be at an end, and we and our descendants therefore are not pledged to give aught to any one. All upright, honorable, and with integrity. This letter, signed with our official seal, we have given into the hand of the oft-mentioned Holbein as a true document. Wednesday the sixteenth day of October, anno XXXVIII.

"Veit the Sculptor"

The agony of the complaints of Lucas Moser (above, p. 76) and of the Basel painters of 1526 (above, p. 131) was turned into a jingle (by Hans Sachs?) which accompanied the woodcut of "Veit the Sculptor" in one of the various later editions of an obviously popular image once attributed to Peter Flötner.[1] Nothing is known about the special circumstances that produced this sheet; but that the period around 1540, to which this poem probably belongs, was one of despair for many German artists is not to be wondered at. The distinction made here between "Southern" and "German" style is particularly noteworthy.

> Fine figures did I carve galore,
> In Southern and in German style,
> But now this art nobody wants
> Unless I carve my figures fine
> As nudes and make them come to life—
> Such could I sell in ev'ry town.
> But since I cannot do this trick
> I'll have to choose some other job
> And with my halberd I will serve
> A potentate of great renown.

Hans Rottenhammer

After long neglect, Hans Rottenhammer (1564–1625) has recently again aroused the interest of collectors and art historians, and the story of his life, as narrated by Joachim von Sandrart,[1] may be welcome here, the more so as it affords a good opportunity to watch the writer dealing

[1] Translated from the text as reprinted by K. Lange in *Jahrbuch der preussischen Kunstsammlungen*, XVII (1896), 174. See also H. Röttinger, *Peter Flettners Holzschnitte* (Strassburg 1916), p. 62, note 33, and E. F. Bange, *Peter Flötner (Meister der Graphik*, XIV [Leipzig 1926]), p. 26. The woodcut is illustrated by J. Reimers, *Peter Flötner nach seinen Handzeichnungen und Holzschnitten* (Munich 1890), p. 55, fig. 40.

[1] Translated from A. R. Peltzer, ed., *Teutsche Academie der Edlen Bau-, Bild- und Mahlerey-Künste* (Munich 1925), p. 152 ff. Peltzer also wrote the basic article on Rottenhammer (*Jahrbuch der Kunstsammlungen des allerhöchsten Kaiserhauses*, XXXIII [Vienna 1916], 291 ff.).

with a compatriot with whose now badly decimated work he was rather intimately acquainted. The first paragraph of the report is copied after Carel van Mander but the second and third are Sandrart's own. The hypocritical note at the end was caused by Sandrart's special aversion to waste, drinking, and "des verbuhlten Cupido Anläuffe." (See his Life of van Dyck.)

Johann Rottenhammer was born in 1564 and learned his art in Munich with a mediocre painter named Danauwer.[2] He then went to Rome and started to paint on copper plates, a technique used by several Netherlanders; but he did this in an original way since he was very talented. The first work to bring him fame was a large upright plate representing All Saints, Holy Virgins, and Angels, very carefully and imaginatively done, with fine rare garments and faces, and beautiful colors.[3] In Venice he married and worked very industriously; he produced very many large and small pictures which were carried to all four corners of the world and sold there. Johann [Knotter] in Utrecht owned his beautiful *Ascension of Mary* as well as an *Actaeon and Diana,* excellently done; [4] these pieces contributed much to his being known in the Netherlands as one of the most praiseworthy masters.

Although the splendid works of his hands are being greatly admired almost everywhere, it is the beautiful city of Augsburg which has been especially enriched by his art. For he painted there a great deal; not only is there a large altar with All Saints in the Church of the Holy Cross [5] but also an excellent altarpiece in St. Ulrich's,[6] and who does not recognize his masterly brush strokes on the Gate of the Barefooted Monks? [7] Who does not praise the precious things in the newly erected house in the Grottenau which belongs to the art-loving Herr Hopfer and which he decorated with his paintings from the top to the very bottom on the street, and all around in court and garden? How charming is the loggia and the excellent art cabinet, in which the fine architecture was covered with poetic fables, stories, poems, grotteschi, lovely landscapes, and other well-conceived art treasures, so delicately represented on the wet plaster that this place is still being visited daily by potentates and art lovers and considered the most beautiful house with the finest frescoes in all of Augsburg; and this is also the reason for its having

[2] Hans Donauer, Rottenhammer's teacher, 1582–1588.

[3] Almost certainly the picture in the possession of Earl Spencer at Althorp which is indeed painted on a large copper plate; see Ingrid Jost, "Drei unerkannte Rottenhammerzeichnungen in den Uffizien," *Album Discipulorum aangeboden aan Professor Dr. J. G. van Gelder* (Utrecht 1963), pp. 67 ff.

[4] The latter is possibly the picture of 1602 in Munich (no. 1588), which van Mander could still have seen before publication of his passage on Rottenhammer.

[5] Still there, painted ca. 1610.

[6] An Annunciation of 1608 (Peltzer).

[7] An error of Sandrart; these frescoes are by Johann Freyberger (Peltzer).

been purchased by the art-loving Herr Eberz and kept in excellent shape to this day through careful restoration.[8] With no less application and effort, this noble hand executed much fresco work in the beautiful Steininger house, where it is still highly appreciated by all experts.[9]

But although he earned a large sum of money from emperors, kings, and other great art patrons through so many superb works in oil and in fresco, such riches have not benefited him; for he spent everything within a short time and lived constantly in great need. People who know him have told for a fact that he made about eighty thousand guilders but spent about eighty-two thousand; thus, at all times he expended more than he earned, with the result that after his demise good friends had to take up a collection in order to give him a decent burial. Other regrettable things which one could report about this excellent man will here be passed over in silence so as to prevent his great reputation as an artist to be blacked out in times to come because of his irregular way of life.

Heinrich Schickhardt on Freudenstadt

Heinrich Schickhardt (1558–1634) was one of the few outstanding German artists from the turn of the century whose writings are of a distinction comparable to that of his art. Besides his reports on Italian journeys made in 1598 and 1599/1600, his account of the origin of one of his most important and precocious architectural achievements, the city planning for the new town of Freudenstadt (Black Forest),[1] is of special interest.

Freudenstadt. This place I inspected first when it was still a forest; I had the ground investigated at considerable depth at many and various spots but found little that was good. Therefore I advanced my humble opinion that it was not advisable to build a town there. However, since His Most Serene Highness, my most noble Lord, Duke Frederick of Württemberg graciously uttered a desire for it, I designed a plan for a large town and castle, arranging it in such a way that each house was to have a court or a small garden, and that the castle was to be on the edge of the town. However, His Highness wished that behind and before each house there should be a street, and the castle in the center of the market place. Therefore I made another design conforming to His Highness's order, in which the town was square-shaped and each side measured 1418 feet (each side of the market place 780 feet) and the castle was to stand in the middle of the market place; and ac-

[8] The house was pulled down in the 19th century.
[9] Destroyed.
[1] Translated from the German text as given by Julius Baum, *Forschungen über die Hauptwerke des Baumeisters Heinrich Schickhardt . . . (Studien zur deutschen Kunstgeschichte,* CLXXXV [Strassburg 1916]), pp. 22 f.

cording to this plan the town has in fact been built.[2] Thus, in the presence of His late lamented Highness, and in the name of the Lord, I, Heinrich Schickhardt, on March 22, 1599, staked out part of such a town for the construction of several houses and streets; and within a few years there were spent on building from His Highness's purse alone more than one hundred thousand guilders, not counting the citizens' houses, of which there were 287 as of January 8, 1612.

[2] Both plans have been preserved (Staatsarchiv, Stuttgart). See the illustrations in Baum, *ibid.* The actual measurements differ from those given in the text: very little for the market sides, considerably more for the town sides (1798 instead of 1418 feet). The famous church, in which two naves meet at an angle of ninety degrees, was begun in 1601.

3

France

*Documents concerning French art of the 15th century are as rare
as the surviving monuments themselves, many of which—including some
of the greatest—have not accidentally remained anonymous. As in the
case of Netherlandish art of the same period, we shall have to call upon
Italians to supplement the small number of important reports, at least
for one outstanding artist, Jean Fouquet. The elaborate and highly
significant contract for Charenton's altarpiece of 1453 is a great ex-
ception.*

*In the early 16th century the situation improves considerably.
Jean Lemaire de Belges (above, p. 26) has given us many if desultory
hints on French as well as Netherlandish artists; more important, he was
closely connected with the vast and complex plans for the tombs at
Brou. After the Italian artistic "invasion" at Gaillon, Fontainebleau,
and elsewhere, the inspiration provided by southern painters, architects,
and theoreticians helped to foster artist-writers of high rank, such as the
architect Philibert de l'Orme. The literary great of the Academy and
the Pléiade were on the whole more passionately interested in music than
in the visual arts but made some interesting contributions to stage design
and official hommages to royalty; the last example quoted here consists
of a literary program drawn up by one of that group for a series of paint-
ings, a type of work not met with in the Netherlands and in Germany
but, strangely enough, encountered as well in our very earliest French
item.*

Jean Lebègue

*The following was written ca. 1410 by Jean Lebègue, secretary to
King Charles VI, bibliophile, and humanist, who was also greatly inter-
ested in the technical aspects of painting.[1] His "recipe" for twenty-two
illuminations to be used in a manuscript of Sallust's* Catilina [2] *was fol-
lowed closely by several artists, including the "Bedford Master," and
verbatim in a Geneva Manuscript from the circle of the same master,
written ca. 1415–1420. Frequent "notes pour l'enlumineur" found in
later manuscripts were doubtless based on similar treatises.*

Here begins the description of the scenes one can effectively in-
vent and depict from the book of Sallust, devised and put down in writ-

[1] His collection of recipes of painting etc. was published by Mrs. Merri-
field, *Original Treatises* . . . (London 1849); a new edition is being prepared
by Mme. L. Brion-Guerry.

[2] Jean Porcher, "Un amateur de peinture sous Charles VI: Jean Lebègue,"
Mélanges offerts à Frantz Calot (1960), pp. 35 ff. Professor E. Panofsky was
kind enough to call my attention to this fascinating publication. Translated
from the French text as given by Porcher after the original in ms. d'Orville
141, ff. 42-46 in the Bodleian Library, Oxford.

ing by me, J. Le Begue. And in order to understand said scenes better one has to know that Sallust, after the custom of the Romans, was introduced as a youth to the study and pursuit of letters, and after having applied himself to this sufficiently well he made the decision to serve the public good and the knightly estate. And when he had become aware of the fact that the vices reigned supreme and exerted greater power and predominance than the virtues, he resigned said estate of knighthood and returned to the pursuit of knowledge. And he conceived the wish and desire to put down in writing the acts of the Romans that had occurred at this time and of which he had knowledge, and this not according to the order in which they happened but according to the degree they seemed to him worthy of being remembered. Thus he decided to write first of all of the plot and conspiracy of Catilina, a noble citizen of Rome who wasted and whiled away his time in idleness and lust. . . . One can depict the first story as follows.

First Scene. Make and portray a man with a long bifurcated beard, on his head a white cap of the kind they used to wear. And he shall sit in a well-constructed pulpit and have before him the tablet on which he seems to write, and all that appertains to a writer when he sits in his pulpit and writes. And said writer shall be clad in a coat that is red or of some other color, with a low collar and open in front in such a way as to make visible, above and below, his coat of mail; and he shall also wear his greaves and golden spurs on his boots. And outside the structure of his pulpit one shall depict his squire or varlet mounted on a grey horse with gilt trappings, a lance with one banner in his left; with the other hand, said squire shall hold the horse of his master, with gilt trappings, and of this horse one shall see only the front half because the other half shall be covered or hidden by said pulpit, indicating that said writer abandoned knighthood for the sake of studies.[3] And the aforementioned varlet shall be placed in a beautiful plain in which grow plants and trees of various kinds; and furthermore the landscape of the scene shall be gracefully depicted on top.

* * *

Fourth Scene. How Catilina makes his companions drink wine mixed with his blood. Here, according to the text "Sed in ea conjuracione" one shall depict Catilina sitting in a chair, his valet before him holding his bare arm from which the blood runs into a small slender pot which Catilina holds in his right hand; below shall be a servant who holds a pot and a bottle full of wine and blood, and he shall hand the drink to the companions of Catilina of whom one can see here three or four. And

[3] This allegorical use of a seemingly simple "naturalistic" motif is of the greatest general interest.

in another section of the place one shall depict a man and a woman of high society talking to each other about said conspiracy.

* * *

Fifteenth Scene. How Vulturnus, examined about the exchange of letters and the alliance with the Gauls, confesses the truth. Here ("Post ubi fide publica") one shall depict the council; Cicero sitting in the chair, clad—as above—in mantle and fur-lined hat and wearing a long beard, and near him are sitting other council members. And before them, a man clad in armor, except for his bare head, is kneeling and handing several letters to the head of the council; and another shall hold several others, opened. And behind said soldier shall be a constable seizing said soldier from behind. And around him there shall be two or three men of Gaul. Also, at the feet of said council there shall be a clerk, seated behind his desk, who shall write down the confession of said soldier.

* * *

Twenty-second Scene. "Postremo ex omni copia." Here one shall depict a great multitude of dead people, heads and arms cut off, and people who despoil the dead; and around this place there shall be towns and villages from which several people have departed and are arriving at the place in order to identify their relatives and friends; they shall look like people in grief and anger. And among the dead there shall be Catilina, recognizable by his armor as he has always been portrayed, quite dead in all his armor.

Here ends the description of the scenes from Sallust's *In Catilinario*, devised by me, J. Le Begue.

Enguerrand Quarton

The altarpiece with the Coronation of the Virgin by Enguerrand Quarton (Charenton), who was born in the diocese of Laon ca. 1410 but was mainly active in Aix, Arles, and Avignon (1447–1466), was ordered for the Chartreuse du Val de Bénédiction at Villeneuve-les-Avignon by the priest, Jean de Montagnac, in 1453, and remained at its original site until 1835. (It is now in the museum there.) The preservation of the elaborate contract [1] for this great work is a most exceptional stroke of good luck. The freedom repeatedly granted the artist in the text was extended to various parts that were kept specific in the contract; however, these changes (not listed in the notes, but see Ch. Sterling's juxta-

[1] From Holt, I, 298 ff., with some emendations; based on the text as given by Charles Sterling, *Le Couronnement de la Vierge par Enguerrand Quarton* (Paris 1939), pp. 25 f. The first and the last two paragraphs are in Latin, the rest in French.

position of text and plates) may have been suggested or in any case accepted by the donor at a later stage of the work. However that may be, the position of the artist was a remarkably elevated one for that time, as may be gathered from a comparison with the contract signed by Dieric Bouts twelve years later (above, p. 10).

On the 24th day of April [1453], Master Enguerrand Quarton, of the diocese of Laon, painter, resident in Avignon, made a contract and agreement with the said Dominus Jean de Montagnac—both contracting parties being present—for painting an altarpiece according to the manner, form, and prescription contained and set forth article by article on a sheet of paper, which they passed over to me, written in French, whose tenor follows and is such:

Here follows the list of items of the altarpiece that Messire Jean de Montagnac has commissioned from Master Enguerrand, painter, to be placed in the church of the Carthusians, Villeneuve-les-Avignon, on the altar of the Holy City.

First: There should be the form of Paradise, and in that Paradise should be the Holy Trinity, and there should not be any difference between the Father and the Son; and the Holy Ghost in the form of a dove; and Our Lady in front as it will seem best to Master Enguerrand; the Holy Trinity will place the crown on the head of Our Lady.[2]

Item: The vestments should be rich; those of Our Lady should be of white damask with a design made according to the judgment of said Master Enguerrand; and surrounding the Holy Trinity should be cherubim and seraphim.

Item: At the side of Our Lady should be the Angel Gabriel with a certain number of angels, and on the other side, Saint Michael, also with a certain number of angels, as it will seem best to Master Enguerrand.

Item: On the other side, Saint John the Baptist with other patriarchs and prophets according to the judgment of Master Enguerrand.

Item: On the right [3] side should be Saint Peter and Saint Paul with a certain number of other apostles.

Item: Beside Saint Peter should be a martyr pope over whose head an angel holds a tiara, together with Saint Stephen and Saint Lawrence in the habits of cardinal deacons, also with other martyr saints as arranged by the said Master.

Item: At the side of Saint John the Baptist will be the Confessors—to wit, Saint Gregory in the form of a pope, as above, and two cardinals, one old and one young, and the bishops Saint Agricolus and Saint Hugh (Saint Hugh in the habit of a Carthusian), and other saints according to the judgment of said Master Enguerrand.

[2] On this iconography see D. Denny, "Trinity in Enguerrand Quarton's Coronation of the Virgin," *Art Bulletin*, XLV (1963), 48 ff.
[3] "Right" here refers to the right of the spectator.

Item: On the side of St. Peter should be Saint Catherine with certain other virgins according to the judgment of Master Enguerrand.

Item: On the side of Saint John the Baptist should be Magdalene, and the two Marys, Jacobi and Salome, each of whom holds in her hands that which they should hold,[4] together with other widows according to the judgment of said Master Enguerrand.

Item: In Paradise below should be all the estates of the world arranged by said Master Enguerrand.

Item: Below the said Paradise, there should be the heavens in which will be the sun and the moon according to the judgment of said Master Enguerrand.

Item: After the heavens, the world in which should be shown a part of the city of Rome.

Item: On the side of the setting sun should be the form of the church of Saint Peter of Rome, and, before said church at an exit, one cone of pine in copper,[5] and from that one descends a large stairway to a large square leading to the bridge of Sant' Angelo.

Item: At the left side of the above-mentioned, a part of the walls of Rome, and on the other side are houses and shops of all types; at the end of said square is the castle Sant' Angelo and a bridge over the Tiber which goes into the city of Rome.

Item: In said city are many churches, among them the church of the Holy Cross of Jerusalem where Saint Gregory celebrated mass and there appeared to Him Our Lord in the form of the Man of Sorrows; in which church will be painted the story according to the arrangement of said Master Enguerrand; in that story will be Saint Hugh, the Carthusian, assisting said Saint Gregory with other prelates according to the judgment of said Master Enguerrand.

Item: Outside Rome, the Tiber will be shown entering the sea, and on the sea will be a certain number of galleys and ships.

Item: On the other side of the sea will be a part of Jerusalem; first, the Mount of Olives where will be the cross of Our Lord, and at the foot of that will be a praying Carthusian, and at a little distance will be the tomb of My Lord and an angel below saying: *He has risen: He is not here: Behold the place where they have laid Him.*

Item: At the foot of said tomb will be two praying figures; on the right side, the valley of Jehoshaphet between the mountains, and in that valley a church where the tomb of Our Lady is, and an angel saying: *Mary has been taken up to a heavenly chamber, in which the King of Kings sits on a star-studded throne;* and at the foot of that tomb a person praying.

[4] I.e., their customary attributes.

[5] Now in the Giardino della Pigna, Vatican; described in the *Mirabilia Urbis Romae* of the 12th century (see Holt, I, 72).

Item: On the left will be a valley in which will be three persons all of one age; from all three will come rays of sun, and there will be Abraham coming forth from his tabernacle and adoring the said three persons saying: *Lord, if I have found favor in thine eyes, pass not thy servant by: Sit, I shall fetch a little water, and your feet will be washed.*

Item: On the second mountain will be Moses with his sheep and a young boy carrying the bag; and there appears to said Moses Our Lord in the form of fire in the middle of the bush and Our Lord will say: *Moses, Moses,* and Moses will reply: *Here am I.*

Item: On the right part will be Purgatory where the angels manifest great joy seeing that hence they [the souls] will go to Paradise, at which the devils show great sadness.

Item: On the left side will be Hell, and between Purgatory and Hell will be a mountain, and on the side of Purgatory above the mountain will be an angel comforting the souls of Purgatory; and on the side of Hell will be a very deformed devil on the mountain turning his back to the angel and throwing certain souls into Hell, handed him by other devils.

Item: In Purgatory and Hell will be all the estates according to the judgment of said Master Enguerrand.

Item: Said altarpiece shall be made in fine oil [6] colors and the blue should be fine blue of Acre,[7] except that which will be put on the frame,[8] that should be fine German blue, and the gold that will be used on the frame as well as around the altarpiece should be fine gold and burnished.

Item: Said Master Enguerrand will show all his knowledge and skill in the Holy Trinity and in the Blessed Virgin Mary, the other parts to be done according to the dictates of his conscience.

Item: On the back of the altarpiece will be painted a fine hanging of crimson [9] with a fleur-de-lis design.[10]

A promise was given, I declare, by the same Master Enguerrand to execute these things faithfully and according to the foregoing description, from the next [feast of] St. Michael, for the next one continuous year, for the price of one hundred and twenty florins, each at the value of twenty-four *sous* of the currency of Avignon. Toward the reduction of which sum of florins the said painter has acknowledged that he has had from the said Dominus Jean forty florins current, concerning which

[6] The actual medium is usually described as egg tempera; the question of oil admixture is still undecided.

[7] I.e., genuine ultramarine (from St. Jean d'Acre).

[8] The frame has not survived.

[9] "Cremesine" probably stands for "cramoisi," crimson red.

[10] Since the text speaks clearly of a *painting* on the back, the interpretation of this passage as referring to a canopy fixed at the upper part of the altarpiece is hardly acceptable.

the same painter has expressed his satisfaction, and made the said Dominus Jean quit of them. Valid etc. . . . , except if, etc. . . . The remaining sum the said Dominus Jean has promised to pay to the same Master Enguerrand as follows, viz.: twenty florins when the same painter shall have done one half of the said work; likewise, forty florins according to the work he does and in proportion to the work itself [i.e., the whole work]; and the remaining twenty florins immediately when the said work shall have been completed and placed in the said Carthusian church; and the said Jean has promised that he will arrange with the prior and community of the Carthusians that they will be liable to the said Master Enguerrand for the said remainder in the case of failure on the part of Jean himself, and by the same token they will refund each other the expenses. This contract to be made valid, etc. . . .

Done in the spice shop in the dwelling of Jean de Bria, spice merchant, citizen of Avignon, in the presence of, etc. . . ."

Jean Fouquet

The little we know about Jean Fouquet from French sources (see above, p. 26 for Jean Lemaire, and below, p. 151 for Pélerin) is significantly supplemented by the words of praise lavished on him by two native Florentines: by Antonio Averlino, who called himself Filarete, architect, bronze sculptor, humanist, and writer on art; and by Francesco Florio, a later resident of Fouquet's home town of Tours.

In his Tractatus de architectura, *written for Francesco I. Sforza about 1461–65, Filarete addresses the prince in the following manner on the availability of good painters in Italy and abroad for the decoration of the ducal palace at "Sforzinda."* [1]

If you would like, we could look beyond the Alps to see if there are any good ones. There was a very good master called Giovanni da Bruggia.[2] He too is dead. I think there is a master Ruggieri [3] who is very good. There is also a Frenchman called Grachetto; [4] if he is alive he is a good master, especially for doing portraits from life. He did a portrait in Rome of Pope Eugene and two of his retainers that seemed to be really alive. He painted this on linen and it was placed in the sacristy of the Minerva.[5] I say this because he painted it in my time.

[1] From *The Trattato of Antonio Averlino, Filarete,* ed. and trans. John Spencer (New Haven: Yale University Press, 1965), I, p. 120. The original spellings of the names have been restored.

[2] Jan van Eyck.

[3] Roger van der Weyden.

[4] Jan Fouquet (as reference to the same work by Francesco Florio proves; see below, p. 146). Vasari's spelling varies from Fochetto to Foccora.

[5] Note that Florio, too, speaks of this work—which seems to be lost—as an early effort of Fouquet (below, p. 146). The picture is also mentioned by Vasari-Milanesi II, p. 461.

Francesco Florio's praise of Fouquet occurs in a treatise he wrote in 1477 in the form of a letter addressed to his friend Jacopo Tarlati: [6]

. . . Here [in Notre-Dame-La-Riche at Tours] I can compare the representations of the saints from older times with the modern ones, and I reflect on how much Johannes Fochetus excels the painters of all other centuries in his art. This Fochetus of whom I speak is a man of Tours who is not only a more skillful painter than his contemporaries but also has outstripped all ancient ones. Let antiquity boast of Polygnotus, let others sing the praises of Apelles! As for me, I should consider it a more than satisfactory achievement if I could match with appropriate words his outstanding accomplishments as a painter. And to convince yourself that I am not waxing poetic you may savor a sample of the art of that painter in our sacristy of the Minerva if there you care to look at the portrait of Pope Eugene, painted on canvas; [7] although he painted this in his early days, his penetrating vision has enabled him to render a perfect likeness. Do not doubt that I am writing you the truth; this Fochetus is capable of producing living images with his brush and almost of imitating Prometheus himself.

Michel Colombe

The tombs at Brou near Bourg-en-Bresse have a long and extraordinarily complicated history.[1] *They were planned by Margaret of Austria, the young widow of Philibert of Savoy, shortly after the Duke's early death in 1504, as a triple monument for him, his mother Margaret of Bourbon, and Margaret of Austria herself, and as the core of a new church to be erected over them. The Ten Virtues described in Jean Lemaire's* Couronne Margaritique *(see above, p. 27) as ornament of the crown were adapted as tomb statues at an early date, certainly under the influence of Lemaire himself; he was the author of a treatise on ancient and modern funeral ceremonies and the mediator between Margaret and Jean Perréal as designer of advanced plans for the tombs (1509), for which his own advice was sought as well, particularly with regard to the material (alabaster) to be used in their execution. The extent of his own interest in this enterprise emerges clearly from the following contract,*[2] *concluded between Lemaire as plenipotentiary of Margaret and the aged Michel Colombe in Tours, whose participation*

[6] *Francesci Florii, florentini, ad Jacobum Tarlatum Castellionensem, de probatione Turonica.* Translated from the Latin text as published by A. Salmon, "Description de la Ville de Tours sous le règne de Louis XI, par F. Florio," *Mémoires de la société archéologique de Touraine,* VII (1855), 82 ff. (105).

[7] See note 5 above.

[1] Paul Vitry, *Michel Colombe et la sculpture française de son temps* (Paris 1901); Pierre Pradel, *Michel Colombe* (Paris 1953); P. A. Becker, *Jean Lemaire* (Strassburg 1893).

[2] Translated from the text as given by P. Vitry, *op. cit.,* pp. 487–90.

Perréal had urged. Not much later both Lemaire and Perréal left Margaret's services, and Michael Colombe's plans were eventually abandoned—fortunately, one is now tempted to say, because this development led to the choice, in 1526, of the great Konrad Meit (see above, p. 106) as the new and definitive sculptor of the tombs.[3] Nonetheless, the contract of 1511 is one of the most enlightening documents of its kind.

I, Michiel Coulombe, resident of Tours and sculptor to the King, our Lord, in my own and personal name as well as in the name of Guillaume Regnault, sculptor,[4] Bastyen François, master mason of the Collegiate Church of St. Martin at Tours,[5] and of François Coulombe, illuminator [6]—all three of them my nephews—acknowledge, promise, affirm, and certify upon the faith of a gentleman that the following statements are correct, for the present and the past as for the future; and this I do for the discharge and acquittance of Jehan Lemaire, chronicler and surveyor of buildings for the very exalted and excellent princess, Madame Marguerite, archduchess of Austria and Burgundy, widowed duchess of Savoy, and Countess Palatine of Burgundy.

To wit, first of all I acknowledge, in the name of the above, that I have got and received from my said lady, by the hand of her said chronicler, Jan Lemaire, the sum of ninety-four German gold florins (each at twenty-seven sous and six denarii), which amount to the sum of 128 livres and thirteen sous in royal money at the present rate. And this is for our trouble, labor, and salary in making the small-scale model of the tomb of the late nobleman of honored memory, Monseigneur the Duke Philibert of Savoy, husband of my said lady, after the design and excellent disposition made by the hand of master Jehan Perréal of Paris,[7] painter and private secretary to the King, our Lord; with which sum of ninety-four German gold florins (amounting to said sum of 128 livres and thirteen sous) I declare myself satisfied and fully paid and without further claim, in the name as above, of said Jan Lemaire, agent of Madame, and all others to whom it may appertain. And for this tomb, I, the aforesaid Michel Coulombe, shall make with my own hand, without anybody else but myself touching it, the terracotta models, in the size and extension indicated in the two sketches I am sending to my said lady, one a ground plan showing the *gisant*, the other an elevation, said drawings having been made by the hand of the aforesaid François Coulombe, illuminator, and Bastyen François, mason, my nephews. And said Bastyen shall make of hard stone the entire masonry used in said small-scale

[3] See now E. Panofsky, *Tomb Sculpture* (New York 1964), p. 78.

[4] Guillaume Regnault succeeded his uncle Michel Colombe as sculptor to Anne de Bretagne in 1512.

[5] Sébastien François, son-in-law of G. Regnault, architect and sculptor at Tours.

[6] François Colombe, died in 1512.

[7] On him see above, p. 27.

tomb in correct proportions and measurements, in such a way that by converting [in her mind] the small scale to the large, Madame will be able to see the whole tomb of the said late Seigneur of Savoy, within the period before Easter, provided no trouble or accident befalls said Coulombe during that time; and of these models I faithfully promise, with the help of God, to make a masterpiece according to the possibilities of my art and skill.

In addition, seeing that said agent Jan Lemaire has informed us that Madame desires to be served on her buildings by mature, solid, wise, reliable, self-assured, experienced, well-behaved people, and considering, as is meet, the expectations attaching in particular to those I have named above, I shall assure my said lady that they are such; now, as in the past, I affirm and testify that the sculptor Guillaume Regnault, my nephew, is able and experienced enough to execute in large scale the carving of the figures used in said tomb, following my models; for he has served and aided me in such matters during forty years or so, in all large, small, and medium-sized undertakings which by the grace of God I have had in hand up to now, and shall still have as long as it pleases God. Specifically, he has served and aided me very well in the last work I have finished—that is, the tomb of Duke François of Bretagne, father of the queen,[8] of which tomb I am sending Madame a sketch. As to said Bastyen François, son-in-law of that nephew of mine, I can vouchsafe that he is capable of utilizing and executing on a large scale the models of said tomb, with regard to masonry and architecture. These models will be made in small size by his own hand.

After these models have been finished, prior to Easter (as said above), and covered with white and black color, as required by the nature of the marble, by said François Coulombe, illuminator; and after the tablet of gilt bronze and the borders, ermine-coated arms, flesh tones of faces and hands, inscriptions, and all other pertinent materials have been furnished wherever required, I, the undersigned, promise to have the afore-mentioned Guillaume Regnault, my nephew, and Bastyen François, his son-in-law, take said small-scale tomb to Madame, wherever she may be, prior to the day of the Purification of our Lady.

With this we shall send the relief model of the ground plan of her church, particularly as it refers to the tombs of the two princesses, of which we have the drawing and pictures, made by the hand of Jehan de Paris; furthermore, said Bastyen François will bring the model and the elevation of the portal and of the flying buttresses; in order that these things be made by said Bastyen François, I have retained the duplicate of the ground plan of said church of the convent of St. Nicolas of Tolentino near Bourg en Bresse, which ground plan was made and very well

[8] Tomb of Duke François II of Bretagne and Marguérite de Foix, erected in the Cathedral at Nantes by Michel Colombe and Girolamo de Fiesole after 1499; E. Panofsky, *op. cit.*, p. 75 and fig. 327.

arranged on the spot, with measurements by the hand of master Jehan of Paris, with the advice and in the presence of master Henriet and master Jehan de Lorraine, both of them very great experts in the art of masonry.[9]

And when the aforesaid Guillaume and Bastyen, my nephews, will have presented to my lady said small-scale tomb, and after the latter has been set up in her presence and all its circumstances and appertaining matters explained, I shall willingly undertake (if Madame so wishes) the task and further work of having it converted to large size by said Guillaume, sculptor, and Bastien, mason. I shall send them to the place of said convent near Bourg en Bresse, together with Jehan de Chartres, my pupil and assistant,[10] who has served me for eighteen or twenty years and is now sculptor to Madame de Bourbon, as well as other assistants of mine for whose artistic skill and probity I shall stand responsible and by whom I am sure I shall not suffer shame or disadvantage.

And as to the fact that on account of my age and slowness I cannot betake myself to said place in person: I would otherwise have done so willingly for the sake of the honor, excellence, and goodness of that very noble princess.

And to bring all this about, in case Madame should be advised to carry out her good intentions through the labor of myself and my people, I herewith (as before) recognize, ratify, and consider valid, firm, and approved all financial arrangements which said Guillaume, sculptor, and his son-in-law, mason, shall conclude with my said lady in my and their own name regarding said tomb and other matters concerning our art of sculpture and architecture, even as if I myself were present; and upon their departure I shall, if necessary, give them express power of attorney for it, as I have done before.

And in order that the journey to the country of Flanders, which is as yet unknown to my aforesaid nephews, may become more secure and safe for them, it has been arranged that Jan Lemaire leave or send us here an agent and a guide to conduct my said nephews to that place; to wit, his nephew Jehan de Maroilles and his servant Jehan Poupart. And we have agreed with said Jan Lemaire that each of my said nephews shall have per day, counting from their departure from this city of Tours (which I shall certify by letter until their return), the sum of one philip d'or, worth twenty-five sous, except if Madame prefers to pay a fixed sum and to recognize their labors and endeavors, since I and my people have complete confidence in Her Excellence of great renown, whom we all desire to serve with all our heart, if she so wishes.

[9] Both mentioned in Perréal's letter of October 8, 1511, addressed to Barangier, as having come to an understanding with him regarding the erection of the church at Brou designed by him.

[10] Jean de Chartres, sculptor at Tours ca. 1493–1511; no works of his are known.

In addition, said Jan Lemaire has brought us a piece of alabaster marble from St. Lothain-lès-Poligny, in the county of Burgundy, where he has recently discovered a quarry or stone deposit.[11] As we have learned on reliable authority, this was once held in great repute and esteem; and at the Carthusians at Dijon, several of the tombs of the late noble dukes of Burgundy have been made from stone quarried there, particularly by master Claux [12] and master Anthoniet,[13] sculptors of the first rank with whom I, Michiel Coulombe, was once acquainted.[14] And at the request of said Jan Lemaire, I have carved, with my own hand, a face of St. Margaret; and my nephew Guillaume has polished it and got it up. Of this I am making a small present to my said lady and pray that she be pleased to receive it graciously.

I certify and affirm that, provided said stone is quarried in good season and the ancient layers uncovered with large and ample clearings made on the right spot, this is a very good and very safe alabaster marble, very smooth and very easy to polish to perfection, and a great treasure found in the country of my said lady, without having to search for other marble in Italy and elsewhere; for the others are not at all so easy to polish and do not preserve their white color, but rather turn yellow and dim with age.

All these things said above I acknowledge, promise, affirm, and certify as true and, as above, promised, assured, and agreed upon between said Jan Lemaire, agent of Madame, and myself; in witness whereof I have signed this with my own hand, on the third of December, 1511.

And for the assurance of both sides, I have requested the learned and discreet gentleman, Macc Formon, royal notary and public officer, citizen of Tours, to subscribe and sign this with me.

Likewise, the aforesaid Jan Lemaire, imperial notary and agent of my said lady, has subscribed and signed this, in testimony of the truth and under the obligations and declarations necessary for both parties, specifically that of said Lemaire concerning the promise and assurance of payment for the journey of my said nephews and, so far as it is in his power, to arrange the affairs to the honor and profit of my said lady and of myself, her very humble and obedient servant.

M. COLOMBE,—FORMON,—LEMAIRE, *Indiciaire*,[15] DE BELGES

11 The exploitation of this quarry was to play a decisive role in Lemaire's financial plans for some time.
12 Claus de Werve?
13 Antoine Le Moiturier, sculptor of Avignon, from 1462 active in Dijon.
14 Colombe was only about eight years old when Claus de Werve died (1439).
15 This is the title I have translated as "Chronicler" above.

Jean Pélerin

The French priest Jean Pélerin (Johannes Viator) occupies a modest place in the history of theoretical art treatises with his De artificiali perspectiva, *first published at Toul in 1505 and in a second edition in 1509. A later edition of 1521 [1] contains, for the first time, a rhymed dedication to outstanding artists of the previous and present generations in an adventurous mixture which may partly be due to the exigencies of the rhyme, but which, nonetheless, poses a number of fascinating questions of prestige and even of identification. It would be hopeless to attempt a translation into English verse. The names have been left in Pélerin's spelling, with a few obvious exceptions.*

Oh my good friends, deceased and still alive, great minds worthy of Zeuxis and Apelles, ornaments of France, Germany, and Italy: Geffelin,[2] Paul and Martin of Pavia,[3] Berthélemi,[4] Fouquet, Poyet,[5] Copin,[6] Andrea Mantegna and Colin of Amiens,[7] Le Pélusin,[8] Hans Fris [9] and Léonard,[10] Hugues,[11] Lucas,[12] Luc,[13] Albert [14] and Benard,[15] Jehan Jolys,[16] Hans Grün [17] and Gabriel, [18] Vuastale,[19] Urbino and Michelangelo, Symon du Mans; [20] diamonds, pearls, rubies, sapphires. . . .

[1] Here translated from the French reprint in *Jahrbücher für Kunstwissenschaft*, ed. A. Zahn, II (1869), 241, with the article by Ed. His-Heusler, "Nachträgliches über Hans Fries" (pp. 241–43). This reprint was taken from Alexandre Pinchart's document addenda to Crowe-Cavalcaselle's *History of Flemish Painting* in the French edition of 1862–1863.

[2] Hans Schäuffelein.

[3] Unidentified.

[4] Bartolommeo Montagna?

[5] See above, p. 26.

[6] Probably Coppin Delf, painter in the service of René d'Anjou and Kings Louis XI and Charles VIII of France, active 1456–1488.

[7] See above, p. 28.

[8] Perugino.

[9] Hans Fries; see note 1 above.

[10] Presumably Leonardo da Vinci.

[11] Hugo van der Goes.

[12] Lucas Cranach.

[13] Lucas van Leyden.

[14] Albrecht Dürer.

[15] Pinturicchio?

[16] This could either be Giovanni Bellini or an error for *Martin* Hübsch," i.e., Martin Schongauer.

[17] Hans Baldung Grien.

[18] Possibly Gabriele da Vaprio, active in Milan between 1452 and 1481.

[19] Looks hopeless, but may possibly stand for (Pieter) van Aelst, who did the famous series of tapestries after Raphael ca. 1515–1519.

[20] Simon Hayeneufve, architect, sculptor, and painter, active in Le Mans from ca. 1495 to 1528.

Pierre de Ronsard

The constant preoccupation of the greatest poet of the Pléiade, *Pierre de Ronsard (1524–1585), with the ancient and modern theories of music, together with the continuous discussion of this subject in Baïf's* Académie, *produced an interesting passage in one of the poet's Palace Academy discourses.*[1] *In it he submitted to Henri III what one may call an "Ut pictura musica" theory of his own.*

When you see, Sire, an excellent picture by the Fleming,[2] well proportioned, with the colors well put on and the lineaments well drawn, the parts of which, by a fine and ingenious symmetry, are related to one another with an air and with perspicacity, that picture suddenly constrains you to admire it, and, quite ravished, you contemplate it, you fix your eyes upon it. Such a picture pleases and charms you, and, if one may speak thus, it tickles you, because the subject which is presented to your eyes in this well-proportioned manner moves you pleasantly and sweetly agitates the sense of sight.

On the contrary, when you see a horrible and hideously ugly monster, such an object, which is not the friend of nature, infinitely displeases you.

When you hear a well-tuned lute, the gentle harmony and sweet symphony of the strings artfully touched by a learned hand move you and gently agitate the sense of hearing, so that you are quite rejoiced.

On the contrary, when you hear an ass braying, or a great noise of bells or of a torrent, this confusion, vehemence, and violence, which are not the friends of nature, annoy and displease you.

Germain Pilon

The triumphal arches and other monuments erected during the 16th century for the solemn entries of kings and queens into their capitals belong to the most spectacular public displays of what one might call ephemeral art of the highest order. The custom, well founded in 15th-century Italian art, reached a first climax in France under Henri II (1549, with the collaboration of Jean Goujon) and a second on the occasion of the entry of Charles IX and, three weeks later, of his Queen, Elizabeth of Austria, in 1571. The programs for these elaborate structures, which were erected by carpenters, sculptors, and painters at main

[1] Quoted in the translation by Frances A. Yates, *The French Academies of the Sixteenth Century (Studies of the Warburg Institute,* ed. F. Saxl, XV [London 1947]), pp. 141 f.

[2] Corneille de Lyon, according to Roger Gaucheron (*Mercure de France,* December 1924, pp. 606 ff.).

points of the royal procession from St. Lazare to Notre-Dame, were prepared by the greatest poet of the Pléiade, *Pierre de Ronsard, who received 324 livres tournois for his services, and who was assisted by Jean Dorat. Ronsard's original advice survives in a few poems, in a description published in 1572 by Simon Boquet, and in quotations inserted in the document accompanying the contract which the sculptor, Germain Pilon, and the painter, Niccolo dell'Abbate, signed with the Paris authorities on October 11, 1570. This contract held them to deliver the vast amount of work expected of them "within the next six weeks." Worse: after the king had finally made his entry on March 6, 1571, without his queen (who was sick or pregnant or both), hers was unexpectedly announced for the 29th of the same month, with the result that frantic calls went out to utilize the existing decorations, which had not yet been removed, for a new program especially designed for the queen's entry. The contract for this revised work was signed by Germain Pilon alone on March 17, 1571, no more than twelve days before the event.*

The elaborate program for the decorations was expounded in detail by Boquet in 1572; it is of the utmost complexity and was certainly one of the sources of van Mander's and Ketel's allegorical refinements (see above, pp. 70 ff. and 51 ff.). Only a few main points will be explained in the notes to the texts that follow; the literature quoted there, together with the pertinent literature on Ronsard, will have to be consulted for additional information.

This is the statement concerning the works of architecture, sculpture and painting which are to be executed for the Entry of the King and the Queen into Paris on the triumphal portals and arches that said city plans to have erected in the places and locations mentioned hereafter, to wit: the Porte Saint-Denis, the Fontaine du Ponceau, the Porte aux Peintres, before the Sepulchre, the Fontaine des Saints-Innocents, and the Pont Notre-Dame.[1]

Firstly, at the Porte Saint-Denis shall be erected a portal eleven feet wide in the clear which shall measure fifteen feet from the bottom up to the keystone. This portal shall have a rusticated front according

[1] Quoted after L. Douet-d'Arcq, "Devis et marchés passés par la ville de Paris pour l'entrée solennelle de Charles IX, en 1571," *Revue archéologique,* V (1848–1849), 519 ff., 573 ff., 661 ff.; this statement, on p. 579 ff., taken from the *Registre de l'Hotel de Ville.* Reprinted also by Jean Babelon, *Germain Pilon* (Paris 1927), p. 38 ff. The "Bref et sommaire receuil . . ." by Simon Boquet appeared in Paris in 1572; it contains a slightly varied text and, most important, sixteen woodcuts pertaining to this document and to the one on the queen's entry. Some of these woodcuts are reproduced by Babelon, by Frances A. Yates, in "Poètes et artistes dans les entrées de Charles IX et de sa reine à Paris en 1571" (Jean Jacquot, ed., *Les Fêtes de la Renaissance,* I [Paris 1956], 61 ff.) and by Sylvie Béguin, "Niccolò dell'Abbate in France," *L'Art de France,* II (1962), 113 ff. (144).

to what the architects call the Tuscan order. The side structures of the front shall be nine feet wide on either side, which makes a total of twenty-nine feet for this entire front.

On either side, measuring nine feet in width, there shall be a stylobate or pedestal, four and one-half feet high, ca. five and three-quarter feet wide, and two feet deep. This pedestal to be decorated at the bottom and top, according to its shape, with rusticated plates; and there shall be a tablet for writing in the description of the figures which will be placed upon these stylobates. Upon the latter there shall be small supports as bases for said figures that are to be placed in front of the niches on said sides; these shall be eight feet high, and about three and one-half feet wide, made according to the program provided by the poet, Monsieur Ronssard. These figures, together with their ornaments, two garlands and pedestal, shall be painted on canvas.

The first figure, on the dexter side, shall be called *Majesty*. She shall be without armor, of a grave countenance and redoubtable mien, clad in a very sumptuous blue mantle, holding a large scepter in one hand and a staff of justice in the other, and shall have many small scepters and small crowns strewn all around. She shall wear a tiara on her head, more or less of the kind one makes for the pope. Her feet shall be placed on top of several towns, and she shall seem to look at the other figure and show her her scepter.[2] And under this figure, on the tablet or stylobate, shall be written: . . . (blank).[3]

On the sinister side, upon the other stylobate and in front of a like niche, shall be placed another figure, in the shape of a young woman, strong and armed in the antique manner, which shall represent *Fortune* and have another *Fortune* under her feet. She shall have wings that are broken in the middle [4] and shall seem to tender a palm to *Majesty*. In the other hand she shall hold the head of the *Gorgon* or *Medusa*.[5] And on the tablet of her pedestal shall be written in Greek: . . . (blank).

As architectural decoration above said figures will serve a projection carried by two brackets, and under the top part there shall be a thick hanging garland as an added decoration, and this shall be painted. And on that projection, over said brackets, there shall be a writing tablet under the cornice which runs along the front of said portal, between the rusticated parts and above the keystones of the arch; and on it, on the center keystone, shall be carved a large mask, and in other places, distributed among the rusticated stones, there shall be made and carved the likenesses of plants, ivy, snails and other objects, which will give the

[2] The features mentioned in this sentence are omitted in the woodcut (illustrated in Yates, fig. 1).

[3] The inscription is found in Boquet's text; none in the woodcut.

[4] No wings are visible in the woodcut (see note 2).

[5] On her shield in the woodcut.

whole the semblance and appearance of something much ruined by age. And above said cornice there shall be seen a composition extending along the said front, carried on both sides by bases or pedestals, which shall be executed in painting and shall carry figures, made of sculpture and seven to eight feet high: on the dexter and sinister side shall stand the statues of *Francion* and *Pharamon,* armed, looking at each other, and holding drawn swords in their hands.[6] The hilt of the sword shall be surmounted by a royal crown. Near the head of *Francion* one must place an eagle in flight, and under the feet of said *Francion,* on his pedestal, shall be made a running wolf, in painting.

Near the head of said *Pharamon* one shall place a raven who shall carry in his beak ears of corn, made in relief like the statues.

And under the feet of said *Pharamon,* on the stylobate, there shall be a cow which seems to be grazing, and this shall be painted.[7] And above the center of the portal, dominating said composition, the gabled part shall form a rusticated frontispiece, and above it shall rise the arms of France, crowned with the royal crown and insignia, and as a triumphal emblem there shall appear below said arms and above the gable, cornucopias overflowing with fruit made in relief by the sculptor, together with other ornaments and decorations as shown in the design and model already made for it; and its woodwork at the cornices, frieze and architrave shall be made by the carpenter.

As to the Fontaine du Ponceau, there shall be placed on it the statue of a goddess who raises both her hands above her head; and in her two hands she shall hold a map full of towns, rivers, boroughs and villages, which map shall be made by the painter, in painting. And said goddess shall resemble the Queen as closely as possible.[8] And above shall be written: *Gallia.* Said goddess shall give the impression of vigorous exertion.[9] Near her feet one must place a crane, a dolphin, a rabbit with open eyes, and on her two sides two herms, three feet high. And the statue of said goddess shall be five to six feet high. And in order to carry said statues, there shall be made some ornament upon said fountain. And on one of said herms shall be placed a square stone, and around said stone, books well closed with large clasps; from the center of this stone shall rise a scepter, and above it, a large eye and an ear. And at the

[6] Francion and Pharamond are mythical ancestors of the Kings of France. Ronsard was then already busy composing his *Franciade.* His poem "Pour la statue de Francion qui ornoit un arc de triomphe eslevé à la porte Sainct-Denis" was reprinted by Prosper Blanchemain, *Oeuvres inédites de P. de Ronsard, gentilhomme vandomois* (Paris 1855), p. 48.

[7] On the meaning of the running wolf and the grazing cow see Yates, p. 64.

[8] The queen-mother, Catherine de' Medici, responsible for the august marriage of her son and for the pacification of France. The Fontaine du Ponceau was on the rue de St. Denis.

[9] "Fera semblant d'enhanner." See Douet-d'Arcq, p. 581, note 3.

lowest end of the small pillar, a crane and a rabbit. On the other side, upon the other little pillar, one ought to paint a large cup and two hands holding it, and above the hands, hearts tied to each other with a love band which shall completely surround the handle of the cup. And above the hearts one ought to place a lute; and further, on top of the cup, a sword with a broken point. And under the feet of the goddess there shall be *Artemisia, Lucretia* and *Camilla*,[10] dressed in royal garb. Further, here and there as decoration of said fountain, shells and covered lions' mouths which seem to spout water. All this of painted sculpture according to need and command.

As to the Porte aux Peintres, it shall have a clear width of twelve feet at the bottom, and under the keystone a height of twenty-five feet, and a depth of approximately twelve feet from outside to outside. This portal or triumphal arch shall have two fronts in the Corinthian order, enriched by decoration in all its parts.

As to a description of each front:[11] There shall be two large stylobates projecting at the base in order to bear the full-round columns on these stylobates. These stylobates shall be provided with their projections, base and cornice; and between, there shall be a kind of frame for the insertion of a picture. Upon these stylobates in their entirety one shall place, on both sides, two columns; they shall be twenty-five and one-half inches in diameter and eighteen feet high, including bases and capitals. These columns shall project fully in the round and be fluted or striated from the third part up. They must also be provided with bases and capitals, enriched with foliage, cartouches and rosettes, as befits this order. And said two fronts shall have eight columns, four on each side, made of sculpture, striped and fluted as indicated. And between these columns, on decorated bases, there shall be large figures, seven to eight feet high, devised by said Ronssard. These bases shall be painted.

One shall also decorate the arch above the impost with painting. Over the voussoirs of said arch there shall be a trophy, likewise in painting, in addition to the arms of the king which rest upon the keystone of said arch, which is decorated with the royal crown and insignia. All this is part of a large triumphal decoration which shall be in the center of said portal, placed against the architrave and frieze, under the cornice. These arms shall be made in sculpture.

Upon the capitals one shall place the architrave, frieze and cornice, which shall also extend over the projection of said columns. Said cornice and frieze shall be decorated, in painting, with foliage work; the moulding of the architrave shall also be decorated in painting, and the upper edge of the architrave with hanging rosettes.

[10] The printed text adds Clelia and gives a detailed explanation of the symbolism of all features mentioned here.
[11] See note 12.

Above said cornice shall rise [the part in] the composite order, decorated all over with small cornices, friezes and picture frames, and in the center one shall make a large picture; and over said columns one shall do likewise, or make inscriptions to denote and describe the representation of the figures arranged in their various places, on the sides as well as in the center of said composite order or front. And in order to render prominent said center there shall be a small support which holds a tablet for the inscription pertaining to what will be placed above.

The whole of said work, as far as the architecture is concerned, may reach a height, from the bottom to the top of the front, of approximately six fathoms. And all of it is to be made according to the design and model, and with due regard to the proportions and refinements, as is meet. The fruit decoration of the archivolts shall be of painting, according to counsel; and the projections and cornices are to be made by the carpenter.

The height of the figures to be placed on top of said Porte aux Peintres, near St. Jacques de l'Hospital, shall be seven feet; that of those between the columns, from six to seven feet. There follows the description of all these figures according to the prescription of said poet:

In the center, on top of one of the fronts,[12] one shall place a vase and, above it, a crowned heart; small infants carrying the urn, and an eagle who with his claw seems to draw and pull said urn toward heaven; around this, one shall make some clouds from which drip down grain or manna. This pertains to the late King Henri [13] and to his children who lament him.

On the right side of the first front there shall be Hercules as an infant who with his strong hands suffocates the serpents.[12] On the other side, Hercules as an adult, with the by-name Alexicaren,[14] who with one hand seems to be strangling Anthec.[15] This Anthec shall have one hand on the ground, and from the ground people seem to be being born.[16]

Below, on the supports between the columns, there shall be made,

[12] Yates, fig. 2; Béguin, p. 144. However, this woodcut is a mixture of the appearance of the Porte aux Peintres during the entry of Charles IX and the Porte St. Denis during that of the queen, because the young Heracles has been replaced with Charlemagne or Pepin (see below, p. 162). An annotated drawing in Stockholm, on the other hand (by Camillo dell'Abbate? Béguin, p. 144), follows the present instruction meticulously, showing the young Heracles with the serpents, the striated columns, etc. (see also note 16).

[13] Henri II.

[14] Alexikakos (he who averts misfortune); see Babelon, p. 20.

[15] Antaeus. The Ronsard poem for this statue: Blanchemain, p. 48.

[16] This is a confusion with the Cadmus story which was represented in the painting in the center; however, the Stockholm drawing (see note 12) faithfully renders this mistaken advice. On Charles IX as Cadmus and on the cycle painted for the banquet hall on the occasion of the queen's entry see Yates, p. 68 ff.

on the first front, two figures of equal height (six to seven feet), according to the design and model already handed over.[17]

On the other front of the same triumphal arch, there shall be, at the top, an armed king [18] and in front of him, two goddesses holding each other's hands, to wit *Fortune* and *Virtue*. And below the feet of *Virtue,* a globe placed on the ground.

Upon the pedestal, on the dexter side, shall be placed a nymph representing *Paris;* at her feet she shall have a river. Around her should be distributed many books, the horn of Amalthea and a Balance. In her hands she shall hold the caduceus of Mercury, and she should seem to present, in great reverence, a ship made of silver, in which, on top of the masthead, one sees a golden fleece, and beside it a dog whose face is turned toward his back.[19]

On the other side shall be placed the figure of a large woman, her head crowned with cities and towers, in one hand a lance, and in the other, ears of corn and grapes; one of her feet is made of gold, the other of silver.[20]

Below, upon the supports of the columns, on this side also two figures.[21]

For the area in front of the Sepulchre, and opposite the Fontaine des Innocents, shall be made two large colossi.

To wit: Two large pedestals or stylobates in the Tuscan or Doric order. And in order to give sturdiness to said stylobates, the first plinths shall be placed on two low steps; this will prevent horses and people from coming too close and damaging said colossi. These stylobates shall be about twelve feet high from the bottom. Upon the cornice of said pedestal which shall be a plinth decorated all around with corner decorations shall be imitations of plates in rustic stone; and between them, on each front, there shall be made the imitation of a large handsome stone. Furthermore, the base of said stylobate shall have a thick round moulding, with its square part, and in such proportions that it fits into said Tuscan order. The height we are giving it shall be proportionate to its width. Above the cornice or plinth, as decoration of the four corners, there shall be large birds, resembling eagles, which support garlands all around. Above these garlands shall be the support for the base; it shall carry, and serve as foundation for, the figures or said base. Around this

17 These are actually described in the paragraph after the next; the scribe became confused here.

18 Henri II; see below, note 35.

19 The figure is seen in this form in the Stockholm drawing (see note 12) but altered in the woodcut.

20 Shown in both the Stockholm drawing and the woodcut.

21 This again refers to the *second* front. The figures were those of "Monseigneur" (the Duc d'Anjou) and "Monsieur le Duc" (the Duc d'Alençon). Ronsard's poem on these figures: Blanchemain, p. 48 f.

shall be written or painted the explanation of said figures. These pictures of the pedestal shall be made in painting by the painter.

And as to the colossus on the right, this shall be the statue of *Hymenaeus*,[22] crowned with flowers, enveloped in marjoram and clad in a long, orange-yellow cloak slung over the shoulder; in his right hand he shall hold a torch, in his left a yellow veil; on his feet he shall wear yellow lace-boots made after the antique manner as of saffron; he shall wear a small downy beard and full hair. Around him shall be placed four torches—no more than that, which with the one he shall hold in his hand makes five; small kids, crows and turtle-doves. He shall have below one hand a small cupid who shall wear a belt with a large buckle, have his bow and quiver, a small sphere which with his feet he causes to roll, and, all around him, many lilies and oranges, roses and poppy. With the other hand he shall lean on a small statue, strong and of beautiful countenance, with full hair and many bags split asunder; out of one shall emerge children's heads, out of others birds, other animals and the inscription.

On the other side of *Hymenaeus* shall stand a goddess of somewhat advanced age who shall have large, cow-like eyes, gilded shoes and a scepter of gold; on her head she shall carry a bird of prey like a sparrow-hawk or a small falcon which has yellow feet and an un-crooked beak, and near her head shall also be a crescent. This goddess is called *Junon Nompride*.[23] Around her feet shall be distaffs and spindles. Said figures of *Hymenaeus* and of the goddess just described shall be from eight to nine feet high.

As to the Pont Notre-Dame and the two portals to be erected there, their architectural order shall in both cases be an approximation of the Tuscan order. Their clear width shall be twelve feet, their height twenty-two feet to the keystone, their depth six feet. And according to the final form and statuary planned for them by Monsieur Ronssard, a strange and rustic structure is to be used,[24] consisting from the bottom to the height of the architrave of rocks, with the decoration of the arch likewise suggesting rocks; the stones shall look as though they were losing their mortar. There shall be snails' shells and fishes for the water which seems to run from that rock. Over the keystone there shall be two dolphins or sea-fish, with a hanging crab and a suggestion that said fishes support a large tablet which shall contain the inscription. Besides this tablet there shall be two large statues of an old, white-haired man and a woman,

22 Ronsard's sonnet on this colossus: Blanchemain, p. 49. The woodcut is reproduced by Babelon, fig. 79 (with wrong caption) and Yates, fig. 3. The text was followed rather closely. The torches dispensed "une odeur aromatique."

23 *Junon Nopcière,* the protectress of marriage. Ronsard's sonnet: Blanchemain, p. 49. The figure, of white stucco, was so well done that "there was no one who did not mistake it for real marble" (Douet-d'Arcq, p. 527).

24 Yates, fig. 4, and Béguin, p. 144.

with full hair and beard, holding oars and leaning on large vases from which water flows. These figures shall represent the rivers *Marne* and *Seine*. And above said tablet and simulated cornice shall be a large boat, like an ancient ship, with water around it and with rushes and islands; and on both sides of this boat shall be large statues, from seven to eight feet high. The boat shall be enriched with fine ornaments in the antique manner and shall have mast and sails. And as to said figures, they shall be made according to the description by said poet,[25] as follows:

Note: Over the first portal of the Pont Notre-Dame, beside said ancient vessel or boat, shall be made two beautiful young men, each with a star on his head, who seem to touch and to aid the vessel.[26] And under one of these figures shall be placed bones; under the other, a horse's bit and bridle.

Upon the second arch of said Pont Notre-Dame, to the right of the boat, one shall place a laurel tree, and attached to said laurel tree a *Bellona,* or *Fury,* or *Mars,* in chains, with a horrible face, or in the form which the poet shall advise.

On the other side one shall place an olive tree, and attached to said olive tree a *Victory,* with a smiling face; and one shall leave room for the inscriptions. All this in the form which shall be advised.

These works of sculpture and figures shall be made by the sculptor, and that which must be made in painting, by the painter.

The contract proper with the sculptor and the painter reads as follows: [27]

The honorable gentlemen, M. Nicolas Labbé,[28] painter to the King, residing in Fontainebleau, and M. Germain Pillon, sculptor to said Sieur, residing at the Hotel de Nesles in Paris, declare, each in his own right, to have made a contract with Messieurs the provosts of the merchants and aldermen of the city of Paris, present here and assembled in the office of said city, to this effect: They will make and complete for said city, as well as they are able, according to the standards of craftsmen and people who understand this matter, all and each of the works of painting and sculpture, fully contained and described in the above-transcribed document made and tendered by them, which ought to be executed for the Entry of the King in this city of Paris. To wit: Said Nicolas Labbé, all and each of the works of painting contained and described in said document, in the places and locations, exactly in the

[25] Ronsard's "Sonnet sur la navire de la ville de Paris, protégé par Castor et Pollux, ressemblants de visage au roy et monseigneur le Duc d'Aniou": Blanchemain, p. 49. It contains the famous line: "France et Paris n'est qu'une mesme chose."

[26] Castor and Pollux as the King and the Duc d'Anjou; see the preceding note.

[27] Douet-d'Arcq, p. 587; Babelon, p. 41.

[28] Niccolò dell'Abbate.

form and manner contained and described in said document, and as it is illustrated by the models made of them, approved by the undersigned notaries. Beyond this, said Labbé shall be obliged to make the paintings, exactly as he will be advised by the pact pertaining to this. And said sculptor Pillon shall make all and each of the works of sculpture which are likewise contained and described in that document, in the places and locations, exactly in the form and manner indicated and explained in that document, and illustrated by said models which have remained in the hands of said Labbé and Pillon for the making of said works. Said Labbé and Pillon shall be obliged, have promised and are promising now to make these works as well as they can. To wit, said paintings to be made in good and vivid colors, and said figures and other things of good materials; all within the next six weeks. And in making this they shall be obliged to furnish and provide all materials, scaffoldings, fabrics, ropes and generally all other things that are required and necessary for the completion of said works, with the sole exception of the carpentry and furniture work which said city shall be obliged to have made at its own expense. This contract provides for the sum of 3500 *livres tournois* which said provosts of the merchant and aldermen shall be obliged, have promised and are now promising to tender and to pay through the honorable gentleman, Monsieur François de Vigny, treasurer of said city, to wit: to said painter Labbé, the sum of 1100 *livres tournois* for each and all works of painting which he shall execute as well as he can, in good and vivid colors, according to said brief and the rules of said pact. Of this sum he shall be tendered and paid in advance, as installment on said works, the sum of 400 *livres tournois*. And to said sculptor Pillon, the sum of 2400 *livres tournois*, for each and all works of sculpture and other accessories of his art, which he shall make as well as possible for said fee, exactly according to the brief transcribed above. Of this sum he shall be tendered and paid in advance, as installment on said works of sculpture, the sum of 600 *livres tournois*. This sum, of 400 *l. t.* in the case of one, and 600 *l. t.* in the case of the other, which shall be tendered and paid them in advance, shall be deducted from their respective wages. And the rest and remainder shall be tendered and paid by the treasurer of this city, in the measure as they shall have executed said works of painting and sculpture, which they promise to make and complete as well as they can (as mentioned above), and within the stipulated time, all expenses, damages and interest to their debit.

Promised etc., under obligations etc., each in his own right, by said Labbé and Pillon, pledging their persons and possessions in debt to the crown etc. Signed and notarized, Wednesday, October 11th, 1570.

YMBERT [29] AND QUETIN.

[29] Babelon has "Ybert."

The statement concerning the changes required for the entry of the queen, dated March 17, 1571, follows: [30]

First, as to the Porte Saint-Denis, there shall be made, in lieu of Pharamond and Francyon, the figures of King Pepin and Charlemagne, in royal cloaks, with crowns, insignia, swords. With their hands they shall hold the columns which have already been used and still are on the Porte aux Peintres near the figure of King Henry; on one of these columns shall be represented a church, and on the other that which will be advised for a representation of the Empire.[31] Both the two figures and the columns shall be colored, decorated and arranged as perfectly as possible. Between these figures, upon the façade or main front, shall be newly made and placed two nymphs, adorned in the antique manner, who shall hold and crown with a laurel and oak wreath the arms of the reigning King and the Queen. In order to achieve this, one will have to make anew and build the coat-of-arms of said Queen of the same size as those of the King, which will have to be set in place again, and to re-work and reconstruct them. And in lieu of those cornucopias one will have to make two bushes on both sides, to coat and to gild them, and further to re-work whatever is necessary at the architecture and rustication of said portal, apart from the inscriptions and paintings which must yet be made.

As to the Ponceau. Out of the figure of the Queen one will have to make a goddess Flora; [32] in order to achieve this one must make changes in her arms causing them to hold flowers in the hands, suggesting that they are offered to the present queen. Her garb will have to consist of a golden drapery with green ornaments, with a head veil forming a silver cap. All bare parts of said figure must show a natural coloration and the figure must be adorned with belt and hat, fruits and flowers. The nymphs must likewise receive new heads displaying greater youth than they do now, and their garbs must be painted with the colors of red or green satin, with the finest ornaments such as shall be indicated, and the bare parts of said figures shall show natural coloration; their hands shall hold some flowery rushes,[33] otherwise, in the most natural manner possible, they shall seem to wear hats and bouquets, the latter containing, among other flowers, several lilies.

As to the Porte aux Peintres, one shall discard the urn with the little children around it, the crown, the eagle and its ornaments, and the Hercules who kills Antaeus. And in lieu of the Hercules there shall appear the figure of the present King, in a natural pose; [34] and in order

[30] Douet-d'Arcq, p. 661; Babelon, p. 42.
[31] See note 12.
[32] Babelon, fig. 80 (with wrong caption).
[33] "Fleurs de plume."
[34] "Ainsy assiz qu'il est"; it is not clear whether "assis" means "seated" here.

to do this, he must be re-worked and reconstructed in all necessary parts; one must also re-whiten and restore the figure of King Henry,[35] and give him different hands, one holding a scepter, the other [a figure] representing Faith. In the center of the front one shall make anew two large standing river gods, six to seven feet high, who hold a terrestrial globe six to seven feet in diameter, and with their other hands hold each other. Beside these rivers one shall make two large vases or jugs, and said rivers shall be crowned with reeds and flowers growing in the water, coated or gilded. One shall also have to re-work the two figures of Monsieur and Monsieur the Duke, as shall be advised, and to make a frieze in the antique manner with foliage in relief and embossed cloth paper [36] twenty-one inches high, of that size which contains twelve fathoms. This foliage shall be gilded, and the background painted white in the semblance of marble, and the capitals and bases of the columns shall also be gilded; in lieu of the ship one must place a caduceus of Mercury, and one shall blacken the niches in the semblance of black marble in order to give more relief to the figures which must be re-whitened and refurbished with their customary ornaments, apart from the paintings and inscriptions.

As to the pedestal in front of the Sepulchre, where there is the figure of Juno, she must be made to hold, instead of a scepter, a Gordian or indissoluble knot; the eagles in the four corners must be coated and gilded, and re-worked where necessary; her garb must be changed and painted with colors indicating satin and velvet as will be advised.

As to the pedestal in front of the fountain, out of the *Hymenaeus* one shall make a *Saturn* with a long beard, holding a scythe in one hand and in the other a ship which was held by one of the figures on the Porte aux Peintres; and in order to achieve this one will have to transform said figure into a nude, inasmuch as it is now clad but must then become nude, with only a drapery to hide the private parts; one shall discard the little children and gild the eagles; all of it to be re-worked and reconstructed as best one can.

As to the first portal of the Pont Notre-Dame, one shall discard the figure of the King and of Monsieur, and the ship; and in lieu of the ship one shall make a structure of two feet and three inches sloping off on both sides, and on it, a figure of Europa, seated on a bull who seems to be swimming, and for this one must make the figure of a lady, embellished according to the best advice.[37] And between the tablet and arch one shall make a large silvered shell. One will also have to re-whiten the two rivers and re-paint whatever is necessary in both the architecture and the rocks.

[35] Henri II, the "armed king" of the first statement; see above, note 18.
[36] "Maillerie de papier de thoille"; not clear.
[37] Yates, fig. 5.

As to the other portal, the large ship must be provided with full sails and riggings, and the flags and coat-of-arms re-done wherever necessary. To the chained *Mars* one shall have to give new free arms and a more serene new head, and of the *Victory* one must make a *Venus* and adorn her as will be advised by the poet; also the rivers and other figures must be re-whitened, and the architecture re-supplied with colors where necessary; all this in addition to the new paintings and inscriptions.

Present at this was Mr. Germain Pillon, sculptor to the King, who recognized and agreed to have made a pact with the provosts of the merchants and aldermen of the city of Paris, also present, to make to the best of his ability, according to the standards of craftsmen and people who understand this matter, each and all of the works listed above, which he promises to complete by the 24th of the current month. . . . This contract to involve the sum of 550 *livres tournois*. . . . Signed and notarized on March 17th, 1571.

Pontus de Tyard

Just as Jean Lebègue had composed a kind of "recipe" for miniaturists with his descriptions of scenes for Sallust's Catilina, *Pontus de Tyard (1521–1605), Bishop of Chalons-sur-Saône and an outstanding member of the* Pléiade *and the Palace Academy, wrote twelve descriptions for the painting of famous mythological stories about rivers and fountains adapted from Gyraldus'* De deis gentium *and similar sources.[1] These descriptions were intended for pictures to be executed in a room of the Château d'Anet, equally famous for de l'Orme's architecture and Jean Goujon's fountains, but nothing is known about the artist or the composition of the paintings, with the result that we are here less well-informed about the effect of the prescription on the artist than in the case of Lebègue. The work, consisting of a short account of the story, the description for the painting, and a poem ("epigramme") on each of the twelve river and fountain subjects, was written ca. 1555 but not printed until 1586. The following selection is restricted to the story and description for one painting, and the description alone for another. The advice on painting a winter landscape at nighttime, in the case of the* Phasis

[1] The original title is: Douze Fables de Fleuves ou Fontaines, avec la Description pour la Peinture, et les Epigrammes. Par P. D. T. A Paris. Chez Iean Richer, rue sainct Jean de Latran, à l'enseigne de l'arbre Verdoiant. 1586. Avec Privilege du Roy. The Phasis story is here translated from the text as reprinted by Ch. Marty-Laveaux, *Les Oeuvres Poétiques de Pontus de Tyard, Seigneur de Bissy* (Paris 1875), pp. 199 ff.; the Callirhoe story is given in the translation by Frances A. Yates, *The French Academies of the Sixteenth Century (Studies of the Warburg Institute,* XV [London 1947]), p. 136. The connection with Anet is explicitly stated in the foreword, written by the author's friend Tabourot in 1585.

story, is most remarkable; one wonders whether the painter was willing and able to follow it. The "recipe" for the story of Callirhoe and Coresus was echoed as late as Fragonard's thoroughly academic rendering of the myth in the Louvre.

IV. Callirhoe [2]

DESCRIPTION OF THE PAINTING

Some Calydonians are to be seen waiting for the Dordonean oracle, and in order to represent this there must be painted at one place and in perspective a distant view of a forest of oaks, at the most visible point of which there is to be an oak taller than the others, on a branch of which the prophetic Dove, white in color, is perched, and in front of the said oak (from which several chaplets are hanging) are the Calydonians listening to the oracle. In another place and more in the foreground is to be seen Coresus the priest standing on the highest step of the altar (upon which is the image of the god Bacchus), wounded by the knife of sacrifice and trying to throw himself into the prepared fire. Lower down and seated near the altar is to be seen Callirhoe wounded, looking at Coresus with her dying glance; her blood is running into the fountain of her name. She is crowned with a Bacchic crown, that is to say of vine, ivy, and fig leaves. As a girdle and as a scarf across her shoulders she wears cords of ivy and of vine tendrils. Around her is a troop of Calydonian men and women whose countenances show various expressions of astonishment.

V. Phasis [3]

In Scythia Phoebus had a son named Phasis by a girl named Ocyrrhoe. When Phasis had grown up, remaining chaste and in strict observance of continence, he once surprised Ocyrrhoe in the act of adultery. Chagrined and disgusted by his mother's sins and unable to restrain his anger, Phasis killed her; then, seized by sudden remorse, he drowned himself in a nearby river called Arcturus (which derived its name from the star that stands between the legs of Bootes in the Northern Constellation). And ever since, that river has retained the name of Phasis, and in it grows a plant called Leucophile which jealous husbands gather in early spring and put in their beds in order to assure themselves of their wives' conjugal faith.

[2] The source of this fable is Pausanias VII, 21, 1-5.

[3] The source is (Pseudo-) Plutarch, de fluv. 5, 1-2 (Fr. Dübner, *Plutarchi Fragmenta et Spuria* [*Plutarchi Opera*, V] [Paris 1855], pp. 83 f.), on which see K. Ziegler in Pauly-Wissowa, XXI, 1 (1951), col. 870 f.

DESCRIPTION OF THE PAINTING

Paint a landscape at winter time; in a section of the background one should see Phoebus with Ocyrrhoe, and near them their little son Phasis. Nearer the front show Ocyrrhoe killed by the thrust of a sword, and the man who had been caught with her, fleeing and saving himself by hiding. Still closer show Phasis throwing himself into a river; and at this spot one should see a plant with white leaves growing here and there along the river like the reeds at our streams. This picture might be painted as a nocturne; and there should be depicted the northernmost region of the sky, with the Polar Star at the zenith, the Bears and other northern stars painted according to their sizes and constellations, done gracefully and not without display of great diligence.

4

England

That the chapter on England should be so short—not much more than an appendix to those on the Netherlands, Germany, and France— will come as no surprise to those surveying the contribution of England to the visual arts in the 15th and 16th centuries; nor will it be considered accidental that the writer quoted here was primarily a painter of miniatures, the one field in which English artists excelled toward the end of that period.

Nicholas Hilliard

A Treatise Concerning the Art of Limning [1] *is not only the earliest but undoubtedly also one of the most valuable and original contributions ever made by a British painter to the literature on the practice and criticism of his profession. Its author, the outstanding miniature portraitist Nicholas Hilliard (c. 1547–1619), wrote it between 1598 and 1602/03 on the insistence of his friend Richard Haydocke, the English translator of the larger part of Lomazzo's* Trattato, *on which Hilliard bestowed special praise. Hilliard, always weary of too much emphasis on theory— like Federico Zuccari he was quite critical of Dürer as a theoretician [2] —stressed the point that he was "only intending to teach the art of limning, and the true method leading thereunto"; but he was by no means a mere dispenser of technical advice, and his remarks on the "genteel" quality of limning, on sitters, on Dürer's and Holbein's art make very good sense and very good reading indeed.*

Of precepts and directions for the art of painting I will say little, insomuch as Paulo Lomatzo and others hath excellently and learnedly spoken thereof, as is well known to the learned and better sort who are conversant with those authors; but only intending to teach the art of limning, and the true method leading thereunto, as also to show who are fittest to be practicers thereof, for whom only let it suffice that I intend my whole discourse that way.

Amongst the ancient Romans in time past [it was forbidden] that any should be taught the art of painting save gentlemen only. I conjecture they did it upon judgment of this ground, as thinking that no man using the same to get his living by, if he was a needy artificer, could have the patience or leisure to perform any exact, true, and rare piece of work, but men ingeniously born, and of sufficient means not subject to those

[1] The following excerpts are taken from the reprint by Philip Norman, *Nicholas Hilliard, A Treatise Concerning the Art of Limning,* in *The First Annual Volume of the Walpole Society,* 1911-12 (Oxford 1912), pp. 15 ff. Spelling has been modernized.

[2] See Horst Vey, "Nicholas Hilliard and Albrecht Dürer," *Mouseion, Studien aus Kunst und Geschichte für Otto H. Förster* (Cologne 1960), pp. 155 ff.

common cares of the world for food and garment, moved with emulation and desire thereof, would do their uttermost best, not respecting the profit or the length of time, nor permit any unworthy work to be published under their name to common view, but deface it again rather and never leave till some excellent piece of art were by him or them performed worthy of some commendations, by reason whereof it was no wonder that the most excellent nation and the greatest wits of the world then brought forth the most rare works in painting that ever were; it must needs be granted then for ever, and like as one good workman then made another, so one botcher nowadays maketh many, and they increase so fast that good workmen give over to use their best skill, for all men carry one price.

Now therefore I wish it were so that none should meddle with limning but gentlemen alone, for that is a kind of genteel painting of less subjection than any other; for one may leave when he will, his colors nor his work taketh any harm by it. Moreover it is secret, a man may use it and scarcely be perceived of his own folk; it is sweet and cleanly to use, and it is a thing apart from all other painting or drawing, and tendeth not to common men's use, either for furnishing of houses or any patterns for tapestries, or building, or any other work whatsoever, and yet it excelleth all other painting whatsoever in sundry points, in giving the true luster to pearl and precious stone, and worketh the metals gold and silver with themselves, which so enricheth and ennobleth the work that it seemeth to be the thing itself, even the work of God and not of man, being fittest for the decking of princes' books or to put in jewels of gold and for the imitation of the purest flowers and most beautiful creatures in the finest and purest colors which are chargeable, and is for the service of noble persons very meet in small volumes in private manner for them to have the portraits and pictures of themselves, their peers, or any other foreign [end of sentence mutilated] . . .

Here is a kind of true gentility when God calleth, and doubtless though gentlemen be the meetest for this genteel calling or practice, yet not all, but natural aptness is to be chosen and preferred, for not every gentleman is so gentle-spirited as some others are. Let us therefore honor and prefer the election of God in all vocations and degrees; and surely he is a very wise man that can find out the natural inclination of his children in due time, and so apply him that way which nature most inclineth him, if it be good or may be made good, as it may be used, though in childhood abused; and as for a natural aptness of or to painting after [the] life, those surely which have such a gift of God ought to rejoice with humble thankfulness, and to be very wary and temperate in diet and other government, least it be soon taken from them again by some sudden mischance, or by their evil customs their sight or steadiness of hand decay. . . .

Here must I needs insert a word or two in honor and praise of the renowned and mighty King Henry the Eighth, a prince of exquisite judgment and royal bounty, so that of cunning stranger[s] even the best resorted unto him and removed from other courts to his, amongst whom came the most excellent painter and limner Hans Holbein, the greatest master truly in both those arts after [the] life that ever was, so cunning in both together, and the neatest; and therewithal a good inventor, so complete for all three as I never heard of any better than he. Yet had the King in wages for limning divers others; but Holbein's manner of limning I have ever imitated and hold it for the best, by reason that of truth all the rare sciences, especially the arts of carving, painting, goldsmiths, embroiderers, together with the most of all the liberal sciences, came first unto us from the strangers, and generally they are the best and most in number. I heard Kimsard,[3] the great French poet, on a time say that the islands indeed seldom bring forth any cunning man, but when they do it is in high perfection; so then I hope there may come out of this our land such a one, this being the greatest and most famous island of Europe. . . .

And here I enter my opinion concerning the question whether of the two arts is the most worthy, painting or carving: [4] I say, if they be two arts, painting is the worthier, as in the last leaf I hope I shall prove sufficiently. Again I will do cunning Albert no wrong, but right; doubtless he was the most exquisite man that ever left us lines to view for true delineation, the most perfect shadower that ever graved in metal for true shadows, and one of the best and truest in his perspective, but yet it must be thought, or rather held for certain, by reason that he was no great traveler, that he never saw those fair creatures that the Italians had seen, as Rosso, Raphael, and Lambertus Swavius,[5] etc., for besides a certain true proportion, some of theirs excel his in mind of beautifulness and spirit in the lineament and gesture, with delicacy of features and limbs, hands, and feet surpassing all other portraitures of the Dutch whatsoever, yea even nature itself, except in very few, which rare beauties are (even as the diamonds are found amongst the savage Indians) more commonly found in this isle of England than elsewhere, such surely as art ever must give place unto. I say not for the face only, but every part, for even the hand and foot excelleth all pictures that yet I ever saw. This moved a certain pope to say that England was rightly called Anglia, of Angely, as the country of Angels, God grant it.

And now to the matter of precepts, for observations or directions to the art of limning which you require, as briefly and as plainly as I

3 Ronsard?

4 I.e., engraving.

5 Probably Lambert Sustris, who was confused with Lambert Suavius at an early date.

can, concerning the best way and means to practice and attain to skill in limning: in a word before I exhorted such to temperance, I mean sleep not much, watch not much, eat not much, sit not long, use not violent exercise in sports, nor earnest for your recreation, but dancing or bowling, or little of either.

Then the first and chiefest precepts which I give is cleanliness, and therefore fittest for gentlemen, that the practicer of limning be precisely pure and cleanly in all his doings, as in grinding his colors in place where there is neither dust nor smoke, the water well chosen or distilled most pure, as the water distilled from the water of some clear spring, or from black cherries, which is the cleanest that ever I could find, and keepeth longest sweet and clear, the gum to gum arabic of the whitest and brittlest, broken into white powder on a fair and clear grinding stone, and white sugar candy in like sort to be kept dry in boxes of ivory, the grinding stone of fine crystal, serpentine, jasper, or hard porphyry; at the least let your apparel be silk, such as sheddeth least dust or hairs, wear nothing straight,[6] beware you touch not your work with your fingers, or any hard thing, but with a clean pencil brush it, or with a white feather, neither breathe on it, especially in cold weather, take heed of the dandruff of the head shedding from the hair, and of speaking over your work for sparkling, for the least sparkling of spittle will never be holpen if it light in the face or any part of the naked.

The second rule is much like the first, and concerning the light and place where you work in. Let your light be northward somewhat toward the east, which commonly is without sun shining in; one only light, great and fair let it be, and without impeachment or reflections of walls or trees, a free sky light, the deeper the window and farther the better, and no by-window, but a clerestory in a place where neither dust, smoke, noise, or stench may offend. A good painter hath tender senses, quiet and apt, and the colors themselves may not endure some airs, especially in the sulphurous air of sea-coal and the gilding of goldsmiths; sweet odors comforteth the brain and openeth the understanding, augmenting the delight in limning. Discreet talk or reading, quiet mirth or music offendeth not, but shorteneth the time and quickeneth the spirit, both in the drawer and he which is drawn; also in any wise avoid anger, shut out questioners or busy fingers. All these things may be had, and this authority may best be used, by gentlemen; therefore in truth the art fitteth for them.

Now know that all painting imitateth nature or the life in everything, it resembleth so far forth as the painter's memory or skill can serve him to express, in all or any manner of story work, emblem, impress, or other device whatsoever; but of all things the perfection is to

[6] Probably meaning: "stiff," encumbering motion and thus jeopardizing the painting.

imitate the face of mankind, or the hardest part of it, and which carrieth most praise and commendations, and which indeed one should not attempt until he were meetly good in story work, so near and so well after the life as that not only the party in all likeness for favor and complexion is or may be very well resembled, but even his best graces and countenance notably expressed, for there is no person but hath variety of looks and countenance, as well ill-becoming as pleasing or delighting.

Whereof it is not amiss to say somewhat in brief touching this point, leaving the better handling thereof to better wits, wherein the best shall find infinite arguments, right pleasant to discourse upon; and hereof it cometh that men commonly say of some drawer, he maketh very like, but better yet for them than the party is indeed; and of some other they also say, he maketh very fair, but worse favored. In the comeliness and beauty of the face, therefore, which giveth us such pleasing, and feedeth so wonderful our affection more than all the world's treasure, it consisteth in three points: the first and least is the fair and beautiful color or complexion, which even afar off as near is pleasing greatly all beholders; the next and greater part is the good proportion sometime called favor, whereof our devine part upon nearer view, by an admirable instinct of nature, judgeth generally, both in wise and foolish, young or old, learned and simple, and knoweth by nature, without rule of reason for it, who is well proportioned or well favored, etc.; but the third part and greatest of all is the grace in countenance, by which the affections appear, which can neither be well used nor well judged of but of the wiser sort, and this principal part of the beauty a good painter hath skill of and should diligently note, whereof it behooveth that he be in heart wise as it will hardly fail that he shall be amorous (and therefore fittest for gentlemen). . . .

Forget not therefore that the principal part of painting or drawing after the life consisteth in the truth of the line, as one sayeth in a place that he hath seen the picture of her Majesty in fewer lines very like, meaning by fewer lines but the plain lines, as he might as well have said in one line, but best in plain lines without shadowing, for the line without shadow showeth all to a good judgment, but the shadow without line showeth nothing. As for example, though the shadow of a man against a white wall showeth like a man, yet it is not the shadow but the line of the shadow which is so true that it resembleth excellently well. As draw but that line about the shadow with a coal, and when the shadow is gone it will resemble better than before, and may, if it be a fair face, have sweet countenance even in the line, for the line only giveth the countenance, but both line and color giveth the lively likeness, and shadows show the roundness and the effect or defect of the light wherein the picture was drawn.

This makes me remember the words also and reasoning of her Majesty when first I came in her Highness' presence to draw, who after showing me how she noted great difference of shadowing in the works and diversity of drawers of sundry nations, and that the Italians, who had the name to be cunningest and to draw best, shadowed not, requiring of me the reason of it, seeing that best to show oneself needeth no shadow of place but rather the open light; to which I granted, and affirmed that shadows in pictures were indeed caused by the shadow of the place or coming in of the light as only one way into the place at some small or high window, which many workmen covet to work in for ease to their sight, and to give unto them a grosser line and a more apparent line to be discerned, and maketh the work emboss well, and show very well afar of, which to limning work needeth not, because it is to be viewed of necessity in hand near to the eye. Here her Majesty conceived the reason, and therefore chose her place to sit in for that purpose in the open alley of a goodly garden, where no tree was near, nor any shadow at all, save that as the heaven is lighter than the earth so must that little shadow that was from the earth. This her Majesty's curious demand hath greatly bettered my judgment, besides divers other like questions in art by her most excellent Majesty, which to speak or write of were fitter for some better clerk. . . .

I have ever noted that the better and wiser sort [of sitters] will have a great patience, and mark the proceedings of the workman, and never find fault till all be finished. If they find a fault, they do but say, I think it is too much thus or thus, referring it to better judgment, but the ignoranter and baser sort will not only be bold precisely to say, but vehemently swear that it is thus or so, and swear so contrarily that this volume would not contain the ridiculous absurd speeches which I have heard upon such occasions. These teachers and bold speakers are commonly servants of rude understanding, which partly would flatter and partly show but how bold they may be to speak their opinions. My counsel is that a man should not be moved to anger for the matter, but proceed with his work in order, and pity their ignorance, being sure they will never rob men of their cunning, but of their work peradventure if they can, for commonly where the wit is small the conscience is less. . . .

The good workman also which is so excellent dependeth on his own hand, and can hardly find any workmen to work with him, to help him to keep promise, and work as well as himself, which is a great mischief to him. Neither is he always in humor to employ his spirits on some work, but rather on some other. Also such men are commonly no misers, but liberal above their little degree, knowing how bountiful God hath endowed them with skill above others; also they are much given to practices, to find out new skills, and are ever trying conclusions,

which spendeth both their time and money, and oft-times when they have performed a rare piece of work (which they indeed cannot afford) they will give it away to some worthy personage for very affection and to be spoken of. They are generally given to travel, and to confer with wise men, to fare meetly well and to serve their fantasies, having commonly many children if they be married; all which are causes of impoverishment, if they be not stocked to receive thereupon some profit by other trade, or that they be, as in other countries, by pension or reward of princes otherwise upheld and competently maintained, although they be never so quick nor so cunning in their professions, depending but on their own hand help. . . .

Index

A

Abbate, Camillo dell', 157, 160, 161
Abbate, Niccolò dell', 153, 160, 161
Abraham, 11, 60, 144
Actaeon, 134
Adam, 45
Adoration of the Kings, 23, 34, 47, 48, 55, 77
Adoration of the Lamb, 8, 103
Adoration of the Shepherds, 47
Aegidius, Peter, 131
Aelst, Pieter Koecke van, 38, 40, 68
Aertsen, Pieter, 63
Agricolus, Saint, 142
Albert Simonsz, 14
Alberti, Leone Battista, 57-59
Albrecht of Brandenburg, 95
Alfonso V of Naples (Aragon), 4, 5, 7
Allegory (see under subjects)
All Saints, 134
Alvarez, Vincente, 9
Anne de Bretagne, 147
Annunciation to the Virgin, 5, 47, 60, 83, 134
Antaeus, 157, 162
Anthony, Saint, 128
Anton of Bordeaux, 29
Antonello da Messina, 6, 30
Antonio Siciliano, 30

Apelles, 26, 37, 51, 64, 84, 112, 122-123, 146, 151
Apollo, 43, 60, 70, 165-166
Apollonia, Saint, 128
Arcturus, 165
Artemisia, 156
Ascension of Christ, 48
Assumption of Mary, 91-94, 127, 134
Athena, 24, 36
Augustus, 70
Averlino, Antonio, 145

B

Bacchanal, 49
Bacchus, 43, 55, 62
Baïf, Jean Antoine de, 152
Bailluwel, Gillis, 11
Baldung, Hans, 151
Barbara, Saint, 128
Barbari, Jacopo de', 89, 106, 108
Bartimaeus (Padua), 34
Bartolommeo, 75-76
Bassano, Jacopo, 61
Baudouin de Bailleul, 28
Baussele, Rase van, 10
Beckere, Stans Roelofs, 10
Bedford Master, 139
Bellini, Giovanni, 27, 89, 124-125, 151